VISUAL TIME

VISUAL TIME

THE IMAGE IN HISTORY

KEITH MOXEY

Duke University Press | Durham and London | 2013

N
7480
.M69
2013
C. 2

Library of Congress Cataloging-in-Publication Data
Moxey, Keith P. F., 1943–
Visual time : the image in history / Keith Moxey.
p. cm
Includes bibliographical references and index.
ISBN 978-0-8223-5354-6 (cloth : alk. paper)
ISBN 978-0-8223-5369-0 (pbk. : alk. paper)
1. Art—Historiography. 2. Time and art. I. Title.
N7480.M69 2013
707.2′2—dc23 2012048671

DUKE UNIVERSITY PRESS GRATEFULLY
ACKNOWLEDGES THE SUPPORT OF THE DUKE
UNIVERSITY CENTER FOR INTERNATIONAL
STUDIES' GLOBALIZATION AND THE ARTIST
PROJECT, WHICH PROVIDED FUNDS TOWARD
THE PRODUCTION OF THIS BOOK.

to Michael

CONTENTS

ILLUSTRATIONS

ACKNOWLEDGMENTS

The ideas contained in these chapters have been developed over a number of years in different venues and varied locations. The thrust of my argument, addressed at the current shape of art history, has been fueled by a growing awareness of the provincialism of its Eurocentric bias. This awareness prompted me to pursue the idea that heterochrony might be a way of articulating resistance to a subscription to a "universal" form of time. I was fortunate to be involved in the development and execution of a graduate lecture course titled "Multiple Modernities," first proposed by Esther Pasztory at Columbia University in 2006 and repeated by Susan Vogel in 2009. This course brought a number of the faculty together to discuss modern and contemporary art in "non-Western" cultures. I learned an immense amount from the presentations of my colleagues who prompted me to articulate my ideas about the significance of these "other" modern narratives for the larger project of the history of art. These ruminations were advanced by my participation in a workshop called "Contemporaneity" organized at the Clark Art Institute by Terry Smith in 2009. Smith's ideas on time in contemporary art that have since resulted in a number of publications stimulated my own. These thoughts were first offered as talks, and my thanks are due to those responsible for the invitations and for their hospitality: Maria Vest Hansen and Hanne Kolind Poulsen (Copenhagen), Olivier Mathieu (Montreal), Hendrik Volkerts (Amsterdam), Marquand Smith and Joanne Morra (London),

Anca Oroveanu (Bucharest), and Shuddhabrata Sengupta (Mexico City). The resulting texts dealing directly with time in part I of the book have benefited from readings by Alexander Alberro, Hagi Keenan, and Miguel Angel Hernandez Navarro. All three have been frequent interlocutors and their friendship is much appreciated. A version of "Do We Still Need a Renaissance?" appeared in *Crossing Cultures: Conflict, Migration and Convergence. The Proceedings of the 32nd International Congress of the History of Art,* edited by Jaynie Anderson (Melbourne: Melbourne University Publishing, 2009), 233–38.

My thoughts relating to the anachronic nature of an aesthetic experience of the work of art resulted from an awareness of the burgeoning importance of ideas of agency or "presence" in the literature of both art history and visual studies. These ideas structure the chapters assembled in part II. Krešimir Purgar and Žarko Paić (Zagreb) and the late José Luis Brea (Madrid) provided me with opportunities to talk about these developments. The resulting article, "Visual Studies and the Iconic Turn," first appeared in the *Journal of Visual Studies* 7, no. 2 (2008): 131–46. I thank Marquand Smith and James Elkins for their suggestions. It was translated into Spanish for *Estudios Visuales* 6 (2009): 8–26 by José Luis Brea, and into French for *Intermédialités* 11 (2008): 149–68 by Johanne Lamoureux, to whom I am most grateful. The importance of this "ontological turn" is further explored in chapter 5, "Bruegel's Crows." Occasions to develop this text were offered by Asbjørn Grønstad and Øyvind Vågnes (Bergen), Beat Wyss (Karlsruhe), Jan von Bonsdorff (Uppsala), Dan Karlholm (Stockholm), Gabriela Siracusano (Buenos Aires), Christine Bernier (Montreal), and James Elkins (Chicago). A version appeared in *Balances, perspectivas y renovaciones disciplinares de la historia del arte: V Congreso Internacional de Teoria e Historia del Arte,* edited by Marcela Gene et al. (Buenos Aires: Centro Argentino de Investigadores de Arte, 2009). The work's capacity to haunt our consciousness is further explored in a chapter on the mimetic power of Hans Holbein's portraits. This text was first developed as a talk, and I thank Marcela Lista (Paris), Susanna Burghartz and Maike Christadler (Basel), and Mar Borobia (Madrid) for opportunities to engage a variety of different audiences. It appeared in *Art History* 32, no. 1 (2009): 52–78, thanks to David Peters Corbett and Samuel Bibby, and was translated into Spanish in *El siglo de Durero: Problemas historiograficos,* edited by Mar Borobia, 109–31 (Madrid: Thyssen-Bornemisza Museum, 2008).

Finally, the idea of time returns as a meditation on the work of the historian, a reflection on historical writing's capacity to realize the past in the present. What is it that drives historians to attempt this impossible task, and how do they negotiate the sense of difference that they discern in the past in the full realization that this recognition is produced in the present? Chapter 7 began long ago when I was the Clark Professor at the Clark Art Institute in Williamstown, Massachusetts. I continue to be grateful to Mark Haxthausen and Marc Simpson for making me feel welcome. It was published as "Impossible Distance: Past and Present in the Study of Dürer and Grünewald" in *Art Bulletin* 86 (2004): 750–63, where it benefited from readings by Joseph Koerner and Lionel Gossman. A shortened version was included in *The Essential Dürer*, edited by Larry Silver and Jeffrey Chipps Smith, 279–310 (Philadelphia: University of Pennsylvania Press, 2009). My debt to the Clark's library, however, goes far deeper. For many years now I have been able to count on its incomparable resources, and I want to thank its librarians, particularly Laurie Glover, Karen Bucky, and Susan Roeper, for their unfailingly good-natured assistance. I must add that published versions of all these texts have been substantially altered and revised for inclusion in this volume.

I also want to acknowledge Stephen Melville for discussions about contemporary French philosophy, and the graduate students in my seminars at Columbia on such topics as "The Iconic Turn," "How Images Think," and "Time and the Image" for intense exchanges about the nature of visual time. Gabriella Szalay was of gracious and unstinting assistance in collecting photos and permissions for the illustrations. I am also indebted to the research stipend associated with the Barbara Novak Chair awarded to me by Barnard College. Most important, however, has been the intellectual adventure shared with Michael Ann Holly in her capacity as Starr Director of the Clark Art Institute's Research and Academic Program. This exciting, multidimensional enterprise has proven an invaluable source of insights and ideas. She has, moreover, read, commented upon, and edited every one of these texts. This book belongs to her in more senses than one.

Where and when is the time of the history of art? This book addresses the image in time as well as the time of the image — the temporal constructs erected to account for the history of visual objects and their inherent temporal potential. The chapters circle around the questions posed by these two issues for the history of art. One argument posits that historical time is not universal but heterochronic, that time does not move at the same speed in different places. The history of art faces the disconcerting possibility that the time it imagines, history's very architecture, is neither uniform nor linear but rather multivalent and discontinuous. How are historians to relate the narratives of artistic creation in different parts of the globe? What are the prospects for a world or a global art history in circumstances that recognize the incommensurability of different national and cultural traditions? The other argument depends on the anachronism involved in the experience of works of art, the awareness that regardless of the moment of their creation they still have the power to affect the present. Approaching works of art as capable of creating their own time, anachronic or aesthetic time, insists on the role of the historical horizon in which their reception takes place.

Integral to the arguments described above is the idea of translation. Translation is, for example, the means by which temporalities interact with each other. It also provides a common, though inadequate, metaphor for the transformation of

what we see into what we read. Translation is as impossible as it is necessary: *impossible* because, as Walter Benjamin points out, every translation from one language into another involves the creation of a third that corresponds with neither, and *necessary* because there is no other way of conceiving the possibility of transcultural communication or the potential of relating the image to the word. Translation neither guarantees easy access from one historical narrative to another, nor can it equate the visible with the legible. I invoke it to suggest the difficult process by which incommensurable discourses and media relate to one another, trailing their accompanying contingencies behind them.

I begin with *heterochrony*. The history of art has traditionally spent much of its time attempting to lend order to the chronological location of the objects it calls its own. In its efforts to contain or tame them, and thus render them more susceptible to attributed meaning, works of art are inevitably assigned a sequential location within a teleological system. Embedded in metonymic horizons, they acquire the distance deemed necessary for so-called historical interpretation. Can art history conceive of time in any other terms? Can chronology be divorced from its identification with a motivated temporal trajectory whose significance is restricted to Euro-American culture?

The colonial project, with which the Western idea of history coincides, is coterminous with modernism. As Johannes Fabian argues, it was only possible for Western powers to aspire to control the rest of the globe's cultures if they were characterized not only as spatially exotic but also as temporally backward. Time's location, the place where time mattered, was in the West. Art history cannot easily abandon its investment in an idea of time embedded in a concept of history structured around a Hegelian narrative that leads from antiquity, through the Renaissance, and on to modernity. There is little space in this scheme for other forms of temporality. As a modernist enterprise, art history is inextricably linked to a notion of teleology and is therefore irreconcilable with an idea of heterochrony (many times existing at the same time). Modernism finds it necessary to believe that time is going somewhere—perhaps even that it has an end. It cannot accept that there might be more than one "shape" of time, for its global dominance depends on the negation of any alternative.

If modernism has come to an end, how is the history of art to deal with heterochronicity, the notion that there are multiple forms of time, and that

they do not necessarily relate to one another? Can the discipline, for example, accept that there is no belatedness to non-Western appropriations of Western styles, that subaltern histories are not repetitions of those that are dominant, and that the "center" is not merely copied when it appears at the "margins"? The distinction between history as a specifically Western mode of making meaning of the past, a history whose ambitions are universal, and the multiple narratives of purely local relevance becomes critical. The logic of chronology, traditionally history's overriding concern, is guaranteed by the sense that time has a purpose and a goal. If subaltern histories are to be recognized, time's passing cannot itself have meaning, and the truths of the stories that are told about time are justified only by their enduring cultural power. Temporal difference, however, matters as much as other forms of difference widely discussed and adopted as axes of historical interpretation in the recent past. If class, ethnicity, and gender are considered meaningful aspects of historical narratives, then heterochrony's claims that time is marked by distinct cultural characteristics must also be taken into consideration.

Turning next to the role of the image in the production of time, I consider its implications for art's history. The discipline has overwhelmingly dedicated its resources to understanding the work in the moment in which it was created. It is no surprise then that the discipline should have been tempted to treat the image as something dead and inert, an object more like a text than something whose visuality rendered it ultimately inaccessible to textual understanding. If the time of the work is not to be restricted to the horizon of its creation, then its status as an agent in the creation of its own reception, its *anachronic* power, shines through. The "presence" of the work of art—its ontological existence, the ways it both escapes meaning yet repeatedly provokes and determines its own interpretation—comes to the fore.

This view of the relation of the work to its historical interpretation differs from most of the interpretive commitments of the second half of the twentieth century. The critical initiatives that marked art historical strategies in this period tended to distantiate the visual by reducing the work of art to a manifestation of social forces and cultural attitudes. In the wake of iconography and iconology, the impulse to devise adequate schemes that might capture every aspect of a work's original meaning led to ever-more-ambitious forms of social history. Political movements seeking social

change added to the contextualization of works of art by provoking a concern for the artistic production of less privileged classes and marginalized groups, such as ethnic minorities and women.

The pendulum has now swung from the semiotic back in the direction of the aesthetic—where the art historical project began. Today the gap between a work of art and its viewers is more difficult to distinguish. Approached as an agent in its own right, rather than as a reflection of cultural attitudes, the work is treated as a collaborator in the production of meaning. Whereas a contextual attitude regarded the work as an object whose message had been encrypted at the moment of creation and whose ideological agendas needed to be read, this more recent position grounds itself on the premise that interpretation depends on an exchange between the work and its viewers. Needless to say, this is neither the first nor the last movement of a historiographic pendulum that has characterized art history's research and pedagogical practice for the past century and a half. The tension between these apparently conflicting demands—the recognition of the specificity of a work's aesthetic presence and the interpretation of its social and cultural significance—has productively animated art historical literature in the past, as it continues to do today.

The rhetorical contrasts offered by contemporary art historical writing raise many provocative questions about historical interpretation. Where, for example, are the "politics" of interpretation? Is the political found in the content of the work of art, in its power to contain and disseminate social and cultural ideas, or in its power to exceed the limitations of language and to create fresh experiential worlds of its own? Can one function be distinguished from the other? Where and when might they come together? Both depend on their interactions with viewers in order to work their magic. If the idea of the aesthetic is often contrasted with political interpretations of works of art, is it not also evident that one cannot survive without the other?

A key to this paradox, it seems to me, lies in the idea of *difference*. If difference was understood in the art history of the 1980s as a form of identity politics—as a means of drawing attention to the issues of class, gender, sexual preference, race, ethnicity, and national origin—it is invoked in this text to call attention to the heterogeneity of temporalities. Rather than fix relations between different time zones, however, the focus is on time differentials—the ever-shifting power dynamics that serve both to reify and transform relations among temporalities. The word *difference* is used here

both to contrast forms of time and to suggest that time and place coincide in ways that hinder efforts to disentangle them. The word is also used to contrast the aesthetic time created by the object from the temporal conventions of the location in which that response is lodged. The experience of the image is distinct from the time that surrounds it. A work can stop us in our tracks, so to speak, and insist that we acknowledge a form of perception that differs from that of the context in which it appears. *Difference* thus attempts to capture the perceptual awareness that temporalities precede our presence and depend on it. It gestures toward the to-and-fro of experience, the sense that what is called *objectivity* only receives that label as a consequence of its encounter with a subject. The term functions in this context to characterize heterogeneities of time in the full consciousness that temporal distinctions can be neither fully described nor defined.

Part I, "Time," contains three chapters that turn attention directly to heterochrony: the question of art historical time in a postcolonial situation. "Is Modernity Multiple?" asks whether, in an age whose growing awareness of the globalized nature of cultural interaction insists on the nonsynchronicity of the contemporaneous (the fact that time does not run at the same speed in all places), it is possible to escape the shadow of the ideological forces responsible for artistic modernism. In the aftermath of colonization, economic, technological, military, and cultural factors still serve to maintain the time of Western Europe and North America as that against which all others are calibrated. Whether these hierarchies are accepted or challenged, it is utopian to pretend they do not exist. The point of this essay is to ask whether the idea of chronology, so identified with the global status quo, might usefully be absolved of its evolutionary connotations. If the passage of time matters, its meaning must always be deciphered anew, and this process becomes one of translation: translation of time into text and different times into texts that might be rendered intelligible to one another. Even if translation must always betray the power relations among languages, and by extension the powers attributed to the visual as opposed to the textual, it may afford us a better working metaphor than tracing an allegedly unified and necessary trajectory of time's unfolding.

"Do We Still Need a Renaissance?" examines the periodizing strategies of the history of art, its chronological structure, in order to discuss their inherent historical value. Embedded within a chronological sequence, are such classificatory terms useful outside the evolutionary logic with which

they are allied? It is clear, for example, that the idea of the Renaissance has undergone continual transformations since its "invention" in the nineteenth century and that no definition can ever capture the essence of that distant, dazzling world. But can we do without it?

"Contemporaneity's Heterochronicity" continues the discussion of periodization by reviewing the current debate on the nature of contemporary art in the context of a postcolonial awareness of time's heterochronicity. The apparent impossibility of defining this moment of artistic production, often considered a way of recognizing the coeval nature of different forms of global time, is in danger of disabling the recognition of temporal and cultural differences. Even if there is no agreement as to how this moment of "now" is to be defined, some characterization, however transient, is crucial for forms of writing that claim to be historical.

Part II, "History," turns to the potential of the work to create time of its own—a form of time often identified with aesthetic experience. How can the otherness of the visual be respected in the face of the necessity to use language to invest it with meaning? This interrogation winds through four chapters. "Visual Studies and the Iconic Turn" serves as an introduction to the clash or confrontation between two different ways of understanding the image. A predominantly Anglo-American tradition approaches the image as cultural product filled with significance that needs to be deciphered, while other perspectives originating in the English-, French-, and German-speaking worlds view it as an agent that provokes meaningful responses in its viewers. The rich spectrum of interpretation afforded by these radically different perspectives, which cover the spectrum from semiotics to phenomenology, suggests the potential of visual studies as well as its compatibility with the more venerable discipline of the history of art.

"Bruegel's Crows" tangles with the nature of the ontological presence of the image in reference to the ability of the textual to do it justice. How does the work continue to inspire interpretations in the course of time? How does it escape the coils of language that would attempt to strangle it with words? Why, in this case, is the historiography of Pieter Bruegel littered with attempts to decipher and decode the meaning of his pictures? Can we ever see around the imaginative work of interpretation to glimpse the object that occasioned it? Does description translate the visual into the verbal or simply replace an image with more images? Inadequate as the verbal may appear in the act of transforming the visual into sense and meaning, translation serves

as a metaphor for the work of historical interpretation. If a motivated chronology is not history's muse, the engine on which an understanding of the past depends, then translation may be its successor.

In "Mimesis and Iconoclasm," the focus of attention lies in the magical power of verisimilitude, its apparent capacity to outrun time in order to maintain its fascination for widely differing historical moments. Contemporary artists are as adept at exploiting its power as are those of the Renaissance. What insights do they offer into verisimilitude's mechanism? The contemporary German artist Thomas Demand, for example, deliberately mocks traditional notions that mimesis might simply be the imitation of nature by producing his hyperrealistic photographs from carefully constructed cardboard models. Drawing attention to the way in which imitation is actually a creative process intended to persuade viewers that works of art correspond with our perception encourages us to reflect on the presence of Hans Holbein's painting *The Ambassadors*. This essay speculates on the potential meaning of this charmed picture. Like Demand's photographs, the mimetic magic of *The Ambassadors* is deliberately challenged in ways that permit us to suggest its allegorical status for those who first saw it, as well as for those of us who see it today.

The final chapter in part II, "Impossible Distance," reviews the twentieth-century historiography on Albrecht Dürer and Matthias Grünewald in order to examine the means by which scholars have both created and canceled the historical interval that separates past from present. German historical writing on these artists was once deeply marked by the nationalist rhetoric associated with both the First and Second World Wars. Nationalist scholars collapsed the historical distance that separated sixteenth-century Germany from their own time to insist on continuities that established and confirmed an eternal German identity. Erwin Panofsky's approach to these artists after the Second World War dwells on the differences between historical horizons rather than on the qualities that make them similar. He claims that the capacity of the Renaissance to distinguish its own culture as a specific moment in time distinct from both the Middle Ages and antiquity, an idea he explicitly relates to the "discovery" of linear perspective, is, in effect, itself a metaphor for the enlightened (rationalist rather than nationalist) historian's ability to distinguish historical "truth." Historical distance, whose neglect once served the interests of racist ideologues, becomes the means by which the alleged autonomy of the past guarantees the veracity of the historical

record. The chapter ends by asking whether this cordon sanitaire placed around the past to keep it at bay can be reconciled with the power of the image to provoke its own response, the fusion of subject and object so often identified with aesthetic experience.

The hinge that unites the two axes around which this book is organized—the nature of history and its relation to the agency of the image—is of course time. Instead of offering even tentative answers to the issues confronting the history of art today, these essays ally themselves with persistent questions. If time is multiple rather than universal, then it is incumbent on art historians to think again about the relation of accounts of time in those parts of the world considered dominant and those that have traditionally been designated subaltern. If an image prompts its own reception, then how are art historians to incorporate it into a diachronic narrative? Can its wild time be tamed? Contemporary thinking about the work of art and about the study of its history challenges the discipline as it struggles to find ways to translate the significance of alternative temporalities that intersect with the universalizing aspirations of its narratives, as well as to negotiate its awareness of the life of images beyond the moment of their creation.

PART I **TIME**

IS MODERNITY MULTIPLE?

At a given moment, then, we are confronted with numbers of events which, because of their location in different areas, are simultaneous only in a formal sense. Indeed, the nature of each of these events cannot properly be defined unless we take the position into account in its particular sequence. The shaped times of the diverse areas overshadow the uniform flow of time.

SIEGFRIED KRACAUER, *HISTORY: THE LAST THINGS BEFORE THE LAST*

Modernity and its artistic partner, modernism, have always been tied to the star of temporal progress. The time of modernity is teleological, and its home lies in the West. In this sense, *multiple modernities* is an oxymoron, a logical contradiction.[1] Consider, for example, the exhibition entitled *The Short Century*, curated by Okwui Enwezor, that took place in New York, among other venues, in 2001–2.[2] The show presented a survey of a number of African movements during the second half of the twentieth century not previously included in standard histories of modernism: spin-offs of European and American art forms, as well as survivals of indigenous traditions dating from precolonial times. Fascinating as these artistic initiatives and works may be, the claim that they deserve scholarly attention and aesthetic appreciation constitutes a challenge to the history of modernism. The triumphal progression from one avant-garde movement to

another, leading ever-more reductively toward greater and greater abstraction, traced by its dominant narrative, simply does not translate into these circumstances. African art typically functions as one of the global shadows that sets off the brilliance attributed to the Euro-American trajectory as it moves from cubism to abstract expressionism and beyond—a necessary backdrop for the performance of those appearing on the world's stage. Only now, after the modernist story has petered out and its internal contradictions have been exposed, has a space for the artistic traditions of other cultures become visible.

The work of the South African Gerard Sekoto offers a compelling example of the art that it is now possible to "see."[3] *Two Friends* (fig. 1.1), painted in Johannesburg in 1941 before Sekoto's departure for Paris in 1948, represents two women seen from the rear, chatting, as they walk along arm-in-arm. Once upon a time our appreciation of the image might have been determined by where and when it was created. The fact that it was made in Johannesburg rather than Paris would have determined our response. The recognition of its style as Post-Impressionist, inspired perhaps by the work of Vincent van Gogh or Paul Gauguin rather than by French Surrealist artists or American Abstract Expressionists, who were the African artist's contemporaries, made it less worthy of attention. The painting's failure to participate in modernism's temporal progression, its irrelevance to the work of the avant-gardes, assigned it to the margins, if not the dustbin of history. So the question is: *What is the time of this work?* If the work resists incorporation into the dominant story of midcentury Euro-American modernism, then where does it belong? Olu Oguibe argues that Sekoto's painting, and the work of other African artists who attempted to incorporate aspects of European art rather than the traditional native art forms deemed more authentic, constitutes its own form of nationalism.[4] Sekoto and others like him, Oguibe claims, saw in the apartheid's desire to deny African artists access to a modernist pictorial rhetoric by refusing them entry to art school a means of essentializing the differences between colonizers and colonized. Their refusal to participate in this system of exclusion is demonstrated in their art.

The role of Sekoto's painting in my story, however, is not to argue the aesthetic value of his work so much as to illustrate the limitations of an ideology: modernism's narrative can operate only by excluding him. This observation will, needless to say, neither change the way we view Sekoto nor

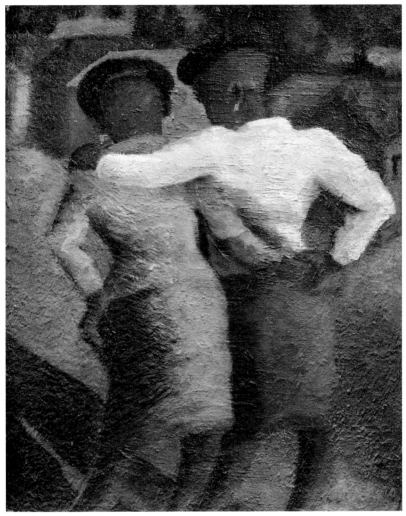

FIGURE 1.1 GERARD SEKOTO, *TWO FRIENDS*, 1941. Oil on canvas on board. © Johannesburg Art Gallery / The Gerard Sekoto Foundation

affect the continuing dominance of that story. Sekoto's absence from art's "history" depends on the economic, political, and ideological powers that determine the relations between cultures. If art history's narrative of choice is still the modernist one, it is because of forces that have little to do with the work itself or even our response to it. My point is that Sekoto belongs to another temporality. His time is not synchronous with that of metropolitan modernism and never will be. If modernism's time is multiple—if its

time flows at different speeds in different situations, if art history has one paradigm by which to understand developments in one context and another to cope with those taking place in others and such paradigms are not hierarchically organized—only then can his story be told. What then might be the relation between Sekoto's absence from the dominant history of art of the twentieth century and his presence in the history of South African art? Are these narratives forever distinct and incommensurable, or can one be translated into the other? Sekoto was a contemporary of Jackson Pollock, yet these artists' circumstances could not have been more different. If Sekoto worked in the period known as modernity but did not belong to it because he was prevented from participating in one of its characteristic features, artistic modernism, how do we negotiate the time that separates Sekoto and Pollock?

The example offered by the *Short Century* exhibition, and others like it, allows us to think anew about issues of time and their relation to art. Art history has long restricted the study of so-called modern and contemporary art to the nations of Western Europe and the United States, rather than to those parts of the globe "discovered" during the age of colonialism. Applied to the artifacts of non-European civilizations as a means of accounting for their extraordinary appeal and presence by those who first encountered them, the concept of art afforded a means by which the incommensurate character of subaltern cultures might be related to the epistemological assumptions of those that were dominant—even if the lack of congruence was often striking. Regardless of the inadequacy of the process of translation, the protean nature of art renders intelligible, and thus accessible, artifacts that are radically alien to the European worldview. A visit to the Louvre, or the Metropolitan Museum of Art for that matter, may begin with the sculptures of Greece and Rome, or European Renaissance and Baroque paintings in which the eighteenth-century notion of aesthetics finds its roots, but sooner or later (usually later), the visitor wanders into areas that display Oceanic door lintels and canoe paddles. Such objects, never originally conceived of as "art," both legitimate and find legitimation in their new surroundings.

Despite the malleability of the concept of art, the study of objects produced in geographical locations beyond the European pale has usually been confined to those created before the moment of contact. Romantic fascination with the "other" tended to freeze European interest in the nineteenth and early twentieth centuries.[5] Cultural artifacts can be ascribed the

status of art only so long as they remain traditional, that is, distinctly non-European. Ironically enough, an invisible apartheid dictates that anything manifesting the cultural exchange resulting from the colonial enterprise — anything that betrays an awareness of the intervention of the colonizers in the lives of the colonized — is to be avoided as derivative and second-rate. The distinction between the colonizers and the colonized, usually marked by race, serves to reinforce the sense of superiority of the white adventurers, whose economic and military might ruled the world. Such attitudes were further confirmed by the philosophical ideas of the late eighteenth century, the age of the so-called Enlightenment, when an epistemological system based on ideas of rigorous objectivity guaranteed an insatiable desire to know (and thus control) the world and everything in it. Political and economic transformations such as the French and Industrial Revolutions enhanced the notion that Europeans had arrived at the end of time — that they looked back on the history of the world as a prelude to their own supremacy.

The gradual process of decolonization that accelerated after the Second World War has not disabused the former colonial cultures of their sense of superiority. Histories of modern and contemporary art sometimes continue to be told as if the only cultural artifacts of the twentieth century that matter are those produced in Europe and the United States. Artistic modernism and Euro-American art of the twentieth century have been indelibly marked by such a teleological thrust. Each aesthetic movement, heralded by a group identified by the military metaphor of the avant-garde, sought to supersede its predecessor in the name of intellectual or spiritual progress.

Modernity, along with artistic modernism, is a distinctly Western affair. Even if the colonized globe took on many of the economic and industrial, not to mention the political and cultural, trappings of the colonizers, there remains little doubt as to where the center of artistic life shines brightest. There may indeed have been movements such as Latin American conceptualism that coincided with similar ones that took place in Europe and the United States, for example, but they are often characterized as provincial echoes, pale shadows of their counterparts at the center of temporal power. Despite the fact that some are distinct, even entirely different from their European equivalents, they are not considered as important as those that transpired in the centers of economic and political power.

This background is, of course, well known. I rehearse it here only as an introduction to a particular argument about the nature of time. If moder-

nity, defined as a set of institutions and technological processes that shape the economic and political life of many of the world's peoples, has become a global aspect of every human experience, does that mean that it has the same significance everywhere? Is the time of modernity the same in London and Johannesburg? Both the United Kingdom and South Africa are nation-states with democratic forms of political organization, and to greater or lesser extent both are industrialized nations, but does modernity's clock run at the same speed and have the same density in the two places? *Is modernity multiple?*

The modernist movement in the arts has been decisively challenged and no longer serves as the motivation for most contemporary art. Beginning in the last quarter of the twentieth century, the narrative of progress ascribed to artistic production by influential critics such as Clement Greenberg has been called into question.[6] No longer is it possible to distinguish art from nonart on the basis of whether a work seems to encourage the movement of the spirit in history, or in Greenberg's case, whether the medium in which it materialized is more or less aware of its essential nature. Artists and critics have tired of the idea that an avant-garde can define art's future. Arthur Danto, following Hegel, argues, for example, that art has come to an end only in order to become philosophy. The impossibility of distinguishing Andy Warhol's *Brillo Boxes* from the commercial product they replicate means that works of art can no longer be distinguished from other objects. When modernism draws its last breath, it is not succeeded by another period, but all time becomes "post-historical."[7]

Is this then contemporaneity? Does the end of modernism coincide with the end of time? Whether or not we agree with Danto that artistic modernism has ended for the reasons he cites, there is general critical consensus that artistic production is no longer motivated by its relation to time. Does this unanimity then mean that history is over, or, rather, that we need histories that acknowledge that time moves at multiple speeds in different locations? Absurd though it seems at first blush, the idea that history might be finished has certain compelling attractions. Decoupling art from time, the aesthetic from the temporal, is often cited as one of the factors that has allowed non-Euro-American art to conquer the contemporary international art scene. If artistic movements cannot be guaranteed by a privileged relation to time, then how can their works be accepted as art rather than as mere objects? The context offered by this confusion, one in which aes-

thetic theories struggle with one another and none is acknowledged as all-encompassing, has favored experimentation of the most varied kind. In the urge, however, to celebrate the arrival of non-Euro-American art forms in the world's art markets, biennials, art fairs, and exhibitions centers (*Kunsthalle*), have time differentials disappeared? In welcoming the inspiration provided by the imaginations of so many new contemporary artists, must we believe that they all operate on the same temporal footing? Has the idea of time, so inextricably identified with progress, and therefore the property of the world powers responsible for industrialization and colonialization, been genuinely democratized? Can works of art appearing in places not previously identified with the privileged home of time now be treated more seriously? If time has no privileged location, do all its forms contend for equal attention?[8]

If time no longer bears a necessary relation to art, is art consequently unmarked by its passage through it? Is it impossible to determine the age of art, to identify the subjects and styles that dominate particular periods? Is the time of the metropolitan centers of political and economic power really no different from those on the periphery? The fate of art in a "post-historical" moment, of course, is part of a much larger debate about the nature of history itself. The discussion as to what, if anything, comes after modernism continues unabated. Is its demise to be identified with the dawn of postmodernism, or does time stretch on without identity?

In the present context, it would be disingenuous not to recognize the existence of a dominant time historically related to that imposed under colonialism—a system whose homogenizing ambitions are still implicit in the designation Greenwich Mean Time as the longitude from which the world's time zones are established.[9] If the times that were once suppressed in the interest of modernism's evolutionary narrative can now enter the spotlight, it cannot be on the basis of history's abolition but rather on an understanding that history and power are inextricably entwined. The term *multiple contemporaneities* draws attention to the unequal speeds at which time unfolds in different locations. Their speed, however, is assessed by the dominant cultures of the day. The cessation of modernism's linear time provides us with an opportunity to look around the edges of the canonical accounts of the recent past, as well as of the present. The challenge is not to dissolve historical periods so much as to create new ones that reflect the ever-changing nature of geographical (very often national) power relations.

The effort to distinguish among moments in time, as well as the desire to conflate them, still dramatizes the necessity to make meaning of their relation to one another.

Sekoto's fate in falling out of the canon of modernist artists of the twentieth century has resonance for the fate of artists currently working in cultures other than those of Europe and the United States. His painting operates in two different conceptual worlds. In one, Sekoto is a cipher, a latecomer, someone who worked in antiquated artistic styles long after the so-called progressive artists of the day had gone on to other things. In the other, he daringly sought to appropriate the art of the colonial culture (itself provincial) of which he was a part in order to participate in a system that denied him admittance on the basis of his color. Whether or not contemporaneity is understood as a form of time or its absence, whether contemporaneity follows modernism as a period, or whether it is the end of time, the work of non-Euro-American artists will forever register on different levels. It is only when the kaleidoscope of values that informs the powerful markets of the artistic capitals of Western culture can accommodate those working on the periphery that it is possible for their work to move from one context to another. Only when non-Euro-American works manifest interests that parallel those working at the center, or more interestingly, when the periphery is a source of inspiration, that "crossovers" are possible.

If contemporaneity is conceived as a temporal framework in which many nonsynchronous forms of time jostle against one another, only the art of those times and places that corresponds with dominant ideological paradigms will be privileged. Such are the mechanisms that ensure the hierarchization of the events (histories) of certain locations above others. Unlike modernity, contemporaneity is both multiple and not multiple at the same time. Dominant cultures export and disseminate hierarchized temporal structures by means of the media of mass persuasion that run the gamut of newspapers, movies, television, and the Internet. The time that matters, that on which the artistic canon depends, has always favored the cultures of the powerful.

It may appear a contradiction to argue both that the decoupling of time from the idea of art in the context of the death of modernism has resulted in aesthetic confusion *and* that the dominant centers of artistic production still dictate what counts as contemporary in contemporary art. Even

if debate and disagreement currently characterize aesthetic thinking in the Euro-American context, this predicament by no means affects the decisive role of such cultures in the art market. If, within the context of increasing homogenization, market forces also serve to ensure a degree of variety in the artistic production of different cultures, does this mean that economic and cultural globalization work together in the promotion of original forms of aesthetic experience? The answer must be a resounding "no!" The imbalance of power that informs the relations between the industrial and post-industrial powers of the West and those of the rest of the world ensures that, even if creativity and imagination are the byproducts of cultural interaction, non-Western artistic production is rarely considered equal to that produced in Europe and the United States. In an incisive analysis of the encounter between the dominant art world of the West and contemporary artistic production in Africa, Salah Hassan writes:

> It must, however, be noted that the recent attentiveness by Western institutions to modern African art, and non-Western representation in general, has not, in any profound manner, altered the sense of inferiority with which those institutions have viewed the cultural production of those conveniently labelled "other." Nor does such attention represent a drastic change in Western institutional hegemonic strategies which continue to view, with deep distrust, cultural practices generated outside its immediate spheres of influence.[10]

According to Alain Quemin, who has undertaken a statistical survey:

> Current globalization does not present any challenge whatsoever to the U.S.–European/U.S.–German duopoly, or even the U.S. hegemony in the international contemporary art world. All the theories being developed in this regard, in particular by art critics, cannot hide the following reality: both the market and the recognition accorded by art institutions remain the preserve of Western countries, and especially the richest few, i.e., the United States and Germany, as well as Switzerland and Great Britain to a lesser extent. Moreover the market — consisting of influential auction houses, fairs, and galleries — has in no way been allowed to get into the hands of any potential rivals and it remains concentrated mainly in Great Britain, Switzerland, and Germany, and particularly in the United States.[11]

What are the implications of such unequal power relations for historical narratives? Even if the historical record attempts to interlace the various narratives of global art in an effort to produce a richer tapestry of the past and the present, these threads will inevitably be woven together according to the idiosyncrasies of a particular loom. The strands insisting on the universal, standing out in silver and gold, will always draw attention away from the more quotidian colors of the particular.[12] If the story of Sekoto's significance within South African art history is incommensurate with stories told about art at the centers of power, if the story of his "belatedness" is preferred to that of his challenge to the ideology of apartheid, then it is all too readily dismissed. If, however, that history can be related to the dominant one in such a way as to suggest the relativity of the latter, then the particular nature of both stories becomes evident. Has *The Short Century* forever changed the ways in which it is possible to tell the history of art in the twentieth century? I doubt it. Have the universalizing ambitions of art history, its status as a "grand narrative," been compromised in favor of a greater acceptance of the particular? Probably not. If temporal stories (histories), discrete, distinct, and possibly incommensurate accounts of the past, can be told in ways that deny time a sense of necessity, then—and only then—will heterochronicity have a chance.

NOTES

1. Discussions of the asymmetrical power relations that have marked modern non-Western artistic production pervade the scholarly literature; see, for example, Partha Mitter, *Much Maligned Monsters: A History of European Reactions to Indian Art* (Oxford: Clarendon, 1977); Partha Mitter, *The Triumph of Modernism: India's Artists and the Avant-Garde 1922–1947* (London: Reaktion, 2007); Partha Mitter, "Decentering Modernism: Art History and Avant-Garde Art from the Periphery," *Art Bulletin* 90 (2008): 531–48; Gerardo Mosquera, "Some Problems in Transcultural Curating," in *Global Visions: Towards a New Internationalism in the Visual Arts*, edited by Jean Fisher, 133–39 (London: Kala Press and The Institute of International Visual Arts, 1994); Everlyn Nicodemus, "Inside. Outside," in *Seven Stories about Modern Art in Africa*, 29–36 (London: Whitechapel Art Gallery, 1995); John Clark, *Modern Asian Art* (Sydney: Craftsman House; Honolulu: University of Hawai'i Press, 1998); John Clark, "Modernities in Art: How Are They Other?," in *World Art Studies: Exploring Concepts and Approaches*, edited by Kitty Zijlmans and Wilfried van Damme, 401–18 (Amsterdam: Valiz, 2008); Tim Barringer and Tom Flynn, eds., *Colonialism and the Object: Empire, Material Culture and the Museum* (London: Routledge, 1998); Geeta Kapur, "When Was Modernism in Indian Art?," in *When Was Modernism: Essays on*

Contemporary Cultural Practice in India, 297–324 (New Delhi: Tulika Books, 2000); Rasheed Araeen, Sean Cubitt, and Ziauddin Sardar, eds., *The Third Text Reader on Art, Culture and Theory* (London: Continuum, 2002); Kobena Mercer, ed., *Cosmopolitan Modernisms* (Cambridge: MIT Press; London: Institute of International Visual Arts, 2005); Kobena Mercer, ed., *Exiles, Diasporas and Strangers* (Cambridge: MIT Press, 2008).

2. Okwui Enwezor, ed., *The Short Century: Independence and Liberation Movements in Africa, 1945–1994* (Munich: Prestel, 2001).

3. For Sekoto, see Lesley Spiro, ed., *Gerard Sekoto: Unsevered Ties*, exhibition catalogue (Johannesburg: Johannesburg Art Gallery, 1989); Barbara Lindop, *Sekoto* (London: Pavilion, 1995); N. Chabani Mangani, *A Black Man Called Sekoto* (Johannesburg: Witwatersrand University Press, 1996); Christine Eyene, "Sekoto and Negritude: The Ante-room of French Culture," *Third Text* 24 (2010): 423–35.

4. Olu Oguibe, "Reverse Appropriation as Nationalism in Modern African Art," in *The Third Text Reader on Art, Culture and Theory,* edited by Rasheed Araeen, Sean Cubitt, and Ziauddin Sardar, 35–47, 351–53 (London: Continuum, 2002).

5. Johannes Fabian, *Time and the Other: How Anthropology Makes Its Object* (New York: Columbia University Press, 1983), 1–35. For a more recent discussion, see Shelly Errington, *The Death of Authentic Primitive Art and Other Tales of Progress* (Berkeley: University of California Press, 1998).

6. For Clement Greenberg, see his *Art and Culture: Critical Essays* (Boston: Beacon Press, 1989). For reflections on art history's modernist moment, see Thomas McEvilley, "Art History or Sacred History?," in *Art and Discontent: Theory at the Millennium,* 133–67 (New York: McPherson, 1991). Art history's linear trajectory has been most forcefully challenged by Hans Belting. See his *The End of the History of Art,* translated by Christopher Wood (Chicago: University of Chicago Press, 1987); and *Das Ende der Kunstgeschichte: Eine Revision nach zehn Jahren* (Munich: Beck, 1995).

7. Arthur Danto, "Introduction: Modern, Postmodern, and Contemporary," in *After the End of Art: Contemporary Art and the Pale of History,* 3–19 (Princeton: Princeton University Press, 1997).

8. For a fascinating discussion of such issues, see Harry Harootunian, "Remembering the Historical Present," *Critical Inquiry* 33, no. 3 (2007): 471–94.

9. Peter Galison, *Einstein's Clocks, Poincaré's Maps: Empires of Time* (New York: Norton, 2003), 144–55.

10. Salah Hassan, "The Modernist Experience in African Art: Visual Expressions of the Self and Cross-Cultural Aesthetics," in *Reading the Contemporary: African Art from Theory to the Marketplace,* edited by Olu Oguibe and Okwui Enwezor, 215–35 (Cambridge: MIT Press, 1999), 217.

11. Alain Quemin, "The Illusion of the Elimination of Borders in the Contemporary Art World: The Role of the Different Countries in the 'Era of Globalization and Metissage,'" in *Artwork through the Market: The Past and the Present,* edited by Jan Bakos, 297–98 (Bratislava: Center for Contemporary Art, 2004).

12. For recent considerations of the possibility of a universal or global history of art, see David Summers, *Real Spaces: World Art History and the Rise of Western Modernism* (London: Phaidon, 2003); John Onians, *Art, Culture and Nature: From Art History to World Art Studies* (London: Pindar Press, 2006); James Elkins, "Art History as a Global Discipline" and "On David Summers's *Real Spaces*," in *Is Art History Global?*, edited by James Elkins, 3–23, 41–71 (New York: Routledge, 2007); Kitty Zijlmans and Wilfried van Damme, eds., *World Art Studies: Exploring Concepts and Approaches* (Amsterdam: Valiz, 2008); David Carrier, *A World Art History and Its Objects* (University Park: Pennsylvania State University Press, 2008); Hans Belting, "Contemporary Art as Global Art: A Critical Estimate," in *The Global Art World: Audiences, Markets, Museums*, edited by Hans Belting and Andrea Buddensieg, 38–73 (Ostfildern, Germany: Hatje Cantz, 2009); Jonathan Harris, ed., *Globalization and Contemporary Art* (Oxford: Wiley-Blackwell, 2011).

CHAPTER 2

DO WE STILL NEED A RENAISSANCE?

Neither can the timeless be stripped of the vestiges of temporality, nor does the temporal wholly engulf the timeless. Rather we are forced to assume that the two aspects of truth exist side by side, relating to each other in ways which I believe to be theoretically undefinable.

SIEGFRIED KRACAUER, *HISTORY: THE LAST THINGS BEFORE THE LAST*

If we can no longer subscribe to historicism's Eurocentric version of the past, if historical time is heterochronous rather than monochronous, how does this affect the apparently indispensable idea of periodization? Do we still need a Renaissance? When first asked, such a question seems nonsensical, even absurd. The idea of the Renaissance is the lodestar, the shining light around which the history of Western art until recently revolved. The concept is so deeply naturalized that it is impossible to conceive of the discipline of art history without it. But let us imagine, for a moment, that it is possible to see through the edges of the period idea to analyze critically the work performed by this seemingly indispensable notion.

As a historical field, the Renaissance has been the subject of debate for many decades. First of all, it is associated with a philosophy of history that has been extensively challenged, even though it continues to maintain an active life in our disciplinary unconscious. Incongruent as the project of telling tales and

speculating about their purposes may be, the historical project is ineluctably a philosophical one. As many historiographers have pointed out, the Renaissance, as an identifiable moment in history, arose in the wake of Hegel's philosophy, according to which the movement of the "Spirit" through time reached a crucial stage when it shed the superstitious beliefs of the Middle Ages and looked at man and nature with secular eyes.

The creation of the Renaissance, in the work of a compelling historian such as Jacob Burckhardt, was instrumental to the project of carving up time into distinct but sequentially related units.[1] It was a grand scheme that attributed meaning to the past by suggesting that it had a teleological movement—that it was going somewhere. In doing so, it satisfied the widespread urge to narrativize the past.[2] In the history of art, the apotheosis of the period of the Renaissance at the hands of perhaps the most distinguished art historian of the postwar period, Erwin Panofsky, ensured it a privileged status in the discipline until relatively recently. If the nineteenth century saw the Renaissance as a glorious moment in which "man" turned away from the darkness of religion—the blindness of faith—toward the rational enlightenment afforded by the empirical study of nature, the twentieth ennobled it as the triumph of humanism in Western civilization. This accomplishment was to be defended against the forces of fascism that threatened to consign humanity once again to the darkness of ideological belief.[3]

Perhaps I need not rehearse the criticisms that have shaken this philosophy of history. Michel Foucault, for example, argues for a vision of the past marked by rupture and discontinuity, rather than continuity and progress, insisting that the epistemological basis for understanding the world is as uncertain as the chaos of events it seeks to order.[4] Historiographers, such as Michel de Certeau and Hayden White, emphasize the role of language in historical writing, arguing that the events of the past should not be confused with their interpretation in the present.[5] Burckhardt's works reveal his conviction that the Renaissance anticipated his own time. His exaltation and vilification of Renaissance figures depends on the belief that the period inaugurated both the glories and the miseries of the modern age. Students of the "founding fathers" of the Renaissance, such as Felix Gilbert and Lionel Gossman, continue to reveal the extent to which Burckhardt's writings manifest the concerns of the nineteenth century in the course of their analyses of sixteenth-century affairs.[6] And, most recently, the idea of the Renaissance has been criticized from a variety of postcolonial perspec-

tives on the grounds of its Eurocentrism. Indian historians, such as Dipesh Chakrabarty and Ranajit Guha, have pointed out that many of the world's cultures have managed to do very well and exist for thousands of years without a teleological concept of history.[7] Others have articulated how Western historical narratives fail to capture the nature of the past in different parts of the globe. Writing about the Americas, Anthony Pagden and Walter Mignolo stress the incommensurability of different cultures and the impossibility of finding grounds for translating the experiences of one into another.[8] Claire Farago suggests the relevance of many of these ideas for the discipline of art history in her book *Reframing the Renaissance*.[9] However, no one has been more vocal in challenging historicist ideas of periodicity than Georges Didi-Huberman, who argues for the "anachronism" of images, insisting that their phenomenological presence makes them capable of defying time. Their capacity to elude a historical framework makes it necessary to reevaluate and reinterpret them throughout the course of their existence.[10] One conclusion to be drawn from this panoply of criticism is that place matters as much as time, that the story of the Renaissance is deeply implicated in a historical narrative that has privileged the importance of events in Western Europe and the United States over those taking place in other parts of the globe.[11]

As a way into our topic, let us think how the ordering of time serves to hierarchize space. Can an idea first used to guarantee the transhistorical importance of Italian culture, for example, be applied to the understanding of different historical and geographical circumstances in the same period?[12] In the hands of Heinrich Wölfflin and Alois Riegl, the movement of the Hegelian "spirit" was identified with the concept of style so as to track its teleological drive through time.[13] Style, however, contains not one but two axes of meaning: it refers both to a time and to a place.[14] When we refer to a Renaissance style, what comes to mind is not only a period in history but also a moment now identified with the European nation of Italy. A good example of the consequences of the enduring prestige accorded to Italian art by the idea of the Renaissance is found in the introductory text to the exhibition *The World of Tycho Brahe* that was on view in Copenhagen's National Museum in the fall of 2006. A large wall hanging informed the visitor:

> The word Renaissance means rebirth—that is, of the Roman and Greek culture of Antiquity. True, the culture of Antiquity had by no means been

forgotten in the Middle Ages. But it was only during the Renaissance that ancient form and ancient content were reunited. Art tried to achieve a harmony that corresponded to an ideal image of ancient society. The development of the sciences formed the basis of many new facets. This also applied to the mathematically correct and logical structure of the human body, of the appearance of the world, and the geometry of perspective. In Italy the Renaissance flourished in the fifteenth century, while Denmark's Renaissance only began in the sixteenth century.

Apart from the lateness attributed to the "Renaissance" in Denmark (one that reduces all its artists to the status of epigones to their Italian forerunners), anyone familiar with Panofsky's brilliant texts *Renaissance and Renascences* and *Perspective as Symbolic Form* will recognize that the historical developments that are said to mark the period all took place in Florence.[15]

What happens when we try to talk about the Renaissance in Europe outside of Italy? One of the most influential treatises on the "Northern Renaissance"—Erwin Panofsky's *Early Netherlandish Painting*—recounts the rise of pictorial verisimilitude in fifteenth-century Flemish painting as an offshoot of Italian tendencies of the fourteenth century.[16] "Naturalism," in other words, is an Italian invention that gradually wended its way to other European outposts. On this view, there is one origin for this style, and Italy is its privileged source. According to Panofsky, the papal schism that took Sienese masters to Avignon introduced "naturalistic" motifs that were then spread throughout France and the Lowlands. These motifs were "pathos formulae," devices by which the emotional content of religious images might be made accessible to the faithful, as well as representations of a greater range of figure and physiognomic types, an interest in the play of light and shade, and a concern with the representation of illusionistic space. This account fails to address the circumstances in which Flemish illusionism was born—that is, the specific nature and function of images within the context of local cultural practice—and, more important, it fails to come to terms with the distinctive qualities of Flemish naturalism as opposed to its Italian counterpart.[17] Why is it, for example, that Flemish artists are so much more concerned with the depiction of the "skin" of objects than are the Italian? Rather than extolling surface textures, linear perspective is the yardstick used to evaluate Flemish painting. The requirement to relate historical developments to one another and to attribute them a common source ob-

FIGURE 2.1 ROBERT CAMPIN, *MERODE ALTARPIECE*, CA. 1425. Oil on wood; overall (open): 25⅜ × 46⅜ in. (64.5 × 117.8 cm). The Cloisters Collection, 1956. © The Metropolitan Museum of Art / Art Resource, NY

scures the particularity of the local for the sake of the universal. Despite the brilliance of its surfaces and textures, a painting such as Robert Campin's *Merode Altarpiece* (fig. 2.1) is implied to be somehow wanting because it flouts the principles of geometric perspective.

Panofsky's approach to Albrecht Dürer similarly privileges Italian achievements over those taking place north of the Alps.[18] Dürer's artistic career is measured by reference to his Italian contemporaries. The highpoints of his oeuvre coincide with those instants in which he engages most seriously with Italian theory and practice. His knowledge of human proportions and perspective and his humanist familiarity with ancient mythology and history are the qualities that rank him the equal of the likes of Leonardo. The work on which Panofsky concentrates most attention, however—the engraving *Melencolia I*—becomes an allegory of the struggle between intellectual principles and artisanal know-how that, he says, characterizes the artist's work as a whole. Concluding that the print represents the defeat of reason by unreason serves to identify Dürer as essentially German and as a star-crossed genius whose melancholy led to an artistic impasse.

How have more-recent scholars of northern European art dealt with the problem posed by the exalted status ascribed to the art of the Italian Renaissance? If we compare Panofsky's account of Dürer with that of a more recent author, Joseph Koerner, we discover less interest in fitting the artist into a

pre-established historical and geographical plot.[19] Koerner suggests that the aesthetic power of the work of art transcends its location within any particular historical structure or sequence. Instead of measuring Dürer against his Italian counterparts in order to show how his northern experience made him different, if not inferior, Koerner focuses on the artist's own achievements. The key to his thesis is Dürer's *Self-Portrait* of 1500 (fig. 2.2), a painting whose artistic self-consciousness is said to provoke a profound transformation of the status and function of the pictorial image. The *Vera Icon* (or "True Likeness") panels that inspired Dürer's portrait were regarded as documents of the miraculous transfer of Christ's features to the veil of St. Veronica on the way to Calvary. By equating his own portrait with these records of the face of the divinity allegedly "made without hands," Dürer, Koerner argues, deliberately calls attention to his own prodigious powers of creation. Whereas the images of Christ's face depend on the deity whose features they transcribe, the power of Dürer's self-portrait depends on the artist's genius. Koerner thus deftly melds his personal response to Dürer's image with his knowledge of the period to produce an original and aesthetically convincing account of the artist's work as well as its importance within the historical horizon in which it was executed. The aesthetic power of the work is primary and proves to be the means by which the author affords us access to its historical significance. A comparison with Panofsky's approach enables us to grasp the difference: whereas for Panofsky, history comes first, for Koerner, it is the work of art.

How does an approach to artistic production as something that has the capacity to break the boundaries of the historical context in which it was produced play out with regard to the Italian Renaissance itself? How does an alternative to a developmental history work here? Like Koerner, Didi-Huberman argues that the dialectical relationship between a painting and its beholder is as important as the necessity to relate the artist to a larger historical framework. The physical execution and material substance of Fra Angelico's frescoes in San Marco, Didi-Huberman claims, are a metaphor of the Christian doctrine of the Incarnation (fig. 2.3). The paintings themselves become meditations on the way in which Christ's divine being becomes material, the means by which a transcendent narrative assumes temporal dimensions.[20] Synchrony, the contemporaneity of aesthetic experience, outweighs diachrony, the location of that experience in a histori-

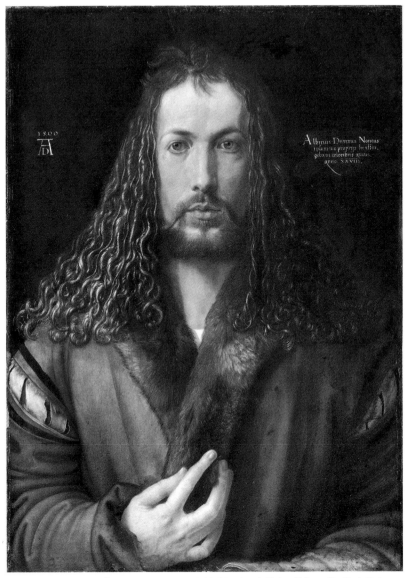

FIGURE 2.2 ALBRECHT DÜRER, *SELF-PORTRAIT*, 1500. Oil on board, 48.9 × 67.1 cm. Alte Pinakothek, Bayerische Staatsgemäldesammlungen, Munich, Germany, Inv. No. 537. © bpk, Berlin / Art Resource, NY

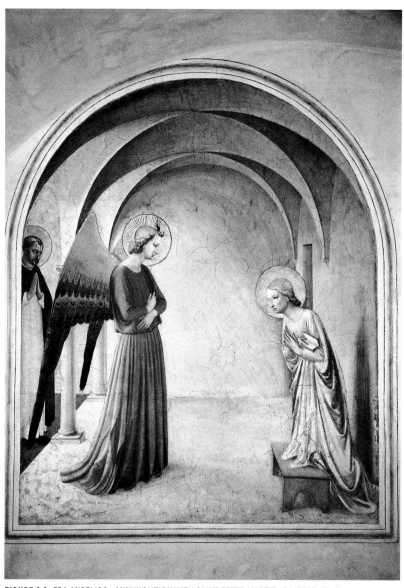

FIGURE 2.3 FRA ANGELICO, *ANNUNCIATION WITH SAINT PETER MARTYR*, CA. 1440–45. Fresco. Museo di San Marco, Florence, Italy. © Nimatallah / Art Resource, NY

cal continuum. Anachronism, once the historian's greatest sin, becomes the means by which to allow the past to speak.[21] Writing of the historian's desire for the past, Didi-Huberman intimates the complexity of the bond:

> Such a desire names simultaneously the indispensable and the unthinkable of history. Indispensable, because we can comprehend the past . . . only by surrendering to a kind of hymenal bond: by penetrating the past as well as ourselves, in other words by feeling that we have married it in order to grasp it completely, while in return we are, by this act, gripped by it ourselves; grabbed, clasped, even stupefied. It is difficult to misconstrue, in this empathetic movement, the deeply mimetic character of the historical operation itself.[22]

Didi-Huberman's words capture both the intricate as well as the intimate nature of the art historian's encounter with the past. Our continuing fascination with what has happened in other ages depends on a process of identification analogous to psychoanalytic processes of transference and countertransference.[23] Personal assumptions and beliefs are the basis by which we evaluate those that came before, but we also allow ourselves to be molded by those we encounter so as to relativize and even alter our own.

The importance ascribed to personal response to the work of art in the present by Koerner and Didi-Huberman might suggest that for the history of art the enterprise of historical periodization takes a unique form. Rather than define a historical horizon in terms of what might be called the general characteristics of the age, the work of art is regarded as something that has the power to break time by addressing us directly and by demanding an aesthetic response. Its capacity to do so, however, depends in part on our awareness of the temporal difference that separates us from it. It appears possible, therefore, to see the limitations of the grand Hegelian trajectory, which has for so long structured the activities of the discipline so as to reflect upon what is gained and what is lost by abandoning its principles.

George Kubler once perceptively wrote that "knowing the past is as astonishing as knowing the stars," thus equating astronomers and historians because they both base their studies on traces of events (the light of distant stars or historical documents) that reach them long after the events themselves have taken place.[24] In this astronomical analogy, the Renaissance, like Venus, is either the evening star that heralds the arrival of the rest of the firmament or it is the morning star, the last one to fade from the

sky at the approach of dawn. If the age of sequential periodization is bankrupt, the interpretation of the past can no longer be organized according to a predetermined temporal scheme. The gleam that reaches us from works of past art has no fixed pattern. Despite the efforts of many civilizations—from the Greeks to the Inca—to impose order on the turbulent appearance of the starry heavens, no one stellar body dictates the appearance of the rest. The extraordinary objects that constitute the history of art demand the imaginative intervention of the art historian. The challenge is not to array their light according to some constellation, but to allow their qualities to shine in all their unique brilliance. This chapter embodies the tension between two forms of historical time. If chronology records a dynamic internal to the passage of time, anachrony calls this rhythm into question. The power of the work of art to inaugurate a time of its own reveals the necessarily mythic nature of the temporal system that claims to contain it. I will address the paradox of the need to recognize time's disjunctions in the absence of an inherent logic to their sequence in the following chapter.

NOTES

1. For discussions of the issue of periodization in historical writing, see Michel de Certeau, *The Writing of History*, translated by Tom Conley (New York: Columbia University Press, 1988; 1st ed. 1975); Reinhart Koselleck, *On the Semantics of Historical Time* (Cambridge: MIT Press, 1985); Hans Ulrich Gumbrecht and Ursula Link-Heer, eds., *Epochenschwellen und Epochenstrukturen im Diskurs der Literatur- und Sprachhistorie* (Frankfurt: Suhrkamp, 1985); Olivier Dumoulin and Raphaël Valéry, eds., *Périodes: La construction du temps historique* (Paris: Histoire au Present, 1991); Francois Hartog, *Régimes d'historicité: Présentisme et expériences du temps* (Paris: Seuil, 2003). For periodization debates in literature, see Hans Robert Jauss, "Literary History as a Challenge to Literary Theory," in *Toward an Aesthetic of Reception*, translated by Timothy Bahti, 3–45 (Minneapolis: University of Minnesota Press, 1982); Marshall Brown, "Periods and Resistances," *Modern Language Quarterly* 62, no. 4 (2001): 309–16, and other essays included in this issue of that journal; the *Journal of Medieval and Early Modern Studies* 37, no. 3 (2007), edited by Jennifer Summit and David Wallace, is dedicated to periodization, as are many of the articles in *Publication of the Modern Language Association* 127, no. 2 (2012). See also Jane Newman, "Periodization, Modernity, Nation: Benjamin between Renaissance and Baroque," *Journal of the Northern Renaissance*, no. 1 (2009): 19–34. For periodization in art history, see Erwin Panofsky, *Perspective as Symbolic Form*, translated by Christopher Wood (New York: Zone Books, 1991); Erwin Panofsky, *Renaissance and Renascences in Western Art* (Stockholm: Almqvist and Wiksell, 1960); Erwin Panofsky, "The His-

tory of Art as a Humanistic Discipline," in *Meaning in the Visual Arts*, 1–25 (Garden City, N.J.: Doubleday, 1955); George Kubler, *The Shape of Time: Remarks on the History of Things* (New Haven: Yale University Press, 1963); Ernst Gombrich, "Norm and Form: The Stylistic Categories of Art History and Their Origins in Renaissance Ideals," in *Norm and Form: Studies in the Art of the Renaissance*, 81–98 (London: Phaidon, 1971); Meyer Schapiro, H. W. Janson, and Ernst Gombrich, "Criteria of Periodization in the History of European Art," *New Literary History* 1, no. 2 (1970): 113–25; Thomas DaCosta Kaufmann, "Periodization and Its Discontents," *Journal of Historiography*, no. 2 (2010): 1–6; Margaret Iversen and Stephen Melville, "Historical Distance (Bridging and Spanning)," in *Writing Art History: Disciplinary Departures*, 15–37 (Chicago: University of Chicago, 2010). For the creation of the Renaissance as a historical epoch, see Jacob Burckhardt, *The Civilization of the Renaissance in Italy: An Essay* (London: Phaidon, 1965); Wallace Ferguson, *The Renaissance in Historical Thought: Five Centuries of Interpretation* (Cambridge, Mass.: Riverside Press, 1948); Karlheinz Stierle, "Renaissance: Die Entstehung eines Epochenbegriffs aus dem Geist des 19. Jahrhunderts," *Poetik und Hermeneutik* 12 (1987): 453–92; William Kerrigan and Gordon Braden, *The Idea of the Renaissance* (Baltimore: Johns Hopkins University Press, 1989); Peter Burke, *The Renaissance* (Atlantic Highlands, N.J.: Humanities Press International, 1987); Stephen Bann, *Romanticism and the Rise of History* (New York: Twayne Publishers, 1995). For the role of Hegelian historicism in writing about the past, see Friedrich Meinecke, *Historicism: The Rise of a New Historical Outlook*, translated by J. Anderson (New York: Herder and Herder, 1972); George Iggers, *The German Conception of History: The National Tradition of Historical Thought from Herder to the Present* (Middletown, Conn.: Wesleyan University Press, 1968); Robert D'Amico, *Historicism and Knowledge* (London: Routledge, 1989); Paul Hamilton, *Historicism* (London: Routledge, 1996). For historicism in art history, see Ernst Gombrich, *In Search of Cultural History* (Oxford: Clarendon, 1969); Ernst Gombrich, "The Father of Art History: A Reading of the Lectures on Aesthetics of GWF Hegel (1770–1831)," in *Tributes: Interpreters of Our Cultural Tradition*, 51–69 (Ithaca: Cornell University Press, 1984); Hans Belting, *The End of the History of Art*, translated by Christopher Wood (Chicago: University of Chicago Press, 1987); Hans Belting, *Das Ende der Kunstgeschichte: Eine Revision nach zehn Jahren* (Munich: Beck, 1995); James Elkins, "Art History without Theory," *Critical Inquiry* 14, no. 2 (1988): 354–78; Stephen Melville, "The Temptation of New Perspectives," *October* 52 (1990): 3–15; Keith Moxey, "Art History's Hegelian Unconscious: Naturalism as Nationalism in the Study of Early Netherlandish Painting," in *The Practice of Persuasion: Paradox and Power in Art History*, 8–41 (Ithaca: Cornell University Press, 2001); Jason Geiger, "Hegel's Contested Legacy: Rethinking the Relation between Art History and Philosophy," *Art Bulletin* 93, no. 2 (2011): 178–94.

2. See Paul Ricoeur, *Time and Narrative*, translated by Kathleen Blamey and David Pellauer, 3 vols. (Chicago: University of Chicago Press, 1984–88); Hayden White, "The Value of Narrativity in the Representation of Reality," in *The Content of the Form:*

Narrative Discourse and Historical Representation, 1–25 (Baltimore: Johns Hopkins University Press, 1987).

3. The classic statement of the central importance of the Renaissance for the history of art is found in Panofsky's *Renaissance and Renascences in Western Art*. The ideological agenda that informed Panofsky's claim has been recognized and described, challenged and defended. See Willibald Sauerländer, "*Barbari ad portas*: Panofsky in den fünfziger Jahren," in *Erwin Panofsky: Beiträge des Symposions Hamburg 1992*, edited by Bruno Reudenbach, 123–37 (Berlin: Akademie Verlag, 1994); Konrad Hoffmann, "Panofskys 'Renaissance,'" in *Erwin Panofsky: Beiträge des Symposions Hamburg 1992*, edited by Bruno Reudenbach, 139–44 (Berlin: Akademie Verlag, 1994); Keith Moxey, "Panofsky's Melancolia," in *The Practice of Theory: Poststructuralism, Cultural Politics, and Art History*, 65–78 (Ithaca: Cornell University Press, 1994); Carl Landauer, "Erwin Panofsky and the Renascence of the Renaissance," *Renaissance Quarterly* 47, no. 2 (1994): 255–81; Georges Didi-Huberman, "The History of Art within the Limits of Its Simple Reason," in *Confronting Images: Questioning the Ends of a Certain History of Art*, translated by John Goodman, 115–17 (University Park: Pennsylvania State University Press, 2005); Christopher Wood, "Art History's Normative Renaissance," in *The Italian Renaissance in the Twentieth Century: Acts of an International Conference, Florence, Villa I Tatti, June 9–11, 1999*, edited by Allen Grieco et al., 65–92 (Florence: Olschki, 1999).

4. Michel Foucault, *The Order of Things: An Archaeology of the Human Sciences* (New York: Vintage Books, 1973).

5. Michel de Certeau, *The Writing of History*, translated by Tom Conley (New York: Columbia University Press, 1988); Hayden White, *Tropics of Discourse: Essays in Cultural Criticism* (Baltimore: Johns Hopkins University Press, 1978); White, *The Content of the Form*.

6. See Felix Gilbert, *History or Culture? Reflections on Ranke and Burckhardt* (Princeton: Princeton University Press, 1990); Lionel Gossman, *Basel in the Age of Burckhardt* (Chicago: University of Chicago Press, 2000); Francis Haskell, *History and Its Images* (New Haven: Yale University Press, 1993); J. B. Bullen, *The Myth of the Renaissance in Nineteenth-Century Writing* (Oxford: Oxford University Press, 1994); Bann, *Romanticism and the Rise of History*; Jo Tollebeek, "Renaissance and 'Fossilization': Michelet, Burckhardt, and Huizinga," *Renaissance Studies* 15, no. 3 (2001): 354–66.

7. Dipesh Chakrabarty, *Provincializing Europe: Postcolonial Thought and Historical Difference* (Princeton: Princeton University Press, 2000); Ranajit Guha, *History at the Limits of World History* (New York: Columbia University Press, 2002). For a debate on whether or not the idea of history is universal, see Jörn Rüsen, ed., *Western Historical Thinking: An Intercultural Debate* (New York: Berghahn Books, 2002), with contributions by Peter Burke, Hayden White, and others.

8. Anthony Pagden, *European Encounters with the New World: From the Renaissance to Romanticism* (New Haven: Yale University Press, 1993); Walter Mignolo, *The*

Darker Side of the Renaissance (Ann Arbor: University of Michigan Press, 1995). For attempts to relate European history of the Renaissance to that of other cultures on the basis of their alleged synchrony, see Lisa Jardine and Jerry Brotton, *Global Interests: Renaissance Art between East and West* (Ithaca: Cornell University Press, 2000); Jerry Brotton, *The Renaissance Bazaar: From the Silk Road to Michelangelo* (Oxford: Oxford University Press, 2002).

9. Claire Farago, ed., *Reframing the Renaissance: Visual Culture in Europe and Latin America, 1450–1650* (New Haven: Yale University Press, 1995).

10. Georges Didi-Huberman, "Obscures survivances, petits retours et grande Renaissance: Remarque sur les modèles de temps chez Warburg et Panofsky," in *The Italian Renaissance in the Twentieth Century*, 207–22; Didi-Huberman, *Confronting Images*; Georges Didi-Huberman, *L'image survivante: Histoire de l'art et temps des fantômes selon Aby Warburg* (Paris: Minuit, 2002).

11. Johannes Fabian, *Time and the Other: How Anthropology Makes Its Object* (New York: Columbia University Press, 1983).

12. For Burckhardt's view that the Renaissance was a specifically Italian phenomenon and that the spread of the Renaissance style across Europe entailed a loss of its original qualities, see Bruce Boucher, "Jacob Burckhardt and the 'Renaissance' North of the Alps," in *Time and Place: The Geohistory of Art*, edited by Thomas DaCosta Kaufmann and Elizabeth Pilliod, 21–35 (London: Ashgate, 2005).

13. Heinrich Wölfflin, *Principles of Art History: The Problem of the Development of Style in Later Art*, translated by M. D. Hottinger (London: Bell, 1932); Alois Riegl, *The Group Portraiture of Holland*, translated by Evelyn Kain and David Britt (Los Angeles: Getty Research Center, 1999).

14. For the indissolubility of the time-space nexus, see Doreen Massey, *For Space* (London: Sage, 2005). For its use as a literary trope, see Mikhail Bakhtin, "Forms of Time and the Chronotope in the Novel," in *The Dialogic Imagination*, translated by Caryl Emerson and Michael Holquist, 84–258 (Austin: University of Texas Press, 1981). See also Svetlana Boym, *The Future of Nostalgia* (New York: Basic Books, 2001).

15. Panofsky, *Renaissance and Renascences in Western Art* and *Perspective as Symbolic Form*.

16. Erwin Panofsky, *Early Netherlandish Painting*, vol. 1 (Cambridge: Harvard University Press, 1953), 1–74.

17. For a critique of Panofsky's Italocentric views, see Svetlana Alpers, *The Art of Describing: Dutch Art in the Seventeenth Century* (Chicago: University of Chicago Press, 1983), xvii–xxvii.

18. Erwin Panofsky, *The Life and Art of Albrecht Dürer*, vol. 1 (Princeton: Princeton University Press, 1955), 156–76.

19. Joseph Koerner, *The Moment of Self-Portraiture in German Renaissance Art* (Chicago: University of Chicago Press, 1993), 63–138.

20. Georges Didi-Huberman, *Fra Angelico: Dissemblance and Figuration*, translated by Jane Marie Todd (Chicago: University of Chicago Press, 1995), part I, 13–101.

21. Georges Didi-Huberman, "History and Image: Has the 'Epistemological Trans-formation' Taken Place?," in *The Art Historian: National Traditions and Institutional Practices*, edited by Michael Zimmermann, 128–43 (Williamstown, Mass.: Clark Art Institute, 2003). The philosophical implications of anachronism for historical writ-ing are explored by Jacques Rancière, "Le concept d'anachronisme et la vérité de l'historien," in *L'inactuel: Psychanalyse et culture*, 53–68 (Paris: Calmann-Levy, 1994). I thank Johanne Lamoureux for this reference.

22. Didi-Huberman, *Confronting Images*, 37.

23. Dominick LaCapra, "History and Psychoanalysis," in *Soundings in Critical Theory*, 30–66 (Ithaca: Cornell University Press, 1989).

24. Kubler, *The Shape of Time*, 19.

CONTEMPORANEITY'S HETEROCHRONICITY

[Periods]...are necessary fictions...because one cannot write history ...without periodizing. Moreover, we require the concept of a unified period in order to deny it, and thus make apparent the particularity, local difference, heterogeneity, fluctuation, discontinuity, and strife that are now our preferred categories for understanding any moment in the past.

DAVID PERKINS, *IS LITERARY HISTORY POSSIBLE?*

The inescapable relationship between an aesthetic response to the art of the past and a historical awareness, the recognition that the power of the work in the present is inextricably linked to its role in the period in which it was produced, can be usefully related to the debates that currently swirl around the status of contemporary art. If the long-lasting hold of the idea of the Italian Renaissance on the historical imagination has tended to distort our understanding of the past in different times and places, the dominant role of the Renaissance within the history of art has clearly been overtaken by the study of the contemporary. The number of doctoral dissertations being written on contemporary art in the United States currently exceeds the number of those being undertaken in all other fields combined.[1] A growing concern of art historians is the dramatic transformation of the

discipline occasioned by the increasing marginalization of the study of art before modernism.[2]

The looming presence that the Renaissance once enjoyed in the history of art has been replaced by a concern that this period no longer receives serious attention within the discipline. Once the center of its interests, the historical moment that attracted the greatest amount of scholarly excitement and intellectual curiosity, the Renaissance sometimes finds itself reduced to marginality.[3] Are we witnessing the "death" of the Renaissance in contemporary historical consciousness? Has a fascination with the contemporary taken its place? If the Hegelian progression once saw in the Renaissance the great forerunner of modernity's triumphs, the current era looks back at this moment with eyes blinded by its own self-importance — obsessed only with the exaltation of the new. If historicism's "grand narrative" has been discarded, so, it seems, has the incentive to understand anything but the recent past. Does our awareness of the presentism of historical writing undermine a commitment to understanding the deep past?

It was inevitable that the Renaissance should be the loser in the ideological battle that established artistic modernism as the legitimate visual culture of the nineteenth and twentieth centuries. Modern art was inherently revolutionary, and thus antitraditionalist, antimimetic, and antihumanist. It explicitly set itself against the established conventions inherited from earlier ages. Rather than see modern culture as the continuation of practices established in the Renaissance as the late nineteenth century had done, the artists of the early twentieth century aspired to a total break. If the Renaissance as a period was discovered as part of a historical progression inexorably leading to the naturalist and realist achievements of nineteenth-century art, it was now possible to see the modernist attack on the naturalism and realism of the previous period as part of a teleological movement toward greater and greater abstraction.[4] Within the history of art the antagonism of modernist ideology toward the culture of the past was sometimes exacerbated by the dismissive attitude adopted by some of the great twentieth-century art historians of the Renaissance who either neglected or disdained the art of their own time.[5]

The continual redefinition of the concept of art during the course of the twentieth century has tended to associate the art of the past with continuity and stasis. The world wars that traumatized the twentieth century permanently altered the fabric of economic, social, and cultural life on a global scale. An age made acutely conscious of the accelerated speed of political

transformation and cultural change, ongoing economic and technological innovation, and the integration of the world's economies defines its own historical moment by contrasting its protean dynamism with the seeming stability of earlier moments in time.

The swirl of synonyms used to refer to the current moment—*modernism, postmodernism, postcolonialism, contemporaneity,* and *the contemporary*—suggests, however, the confusion surrounding its idea of time. Have we run out of time, or has time come to an end? Is *contemporary* a period, or have periods ended? Have we exhausted our capacity to believe in time as a given, its apparent enduring natural existence? Has the meaning of time changed so radically that we no longer require its enveloping presence? Even if time is always a figment of our imaginations, do we not still need it? The philosophical and psychological consequences of the negation of the cultural narratives inherited from the nineteenth and twentieth centuries—founded on chronological and often teleological notions of historical development—are more acutely present than ever before. Time haunts contemporary cultural production in new and disturbing ways. Whether it be history or anthropology, art history or visual studies, the work of interpretation is confronted with the necessity to construe time anew. What sort of time do we inhabit now? Does acceptance of the constructed nature of our ideas of time indicate that we can live without them, or does it imply that they serve necessary cultural functions, and that they themselves have a shelf life?

First then, a few familiar historiographic reminders: In the maelstrom of political and cultural transformations that marked the 1960s, thinkers such as Michel Foucault, Jacques Derrida, Jacques Lacan, and others, revolutionized the terms in which we think about both the past and the present, as well as their relation to one another. Arguing that the philosophies that had animated cultural criticism during much of the twentieth century were either illegitimate or unfounded, Jean-Francois Lyotard suggested that modernism itself has come to an end, and that postmodernism was its successor.[6] This claim produced a furious response, and the value of the term *postmodern* is still debated today. The discussion proved so exhausting that it is difficult to use the term without a degree of irony. Among its most ardent opponents is Fredric Jameson, who argues that the philosophical claims of poststructuralism—dissolution of traditional narratives (Lyotard and Foucault), the banishment of the "real" (Derrida and Lacan), and the attack on the agency of the humanist subject (Foucault, Roland Barthes, Derrida,

and Lacan)—are all symptoms of a deeper underlying power, namely the operations of the capitalist economy.[7] On this model, postmodernism does not constitute a break with modernism, it simply reflects the continuing dominance of the capitalist economic system. Capitalism guarantees the triumph of modernism as the ultimate historical period. *Capitalism* and *modernism*, in other words, are synonymous. Since the cultural characteristics of our time are economically determined, we live in a kind of eternal present. Sophisticated critics may be able to discern fine adjustments in our culture that are the consequence of, say, new technologies or the invention of exotic financial instruments, but the most fundamental attributes of this period continue to be determined by so-called economic realities.

When it comes to images, Jameson's perspective on time as capitalism's fulfillment of a teleological trajectory is echoed by, among others, the art critic Arthur Danto, for whom time has also come to an end. In his case, it is not the inescapably capitalist structure of the circumstances in which art is produced that condemns it to a kind of timeless limbo, but rather its lack of identifying characteristics. Recognizing that the artistic movement known as modernism is over, he is nevertheless hesitant to name the art that follows as a period in its own right. Rather than *postmodern*, he argues that the art of our own time should be named *posthistorical*: "But that [the lack of an identifiable style] in fact *is* the mark of the visual arts since the end of modernism, that as a period it is defined by the lack of a stylistic unity, or at least the kind of stylistic unity which can be elevated into a criterion and used as a basis for developing a recognitional capacity, and there is in consequence no possibility of a narrative direction."[8] The impossibility that Danto perceives in attempting to describe artistic developments after the death of modernism suggests that history, here viewed as temporal progression, has indeed ended. This verdict does not mean that art does not continue to be produced, but that it no longer belongs to history.

Is this unwillingness to grant historical status to the present simply due to the difficulty of writing historically about one's own time? Is this the blindness on which the insights of hindsight depend? How do philosophers of history assess the contemporary situation? Independent of the art historical debate, Reinhart Koselleck asserts that in the context of modernity (*Neuzeit*), the "space of experience" has become ever more distant from what he terms the "horizon of expectation."[9] Life experience is thought less and less relevant in foretelling the future, for it is harder and harder to extend

one's experience of the past into an expectation of what is to come. Kosel-leck dates this development to the French Revolution and the technological innovations that led to the Industrial Revolution. These political and eco-nomic developments, he claims, destroyed what had been an age-old con-fidence that the future could be known on the basis of the past. Koselleck's thesis bears an uncanny resemblance to the cultural uses to which both the concepts of contemporaneity and "the contemporary" are currently being deployed with regard to the present. The acceleration of time is the thesis of a book by Marc Augé, who argues that we are being overwhelmed by his-tory. He suggests that the speed of historical change means that nothing can any longer be assigned to the past and that nothing lies in the future. Time collapses into an eternal present: "This overabundance [of events], which can be properly appreciated only by bearing in mind both our overabundant information and the growing tangle of interdependencies in what some al-ready call the 'world system,' causes undeniable difficulties to historians, especially historians of the contemporary—a denomination which the in-tensity of events over the last few decades threatens to rob of all meaning."[10]

According to this view, the future cannot be forecast in the light of past experience and the present is poised on the verge of the unknown. An apocalyptic tone informs much of the writing about contemporaneity. End-of-world scenarios come readily to the mind, whether they take the form of the end of art (at the hands of the culture industry), the destruc-tion of the environment (in an age of global warming), the destabilization of the nation-state (at the hands of international capital), the collapse of the global economy (a consequence of the integration of financial markets), or the demise of secular democracy (in the face of religious fundamentalism), they all offer dire scenarios of dissolution and catastrophe. Who knows what tomorrow will bring? According to Augé (who calls contemporaneity "supermodernity"): "We barely have time to reach maturity before our past becomes our history, our individual histories belong to history writ large. . . . Nowadays the recent past—'the sixties,' 'the seventies'—becomes history as soon as it has been lived. History is on our heels, following us like our shadows, like death."[11]

Perhaps the greatest difficulty in conceiving the historical nature of the contemporary lies not so much in the ever-increasing blur of events or the instantaneity of communication in the age of the Internet, as in coming to terms with the asynchrony, the nonsynchronous nature of temporal devel-

opments.[12] If we recognize that time flows at different speeds in different locations, it is difficult to select one dimension or another of that multiplicity as that whose characteristics define a period—say, "the contemporary." On what grounds can diverse temporal schemes be reduced to an account that privileges only one of them?[13] Can synchrony be reconciled with asynchrony—one idea of time with many—or does this maneuver result in a contradiction that is an insurmountable obstacle to any future prospect for what we might call universal history? How can the rich complexity of events taking place according to different understandings of the nature and speed of time be reduced to an abbreviated and reductive narrative that in aspiring to generality sacrifices the texture of particularity? To be more direct, the nonsynchronic quality of the passage of time cannot be squared with the ongoing need for a common historical narrative.

A rising awareness of time's multiplicity has absorbed the attention of a number of historians and art critics, as well as an exhibition in London at Tate Britain.[14] Nicolas Bourriaud, the curator of the *Altermodern* exhibition, argues that the postmodern is finished and that we find ourselves in a moment he labels *altermodern*, a term to be understood as a moment rather than a period, for it bears no relation to the past. If, for Augé, the speed of current events means that the present cannot be distinguished from the past, Bourriaud proposes that they cannot be distinguished because time's "arrow" is no longer visible. A characteristic of the "now" is its heterochrony, "a vision of human history as constituted by multiple temporalities."[15] Bourriaud's position seeks to avoid the teleological implications that have so often marked past efforts at periodization, as well as the necessarily essentialist connotations associated with any attempt at definition and narrativization. Rather than envision a proliferation of histories, one for each of time's distinct manifestations, Bourriaud assumes that contemporaneity is ahistorical. Heterochronicity translates as achronicity. The multitude of time's rivers, its many streams, and the impossibility of fording them, is interpreted as equivalent to time's absence. This strategy, which evades the lure of universal time, nevertheless fails to engage with the possibility that time possesses many dimensions and textures. The heterochronous trajectories traversed by different cultures are rejected in favor of a "non-time" that flattens and obliterates the specificities of geographical and cultural location.[16]

If the contemporary is to be treated historically, if it is to be understood as distinct from either the past or the future, then the multiplicity of the

heterochronous forms that characterize it must somehow be subject to narrativization. The heterochronic nature of the world's cultures, including their incoherencies and incommensurabilities, can only be articulated through reference to some common denominator. In the present context, the dominant time system is that put in place during the colonial period. It has, until relatively recently, proven easy for those involved in the study of modern and contemporary art to ignore art produced in cultures outside the West.[17] The suppressed narratives that fell out of time as a consequence of the institutionalization of colonial time offer boundless possibilities for future historians. Not only are many of these histories still to be written, but their relation to one another, as well as to the dominant story of modernity, must still be told. Writing about contemporary art of Eastern Europe, the Polish scholar Piotr Piotrowski describes the situation as follows: "The center provides the canons, the hierarchy of values and the stylistic norms; it is the role of the periphery to adopt them in the process of reception. It may happen, of course, that the periphery has its own outstanding artists, but their recognition, their consecration in art history, depends on the center; on the exhibitions organized in the West and the books published in Western countries."[18]

Terry Smith's book *What Is Contemporary Art?* is perhaps the most ambitious attempt to date to think through the historical issues raised for contemporary art by the discreditation of teleological conceptions of historical time.[19] Smith's views agree with those articulated by Bourriaud in doubting whether the contemporary can or should be treated like a period:

No longer does it feel like "our time," because "our" cannot stretch to encompass its contrariness. Nor, indeed, is it "a time," because if the modern was inclined above all to define itself as a period, and sort the past into periods, in contemporaneity periodization is impossible. The only potentially permanent thing about this state of affairs is that it may last for an unspecifiable amount of time: the present may become, perversely, "eternal."[20]

Like Bourriaud, Smith wishes to avoid what he perceives as the essentializing dangers inherent in the project of periodization by arguing that contemporary art is just too diverse to describe or categorize in any way. Contemporaneity is marked by the impossibility of its definition — a historical moment that is identified by irreconcilable antinomies. The unconscious irony of this position is that it replaces one essentialism for another: if periodization de-

pends on the identification and definition of particular temporal characteristics, so does the idea of an atemporal void, a "non-time."

While Smith's argument constitutes a dramatic challenge to an evolutionary theory of history and expresses a widespread and legitimate dissatisfaction with its failure to do justice to historical experience, it also asserts that history has come to an end, and that the narrative structure on which the attribution of meaning to the past has depended is no longer relevant. An attack on the inherent essentialism of narrativity, however, appears to cut both ways. In eliminating universal time, this perspective eliminates not only differences among moments in time but also the possibility that there might be other ways of telling time. A featureless contemporaneity registers differences in neither time nor culture.

In contrast to the desire to marshal the contemporary to dispense with the necessity for periodization altogether, an enduring compulsion to understand the contemporary as a period—as an art historical moment, for example, that succeeds modernism and postmodernism—remains. If the contemporary is incorporated into an evolutionary narrative identified with both the Renaissance and with modernism, however, then it simply becomes another stage in a familiar but discredited story. Privileging the present and the cultures that dominate the global scene as the place at the end of time from which all other moments are to be calibrated and evaluated extends the historicist structure of our understanding of the past by implying that the present fulfills a historical development. Like historical writing of the nineteenth and twentieth centuries, the contemporary becomes the latest place from whose exalted perspective it is possible to discern the workings of the Hegelian "spirit." Narrative, the rhetorical form to which historical writing belongs, seems to insist that the present cannot be conceived as a period without being incorporated into a story that has a beginning, a middle, and an end. If chronology relies on ideological agendas, then the power relations on which they depend cannot be overlooked.

No longer believing that time moves toward a goal, nor convinced that contemporaneity enjoys a favored position in a progressive sequence of historical periods, the postmodern condition nevertheless searches for some way to understand its own situation.[21] *So now what?* To what other form of time can we turn in order to ascribe temporal meaning to works of art? Perhaps the very materiality of culture, the physical vestiges of time's passage with their demand for a perceptual and cognitive response from the

viewer, prompts another way of thinking about the issue of periodization. George Kubler, the most poetic art historian to address the riddle of time, once wrote: "The cultural clock . . . runs mainly upon ruined fragments of matter recovered from refuse heaps and graveyards, from abandoned cities and buried villages."[22] For any study of the visual, the traces and tracks of time's existence are located in artifacts. Many, if not all such objects, have long been ascribed an aesthetic and ontological presence that prevents them from nestling securely within epistemological systems. They intimate something in excess of the entirely comprehensible, something that language cannot capture. Even if images serve as records of the time and place of their creation, they also appeal to the senses and possess an affective force that allows them to attract attention in temporal and cultural locations far from the horizons in which they were created.

The phenomenological dimension of art history has always insisted that the visual artifact can create its own history. Arguing that images call for attention and demand interpretation, several recent thinkers have developed the concept of *anachronism* as a means of describing the process of mediation that goes on between artifacts that both solicit an affective response and invite the desire of the contemporary historian or critic to make meaning.[23] By emphasizing the contemporaneity of their response to images, by folding the historicity of their own temporal locations within accounts of historical horizons, such scholars effectively disrupt any absolute distinction between past and present. In weaving what has been with what is, they often offer us a different conception of time no longer dominated by the linear progression with which art history is so familiar, but one that instead erases the distinction between the observer, on one side of time, and the epoch in which the work was created, on the other. The texture of the past is threaded through an account of the work's reception in the present. History is recognized as the attempt to grasp the otherness of temporal distance in full recognition of the impossibility of ever doing so. Disabused of any pretension of offering an objective account of the past, historical writing of this kind affirms the presence of the present in the past, as well as of the past in the present.

If the work of art carries its own time, or has the power to create time in the response of those who receive it, then how is it to be narrativized? How can a physical object that appears to escape the bonds of language be made subject to textual power? How can anachrony be reconciled with chronology? Constructing a period, defining the temporal as well as the onto-

logical value of objects, is clearly as fraught with difficulty as subscribing to the "end of history." Periodization involves negotiating the nonsynchronous nature of temporality—the need to relate multiple streams of time to one another in a narrative that does not do them undue violence. The compromising process of translating multiple forms of time into a singular narrative in order to ascribe them meaning will always be subject to revision. While it seems imperative to distinguish different moments in order to construct the idea of a period, be it in the past or the present, it is also necessary to admit that these distinctions are never permanent and that their differences depend on the interests of the now. As Lydia Liu points out in discussing the problems of translation in the age of globalization, the concept of "difference" depends on the context in which it is uttered.[24]

Periodization—time's categorization—is as crucial to historical writing as the continual renegotiation of what is to count as a period's identifying characteristics. Historians find themselves in the paradoxical situation of insisting that distinctions among historical moments matter, while at the same time acknowledging that the qualities of such differences can never be fixed. What counts either as past or present may well be a fabrication, yet the distinction is there to provide a structure with which to deal with the trajectory from a shadowy past through the bright intensity of the present and on into a dim and unrecognizable future.

If we are never fully aware, however, of what it is to be contemporary, historical writing must take place in circumstances of uncertainty and even in a kind of blindness. If history inevitably betrays the nature of the present in which it is written, those of us who engage in it have nevertheless only an indistinct idea of the qualities of our own temporal location. The present seems to be filled both with the presence of the past and the anticipation of the future. Does it have an identity we can call its own? It is Kubler who manages to articulate the difficulty of our circumstances most effectively: "Actuality is when the lighthouse is dark between flashes: it is the instant between the ticks of the watch: it is a void interval slipping forever through time: the rupture between past and future: the gaps at the poles of the revolving magnetic field, infinitesimally small but ultimately real. It is the interchronic pause when nothing is happening. It is the void between events."[25] That past time is defined in terms of present time is by now a truism, but it is one whose meaning is changed if the anachronic encounter with other historical horizons—an interaction mediated through

artifacts, be they images or books—is taken into consideration. Visual objects are fully historical not because they have been mortified and forced to become part of a lifeless epistemology, but precisely because they cannot be captured, frozen, or embalmed. Artifacts of all kinds, whether or not they have been accorded the status of art, call forth their own interpretations. If history's clock runs on Kubler's fragments of matter, these fragments are as much a part of the present as of the past. The idea that contemporaneity is so distinct that it cannot be placed in historical perspective seems to be a product of the darkness of actuality, of "the void between events," of the impossibility of discerning what is happening around us now. Whether we like it or not, "this too shall pass," and the contemporary seems likely to be periodized and re-periodized in future contexts in ways that might currently seem unexpected and improbable. In the full realization of the difficulty of saying anything conclusive about the elusive topic of time, let me try to bring this chapter to an end. Rather than obliterate the necessity to characterize something as fleeting and ephemeral as time, an awareness of heterochronicity—time's varied significance in different cultural contexts—adds urgency to the search for ideas adequate to the understanding of time's multiplicity. The idea that contemporaneity is a form of "non-time," one in which history no longer operates, threatens to impoverish not only our sense of the alterity of the past but also our appreciation of the differences between cultures.

The contemporary is therefore different from the past and the future not because this difference is dictated by any inherent characteristic but because of the need to create distinctions in the texture of time. While such temporal identities may be difficult to defend, and their perceived characteristics depend on the perspectives of those articulating them, their ambivalence seems necessary. Time past, time present, and time future are both actual and virtual, both graspable and ungraspable, both concrete and abstract, both intelligible and unintelligible all at the same time.

NOTES

1. See Robert Baldwin, "A Sea Change in Art History: The Decline of the Past and the Rise of Contemporary Art," www.socialhistoryofart.com, February 15, 2012. In 2010 the College Art Association's website listed 605 dissertations in progress on topics after 1900, 586 dissertations on topics before 1900, and 273 on non-Western topics (many of which are post-1900).

2. These concerns were discussed at a workshop cosponsored by the Clark and Getty museums, "Art History and the Present," that took place in Williamstown, Massachusetts, and Los Angeles in October 2007 and February 2008. See also Thomas Crow, "The Practice of Art History in the United States," *Daedalus* 135, no. 2 (2006): 7–91.

3. See, for example, James Elkins, "Introduction to an Abandoned Book," in *Renaissance Theory*, edited by James Elkins and Robert Williams, 29–46 (New York: Routledge, 2008). See also Anthony Molho, "The Italian Renaissance, Made in America," in *Imagined Histories: American Historians Interpret the Past*, 263–94 (Princeton: Princeton University Press, 1998). Molho ends his essay on the rise and fall of Renaissance studies in the United States with the plaintive question: "Will American scholars be able to imagine a concept comparable to that of modernity, in all its positive and negative valences, with which to root American culture in a past as distant as that of medieval and early modern Europe?" (294).

4. One of the most enduring articulations of this ideology is found in the work of Clement Greenberg. See his *Art and Culture: Critical Essays* (Boston: Beacon Press, 1989). For reflections on art history's modernist moment, see Thomas McEvilley, "Art History or Sacred History?," in *Art and Discontent: Theory at the Millennium*, 133–67 (New York: McPherson, 1991).

5. See, for example, Ernst Gombrich, "Vogue for Abstract Art," in *Meditations on a Hobby Horse*, 143–50 (London: Phaidon, 1965). Beat Wyss discusses Erwin Panofsky's antipathy to Barnett Newman's abstractions in "Ein Druckfehler," in *Erwin Panofsky: Beiträge des Symposions Hamburg 1992*, edited by Bruno Reudenbach, 191–99 (Berlin: Akademie Verlag, 1994).

6. Jean-Francois Lyotard, *The Postmodern Condition: A Report on Knowledge*, translated by Geoff Bennington and Brian Massumi (Minneapolis: University of Minnesota Press, 1984; 1st ed. Paris, 1979).

7. Fredric Jameson, *Postmodernism, or, the Cultural Logic of Late Capitalism* (Durham: Duke University Press, 1991); Fredric Jameson, *A Singular Modernity: Essay on the Ontology of the Present* (London: Verso, 2002); Fredric Jameson, "The End of Temporality," *Critical Inquiry* 29, no. 4 (2003): 695–718.

8. Arthur Danto, "Introduction: Modern, Postmodern, and Contemporary," in *After the End of Art: Contemporary Art and the Pale of History*, 3–19 (Princeton: Princeton University Press, 1997), 12. The prospect of a directionless contemporary art prompts Hal Foster to comment: "But our paradigm of no-paradigm has also abetted a flat indifference, a stagnant incommensurability, a consumer-touristic culture of art sampling—and in the end is this posthistorical default in contemporary art any great improvement on the old historicist determinism of modernist art à la Greenberg and company?" "Roundtable: The Predicament of Contemporary Art," in *Art since 1900: Modernism, Antimodernism, Postmodernism*, edited by Hal Foster et al., 671–79 (New York: Thames and Hudson, 2004), 679.

9. Reinhart Koselleck, "'Space of Experience' and 'Horizon of Expectation': Two

Historical Categories," in *Futures Past: On the Semantics of Historical Time*, 267–88 (Cambridge: MIT Press, 1985). Christine Ross has put these ideas to work on the work of contemporary artists; see "The Suspension of History in Contemporary Media Arts," *Intermédialités*, no. 11 (2008): 125–48.

10. Marc Augé, *Non-places: An Introduction to an Anthropology of Supermodernity*, translated by John Howe (London: Verso, 1995; 1st ed. Paris, 1992), 28.

11. Augé, *Non-places*, 26–27.

12. For the concept of nonsynchronous contemporaneities, see Ernst Bloch, "Noncontemporaneity and Contemporaneity, Philosophically," in *Heritage of Our Times*, 104–16 (Cambridge: Polity Press, 1991).

13. For a discussion of the difficulties confronting the historical project in its attempt to recognize the variety of perspectives from which its possibly incommensurate narratives must be written, see Harry Harootunian, "Remembering the Historical Present," *Critical Inquiry* 33, no. 3 (2007): 471–94; Harry Harootunian, "Some Thoughts on Comparability and the Space-Time Problem," *boundary 2* 32, no. 2 (2005): 23–52. For a range of opinions on the problem of world history, see Peter Burke, ed., *The Writing of World Histories* (Copenhagen: Akademisk Forlag, 1989).

14. See Nicolas Bourriaud, "Altermodern," and Okwui Enwezor, "Modernity and Postcolonial Ambivalence," both in *Altermodern: Tate Triennial*, exhibition catalogue, edited by Nicolas Bourriaud (London: Tate Publishing, 2009), n.p. I am indebted to Alexander Alberro for this reference. For other contributions to the discussion of the status and meaning of time in contemporary art, see Dan Karlholm, "Surveying Contemporary Art: Post-war, Postmodern, and Then What?," *Art History* 32, no. 4 (2009): 712–33; Miguel Angel Hernandez Navarro, "Presentación: Antagonismos temporales," in *Arte, tiempo y arqueologías del presente*, edited by Miguel Angel Hernandez Navarro, 9–16 (Murcia: CEDEAC, 2008).

15. Bourriaud, "Altermodern," n.p.

16. Writing on the aesthetics of migratory art, Miguel Angel Hernandez Navarro and Mieke Bal, by contrast, use the concept of heterochrony to emphasize the differences that distinguish temporal cultures by arguing for their incommensurability. See Miguel Angel Hernandez Navarro, "Out of Synch: Visualizing Migratory Times through Video Art," in *Art and Visibility in Migratory Culture: Enacting Conflict and Resistance, Aesthetically*, edited by Mieke Bal and Miguel Angel Hernandez Navarro, 191–208 (Amsterdam: Rodopi, 2011); Mieke Bal, "Heterochrony in the Act: The Migratory Politics of Time," in *Art and Visibility in Migratory Culture*, 211–38. I am grateful to Bal for providing me with page proofs of these essays while the book was in press. See also Miguel Angel Hernandez Navarro, "Contradictions in Time-Space: Spanish Art and Global Discourse," in *The Global Art World: Audiences, Markets, and Museums*, edited by Hans Belting and Andrea Buddensieg, 136–53 (Ostfildern: Hatje Cantz, 2009).

17. A typical example of this attitude is the textbook *Art since 1900: Modernism, Antimod-

ernism, Postmodernism, edited by Hal Foster et al. (New York: Thames and Hudson, 2004). For criticism, see Nancy Troy et al., "Interventions Reviews," *Art Bulletin* 88, no. 2 (2006): 373–89.

18. Piotr Piotrowski, "On the Spatial Turn, or Horizontal Art History," *Umeni*, no. 5 (2008): 378–83, 378.

19. Terry Smith, *What Is Contemporary Art?* (Chicago: University of Chicago Press, 2009).

20. Terry Smith, "Introduction: The Contemporaneity Question," in *Antinomies of Art and Culture*, edited by Terry Smith, Okwui Enwesor, and Nancy Condee, 9 (Durham: Duke University Press, 2008).

21. For an attempt to sketch a periodization of contemporaneity, see Alexander Alberro, "Periodizing Contemporary Art," in *Crossing Cultures: Conflict, Migration and Convergence; The Proceedings of the 32nd International Congress of the History of Art*, edited by Jaynie Anderson, 935–39 (Melbourne: Melbourne University Publishing, 2009).

22. George Kubler, *The Shape of Time: Remarks on the History of Things* (New Haven: Yale University Press, 1962), 14.

23. See Georges Didi-Huberman, *Fra Angelico: Dissemblance and Figuration*, translated by Jane-Marie Todd (Chicago: University of Chicago Press, 1995); Georges Didi-Huberman, *Confronting Images: Questioning the Ends of a Certain History of Art*, translated by John Goodman (University Park: Pennsylvania State University Press, 2005); Hubert Damisch, *The Judgment of Paris* (Chicago: University of Chicago Press, 1996); Mieke Bal, *Quoting Caravaggio: Contemporary Art, Preposterous History* (Chicago: University of Chicago Press, 1999); Alexander Nagel and Christopher Wood, *Anachronic Renaissance* (New York: Zone Books, 2010).

24. Lydia Liu, *Tokens of Exchange: The Problem of Translation in Global Circulations* (Durham: Duke University Press, 1999), 2.

25. Kubler, *The Shape of Time*, 17. Commenting perceptively on Kubler's point, Pamela Lee writes: "History, then, becomes a matter of both belatedness and regressivity, eternal recurrence reinscribed as a problem of communication. Compromised by an endless temporal switching, one always returns to the past too late, just as one always projects the future too early. The problem, however, is that the fullness of the present is forever at a loss, flagging the crisis of historicity that is the constituent feature of postmodernism" (*Chronophobia: On Time in the Art of the 1960s* [Cambridge: MIT Press, 2004], 256). For Giorgio Agamben, contemporaneity's incapacity to understand its own time is likened to the impossibility of seeing the light of distant stars that never reaches us because it recedes from us too rapidly to be discernible. See Giorgio Agamben, "What Is Contemporary?," in *What Is an Apparatus? And Other Essays*, translated by David Kishik and Stefan Pedatella, 39–54 (Stanford: Stanford University Press, 2009), 46–47.

PART II **HISTORY**

VISUAL STUDIES AND THE ICONIC TURN

Images are not just a particular kind of sign but something like an actor on the historical stage, a presence or character endowed with legendary status, a history that parallels and participates in the stories we tell ourselves about our own evolution from creatures "made in the image" of a creator, to creatures who make themselves and their world in their own image.

W. J. T. MITCHELL, *ICONOLOGY: IMAGE, TEXT, IDEOLOGY*

The idea of presence, as startling to post-Enlightenment thinking as the appearance of Banquo's ghost at Macbeth's table, has entered the precinct of the humanities and made itself at home. Affirmations that objects are endowed with a life of their own—that they possess an existential status endowed with agency—have become commonplace. Without a doubt, objects (aesthetic or not) induce pangs of feeling and carry emotional freight that cannot be dismissed. They return us to times and places that are impossible to revisit and speak of events too painful or joyous or ordinary to remember. Yet they also serve as monuments of collective memory, as indices of cultural value, and as foci for the observation of ritual, and they satisfy communal as well as personal needs. The life of the world, materially manifest, once exorcised in the name of readability and rationality, has returned to haunt us.

Bored with the *linguistic turn* and the idea that experience is mediated through the medium of language, many scholars are now convinced that we may sometimes have unmediated access to the world around us, that the subject/object distinction, so long a hallmark of the epistemological enterprise, is no longer valid. In the rush to make sense of the circumstances in which we find ourselves, our tendency in the past was to ignore and forget "presence" in favor of "meaning." Interpretations were hurled at objects in order to tame them, to bring them under control by endowing them with meanings they did not necessarily possess. Works of art are objects now regarded as more appropriately encountered than interpreted. This new breed of scholars attends to the ways in which images grab attention and shape reactions, for they believe that the physical properties of images are as important as their social functions. In art history and visual studies, the disciplines that study visual culture, the terms *pictorial* and *iconic turn* currently refer to an approach to visual artifacts that recognizes these ontological demands.[1] Paying heed to that which cannot be read, to that which exceeds the possibilities of a semiotic interpretation, to that which defies understanding on the basis of convention, and to that which we can never define, offers a striking contrast to the dominant disciplinary paradigms of the recent past: social history in the case of art history and identity politics and cultural studies in the case of visual studies.

At their most radical, theories that claim access to the "real" argue that perception allows us to "know" the world in a way that may sidestep the function of language. The literary theorist Hans-Ulrich Gumbrecht claims that an insistence with reading the world around us — approaching it as if it were composed of sign systems — has blinded us to its status as an existing "being." Rejecting the hubris of methods that bury the objects that surround us in ever-greater layers of meaning, he favors attending to the means by which those objects determine and define our own attitudes. We need to be attuned to the intentionality of nature, the life and purpose of objects, their active role in the subtle to-and-fro of experience. Gumbrecht consequently calls for interpretations that are as sensitive to "presence effects" as they are to "meaning effects."[2] Fatigued by regimes of representation that trade in ascriptions of meaning, Gumbrecht desires to do justice to the peculiar life of objects.

This chapter sketches a brief historiography of the introduction of issues of presence, the demand that we take note of what objects "say" before we

try to force them into patterns of meaning, in Anglo-American, German, and French art history and visual studies in order to compare and evaluate their interpretive implications. I have surveyed essays by some of the most influential authors in order to draw a few preliminary and possibly controversial conclusions. I argue that the recent preoccupation with the existential status of images, one that concentrates on their nature and structure, adds a valuable dimension to the interpretive agenda of both art history and visual culture. Art history and visual studies in Britain and the United States have tended to approach the image as a *representation*, a visual construct that betrays the ideological agenda of its makers and whose content is susceptible to manipulation by its receivers. By contrast, the contemporary focus on the presence of the visual object, how it engages with the viewer in ways that stray from the cultural agendas for which it was conceived and which may indeed affect us in a manner that sign systems fail to regulate, asks us to attend to the status of the image as a *presentation*.[3]

Attending to the presence of the object, being sensitive to its "aura," respects the immediacy of its location in space and time. Interpretations that capture the specificity of such encounters betray their "situatedness"; they reveal the unique quality of the particular process of understanding. While writing that recognizes the ontological power of the object often conceals the subject position from which meaning is constructed, the texts themselves suggest the ideological "supplements" that haunt them. The phenomenological gesture that uses anachronism to allow a historical object to escape time (or more accurately to create time), by endowing it with contemporary significance, depends on chronology for its meaning. An appreciation of the exterior of the visual object, its protean interventions in the life of culture, its vitality as a representation, need not be regarded as an alternative to attempts to come to terms with its interior, its capacity to affect us, its aesthetic and poetic appeal, its status as a presentation. Both approaches, I argue, add power and complexity to our current understanding of the visual.

This contemporary fascination with the other side of experience, what comes to meet us rather than what we bring to the encounter, occurs in many aspects of the humanities, from philosophy to science studies and from anthropology to historiography. Philosophers such as Gilles Deleuze, Felix Guattari, and Alain Badiou claim that human experience is shaped by an ontological multiplicity (events) that outruns any attempt to postu-

late "Being" as a unified, but unknowable, entity underlying the "reality" to which humans respond; they deny the power of linguistic representation to offer a consistent account of that experience.[4] Events and their effects are not understood in terms of a personal lived experience as in phenomenology, but as impersonal neurological and physiological occurrences.[5] In contrast to poststructuralist theory, language is no longer regarded as the privileged medium through which we come to know both ourselves and the world. Rather than interposing itself between us and what we experience, language is regarded as part of an experiential continuum. Instead of offering varying but commensurable approaches to the same world, language produces incommensurate accounts of different worlds. It is not a reflection of being so much as an agent in its constitution; that is, language has a performative status in the production of meaning.[6] Works of art become locations in which artists register the sensations caused by the events of experience in forms that allow those who view the works to react to the "affects" they provoke. Like language, the work of art performs its function; it no longer means but does: "You cannot 'read' affects . . . , you can only experience them."[7] Affects are like events: they can only be appreciated in retrospect when they are attributed signification by means of linguistic representation.

A similar concern with the presence rather than the meaning of objects may be discerned in the burgeoning field of science studies. Lorraine Daston, Peter Galison, Bruno Latour, and others, have rethought the project of science by declaring that the facts, to whose elucidation and interpretation empirical activity is dedicated, are as much created as discovered.[8] There is nothing pure about scientific research; it is a complex, profoundly social, and therefore cultural and political enterprise, in which it is impossible to tell where empirical evidence leaves off and theoretical, and ideologically inflected, imagination begins. Far from being constructed, scientific facts emerge from the blurring of the subject/object distinction in the interaction between human and nonhuman forms of nature. While forever distorting what it describes, language has the power to bring its subjects into being. An inevitable slippage takes place as a signifying system of human invention slides over a world that antedates and exceeds its analytical potential, yet language nevertheless structures the world as we know it: "Once . . . it is realized that the signified is originally and essentially trace, that it is always already in the position of the signifier, the metaphysics of presence

must recognize writing as its source."[9] Language does not alienate us from access to the real; it is the mechanism that allows us both to discover and to make the circumstances in which we find ourselves.

Sociologists and anthropologists similarly evince a new respect for the status of objects. Daniel Miller emphasizes the power of objects in the creation of subjectivities, their ability to call subjects into being before they are themselves turned back into objects by the subjects they created.[10] Understood as one kind of thing, objects metamorphose in the course of time to become what they were never anticipated to be. Arjun Appadurai writes about the "social life of things," the capacity of objects to slip in and out of different roles—from commodity to gift and back again—during the course of their existence; Nicholas Thomas describes how the "recontextualization" of objects—their forms of exchange—transfigures their cultural status and value in the course of time; while Alfred Gell speaks provocatively of the "lives" and "families" of images.[11] The relation between objects and subjects is a two-way street in which it is impossible to distinguish where agency lies. Once again, the role of language is as much to describe as it is to create: "Discourse can have effects not because it 'overdetermines reality,' but because no ontological distinction between 'discourse' and 'reality' pertains in the first place. In other words, concepts can bring about things because concepts and things just are one and the same (one and the same 'thing,' we could say—using the term heuristically)."[12] Whether the thrust of the argument is that experience affords us access to Being—that which necessarily escapes our capacity to transform it into meaning—or that experience records events that that are multiple and impossible to attribute to any unitary or unifying idea, a post-Derridean disappointment with the referential power of language has been replaced by a fascination with the power of objects and the languages they speak. The search for meaning in the agendas implicit in the existence of objects replaces the attempt to capture their essence with the lost power of language.

How does this transformation of the philosophical foundations of the humanities affect historiography? How does this anti-epistemological perspective impact the writing of history? In contrast to Hayden White, who once persuasively suggested that the mediating role of language deprives us of access to the past and thus prevents us from ever knowing it, Frank Ankersmit currently argues for what he calls "sublime historical experience," an immediate and unmediated experience of the past, one akin to aesthetic

response, that triumphs over the totalizing and universalizing ambitions of language.[13] Commenting on this shift away from the linguistic preoccupations of poststructuralism, he writes: "As a result meaning now tends to weaken its ties with 'theory,' that is, with the theoretical instruments we traditionally relied on to courageously expand the scope of cultural, narrative, and textual meaning; it now preferably draws its content from how the world is given to us in *experience*. 'Theory' and meaning no longer travel in the same direction; meaning has now found a new and more promising traveling companion in experience."[14]

Eelco Runia also argues that new forms of historical writing may afford us access to the "presence" of the past. Historical texts may be better served by metonymy than by metaphor. By shifting registers within language, metaphor insists on the subject/object distinction in a way that creates meaning yet blocks access to presence. Where metaphor implies verticality and hierarchy, metonymy rests in the immanence of the plane, neither adding nor subtracting from language's freight. Because metonymy equates its terms, it transfers meaning laterally or horizontally so as to come to no conclusion. Where the movement of metaphor brings significance to a close, that of metonymy does not alter its import: "a metonymy is a 'presence in absence' not just in the sense that it presents something that isn't there, but also in the sense that in the absence (or at least the radical inconspicuousness) that is there, the thing that isn't there is still present."[15] Runia suggests that metonymy works in ways that are analogous to what Roland Barthes would have called a "reality effect."[16] For Barthes, the reality effect he discerns in nineteenth-century French literature is a device by which narrative action can be slowed (say, by meticulous description), so as to more effectively invest the fiction with the attributes of the real. For Runia, metonymy affords historical writing the opportunity to capture the qualities of another time without enveloping them in presentist meaning. Where Barthes draws a distinction between writing and reality, Runia urges us to collapse it. Barthes regards writing as a medium that lies between the reader and the subject of the narration; Runia does not: "The wonder of a historical text is not — as representationalism implies — that it *fails* to bring us into contact with historical reality, but that it, despite its textuality, somehow, sometimes, *does* bring us into contact with historical reality."[17]

And what about the history of art? How does it respond to this call for the recognition of presence implicit in objects; how does it react to attempts

to invest them with a life of their own? This discipline has been riven since its inception between an awareness of the presence of works of art and their historical distance from the viewing subject. Its historiographic pendulum shifts according to whether one aspect of the work's dual status is emphasized or the other—its affective role in the present or its location in history, its apparently ahistorical form or its historical content.[18] Art history's founding fathers, Heinrich Wölfflin, Alois Riegl, Aby Warburg, and Erwin Panofsky, straddle the divide. If Wölfflin and Riegl use Kantian aesthetics and Hegelian historicism to animate histories of art's form, Panofsky uses them to account for art's content.

It would take too long to trace the hydraulic relation between these two principles through the history of the twentieth century, the ways in which their fortunes have waxed and waned in the course of time—so let me cut to the recent past. The current ontological turn stands in marked contrast to the recent history of English-speaking art history. Beginning in the 1970s, art history's traditional procedures, consisting by and large of connoisseurship, stylistic analysis, and iconography, were called into question by the advent of the social history of art. Michael Baxandall and T. J. Clark argue that the discipline had long overlooked the social circumstances in which art is produced. Baxandall emphasizes that the artist is only one contributor to art's creation, and he develops the idea of the "period eye" as a means of accounting for the way in which a work registers every dimension of the culture of which it is a part.[19] More expressly indebted to Marxist theory, Clark insists on the role of works of art both as agents in the definition of social class and as manifestations of class interests.[20]

These developments were succeeded, and sometimes challenged, by the advent of French poststructuralism. In the 1980s the philosophy of history of Michel Foucault, the philosophy of language of Jacques Derrida, and the language-based psychoanalysis of Jacques Lacan led to skepticism about the power of historical writing to do justice to the events of the past, the replacement of mimetic theories of visual representation by those based on semiotics, and a challenge to humanist conceptions of subjectivity undertaken in the name of ethnic and gendered minorities.[21] Such theories have the effect of distancing art history's objects—works of art—from the interpreting historian. The intervening layer of language on which understanding depends denies the physical presence of the work a function in the process of interpretation.

These theoretical initiatives never wholly eclipsed a phenomenological tradition that ascribes a crucial role to our response to objects in developing an interpretation. Every initiative that emphasizes the mediating power of language, the opacity of the past, and the unavailability of the objects of art history's disciplinary fascination is echoed by publications that insist on the accessibility of works of art and their power to create their own histories as they work on the responses of those who encounter them. Hubert Damisch, Wolfgang Kemp, David Freedberg, Svetlana Alpers, Rosalind Krauss, and, above all, Michael Fried emphasize the active role of images over the importance attributed by others to the reconstruction of the circumstances of their production, or their interpretation from culturally unrepresented points of view.[22]

This intellectual ferment, so briefly sketched, has transformed the history of art into a decidedly more philosophical discipline than it had been in the past. The truths on which the discipline had been constructed—a Kantian theory of aesthetic value and Hegelian conceptions of history, both of which depend on claims to universality for their legitimacy—have found themselves under attack. The assumptions of art history's traditional methods, such as connoisseurship, stylistic analysis, and iconography (already superseded by the advent of the social history of art), have been displaced by approaches that neither take the status of art as a given nor agree upon a definition of the concept of history.

Where poststructuralism is dominated by Derrida's claim that there was nothing outside language and that language is both the principal means by which we come to understand the world and the very medium that prevents us from a direct experience of it, new assertions of presence have led art historians to rethink the relation of language and world. The French art historian Georges Didi-Huberman, who draws inspiration from philosophical models created by Martin Heidegger and Maurice Merleau-Ponty during the 1930s and 1950s, is perhaps the most outspoken critic of the way in which the history of art's preoccupation with the construction of meaning has obscured our appreciation of the presence of the work of art.[23] In a series of essays, Didi-Huberman explores how received methodologies—Panofsky's iconology or Baxandall's social history—fail to capture some of the most important characteristics of the works of art they address.[24] Insisting on the primacy of the spectator's response to the image, he believes it is the experience of the work that guides its historical appreciation.

In a book on Fra Angelico, for example, Didi-Huberman conceives of the act of painting as an allegory of the divine made physical. Paint is the means by which transcendental truths are vouchsafed to human beings. Just as the theologians of the period added commentary to the Bible without seeking to bring the process of interpretation to an end, so does the artist. Whereas Panofsky or Baxandall set the work against, or into, the context in which it was produced—approaching the object of analysis as if it were inert and in need of explanation through reference to circumstances that are more stable and less opaque—Didi-Huberman regards the work as an active principle, one capable of generating its own significance. Demonstrating a scholarly erudition through a command of theological sources that would make an iconographer proud, he nevertheless insists that we cannot ignore the fact that we encounter the image in the present. Regardless of the period in which it may have been created, it is necessarily alive in our own time.

It comes as no surprise to learn that Warburg is Didi-Huberman's historiographic hero, for Warburg recognized the power of the image to break time. For the past century, working concepts such as *Nachleben* (afterlife) and *Pathosformeln* (emotional formulae) have articulated the ways in which images have lives that continue to haunt us long after the moments of their creation.[25] One of the consequences of the unique importance that Didi-Huberman ascribes to the presence of the visual artifact is that it calls into question art history's received notions of historical development. If the object breaks or creates time, then the history of art is necessarily an anachronistic enterprise. The intensity of the rapport established between the work and the contemporary spectator does not allow us to subordinate art to some pre-established historical trajectory: "One must not claim that there are historical objects relevant to this or that duration: one must understand that in each historical object, all times encounter one another, collide, or base themselves plastically on one another, bifurcate, or even become entangled with one another."[26]

Renewed interest in the presence of objects—in their capacity to outrun the meanings attributed to them by generations of interpreters—has also had important repercussions for visual studies. W. J. T. Mitchell, for example, has named it the "pictorial turn."[27] Mitchell rejects as reductive the concern with the semiotic analysis of images that was a feature of the 1980s because it depended on a linguistic model and argues that pictures should be considered independently of language—as having a presence that es-

capes linguistic ability to describe or interpret — even if they are inextricably entangled in its coils. Although intimately related, words and images are orders of knowing that cannot be equated with one another. Pursuing this argument in a book interrogatively titled *What Do Pictures Want?*, Mitchell suggests that depictions have lives and that these lives are only partly controlled by those who give birth to them.[28] We may create images, but in doing so we endow them with human characteristics, including the anthropomorphic power of agency. Their second-hand life enables them to proliferate and reproduce themselves. Pictures thus mimic our lives and haunt our steps at every turn.

The importance of the pictorial turn lies in the fact that Mitchell does not restrict the study of images to those traditionally privileged by inclusion in the category *art*. Works of art, whose significance has traditionally been guaranteed by notions of aesthetic value, are not the only kind of visual objects whose presence needs to be acknowledged. Mitchell recognizes that the power of their appeal comes in many different shapes. If art history has tended to ignore the challenge posed to its canonical parameters by the existence of ontologically fascinating artifacts whose aesthetic potential is worth exploring,[29] visual studies attends to the varied and incongruous families that inhabit visual culture as well as to the changing nature of perception and visuality.[30]

For James Elkins, another leading theorist of visual studies, pictures accorded the descriptive label *art* constitute only a small portion of the sea of imagery in which the world's cultures are adrift. He sees no reason why the discipline should continue to dedicate its attention to this small island when it is surrounded by a vast ocean of visual interest: "I will be arguing that non-art images can be just as compelling, eloquent, expressive, historically relevant, and theoretically engaging as the traditional subject matter of art history and that there is no reason within art history to exclude them from equal treatment alongside the canonical and extracanonical examples of art."[31] Elkins conceives of the field as encyclopedic in scope, but at the same time methodologically focused on the specific nature of each image medium.[32] The sciences are not the only disciplines making use of "informational images," but they do provide the greatest variety and demonstrate the most creative invention. Elkins is fascinated, for example, by how scientists invent and manipulate technology in order to find ways of visualizing the often unseen phenomena they study. His book *Visual Practices across the*

University is an anthology of the use of visual data across the entire spectrum of disciplines that constitute the arts and sciences. While these images are created to permit the transfer of information and thus have the character of representations, their perceptual status, their impact on our optical experience, nevertheless varies according to the media in which they are constructed. The status of the image as presentation is thus just as important as the informational transactions it may enable. For Elkins these visual objects have more than merely representational significance, and he is prepared to ascribe them affective or aesthetic value: "The strategies that scientists use to manipulate images might well be called aesthetic in the original sense of the word, since they are aimed at perfecting and rationalizing transcriptions of nature."[33]

In order to make this historiographic picture yet more complex, I turn to developments in Germany that have followed an analogous, yet distinct, trajectory. Curiously enough, the Anglo-American and German initiatives often appear to be unaware of each other, though they have much in common. Gottfried Boehm sparked a new concern for the existential presence of images—their status as objects with a life of their own—in the introduction to an edited volume titled *Was ist ein Bild?* (What is an image?). Unlike English, in which *image* may be contrasted with *picture* to suggest forms of visual artifacts that are either associated with aesthetic value or not, the German *Bild* covers both categories. Boehm consequently makes no such distinction. While most of his examples are indeed works of art, the implications of his argument nevertheless apply to visual objects of all kinds. Invoking the notion of divine presence immanent in the concept of the religious icon, his concept of the "iconic turn" captures more effectively, perhaps, the sense of life attributed to visual objects than Mitchell's "pictorial turn," even if they are, admittedly, talking about somewhat different things.[34] Boehm argues that the traditional view, according to which the linguistic is thought to dominate the visual as a more powerful form of signification, has no philosophical justification. Words are no more a medium of epistemological certainty than are pictures. Citing Friedrich Nietzsche and Ludwig Wittgenstein, Boehm argues that images are integral to all linguistic operations. Rather than deliver information in an orderly linear sequence and on the basis of logical principles, language depends on visual metaphors to move meaning from one level of significance to another.[35] He also points to the way in which Lacan develops the ideas of Merleau-Ponty, drawing a

parallel between the former's idea of the "gaze," the means by which pre-existing visual conventions, models of seeing, and paradigms of visuality serve to condition and mold subjectivity, and the latter's idea that vision surrounds us.[36] Boehm's intransigent assertion of the autonomy of the visual is accompanied by a radical perceptual formalism that tends to eschew considerations of content:

> What we see in pictures are constructions of colors, forms, and lines that neither describe objects nor offer us signs, but give us something to see. . . . The painter, consequently, does not translate an inner idea into an exterior one of colors, he does not project on to the screen of the canvas; rather he works between the stains, lines and forms, puts them together, reorganizes them, and is as much the author as the medium of his action.[37]

Two of Germany's most prominent art historians, Hans Belting and Horst Bredekamp, have followed Boehm's recognition of the animated status of images (both those traditionally defined as art and those that have not been so designated) by calling for art history to expand the parameters of its disciplinary activity so as to study the whole spectrum of visual imagery. In the introductory chapter, "Medium-Bild-Körper" ("Medium, Image, Bodies"), of his book *Bild-Anthropologie* (*An Anthropology of Images*), Belting argues that visual artifacts are embedded in media and that one cannot be studied without the other. The idea of the medium—all-important to his conception of the image—is a metaphor of the human body: just as visual artifacts are inscribed in media, so internal images are inscribed in the human body.[38] The medium is thus a figure for the agency of visual objects that are conceived as more than mere representations. He writes:

> Images traditionally live from the *body's absence*, which is either temporary (that is, spatial) or, in the case of death, final. This absence does not mean that images revoke absent bodies and make them return. Rather, they replace the body's absence with a different kind of presence. *Iconic presence* still maintains a body's absence and turns it into what must be called *visible absence*. Images live from the paradox that they perform *the presence of an absence* or vice versa.[39]

According to Belting, the idea of the visual object cannot be reduced to codes and signifying systems: "Was Baudrillard right when he sharply

distinguished images from reality and accused contemporary image practice of forging reality, as if reality existed totally apart from the images by which we appropriate it? Is it possible to distinguish images from so-called reality with such ontological naiveté?"[40] Visual artifacts thus afford us access to human behavior, understood broadly enough to include reference to the emotional and psychic, as well as the more straightforwardly rational dimensions of experience. Belting's book includes a fascinating account of the way in which pictures have been used to mediate between life and death. By furnishing the dead body with substitutional objects—masks, puppets, portraits—images insist on the presence of the deceased in their absence.

Horst Bredekamp conceives of *Bildwissenschaft* (image science) as a means of institutionalizing Boehm's recognition of the independence of the visual. As with Belting, this recognition is not based on affirmations of the aesthetic value of artifacts but rather on other forms of presence. The object becomes central to a technical and philosophical discussion that recognizes it as a form of visual thinking. Bredekamp argues that scientific representations have been mistakenly identified as illustrations when they are actually forms of thought independent of language: "Images are not illustrations but universes that offer a semantics created according to its own laws that is unusually expressively materialized."[41] Scientific images are like scientific objects, specimens, and so on, that, when made the object of systematic interest, are invested with an aura not unlike that attributed to works of art: "As soon as natural objects are seized by humans they cross boundaries in the zone that separates natural images from works of art."[42]

In an analysis of the drawings made by Charles Darwin in the notes that led to the composition of *On the Origin of the Species*, Bredekamp claims that Darwin's sketches are as important a dimension of his thought process as his writing. A sketch of a branching coral, for example, is crucial to his conception of evolution as nonlinear. In substituting the branching coral for the tree trunk—the standard means of depicting the idea of evolution before his time—Darwin found a way to conceive of evolution as a process endowed with multiple timelines. An added benefit of his choice of visual metaphor is that the dead coral on which the living grows can be understood as the extinct species from which the living ones are descended. The image bears the inscription "I think," and the drawing is clearly intended as a substitute for language. Bredekamp concludes: "The image is not a derivative nor an illustration but an active medium of the thought process."[43]

The interest in the work of pictures, along with a concern for their reception and their effect on the viewer, has an unapologetically formalist dimension, one that echoes the agenda earlier espoused by Boehm. In launching a new periodical, *Image-Worlds of Knowledge: Art Historical Yearbook for Image Criticism*, Bredekamp and Gabriele Werner make this position explicit: "Our conception of image criticism begins with form analysis, that which is essential to the constitution of pictures. If we have an opportunity to make mediality a formal problem once again, it is done with the certainty that it is absolutely impossible to explain visual content and its effects, be they in the realm of art, the sciences or politics, without a discussion of forms and their histories."[44]

The nature of the revolution wrought in the approach to visual objects by Didi-Huberman in France, Mitchell and Elkins in the United States, and Boehm, Belting, and Bredekamp in Germany responds to a new conception of the visual object as invested with an animating power of its own. This approach contrasts vividly with another branch of visual studies whose intellectual ancestor is English cultural studies. I rehearse its ambitions here in order to throw those of the "iconic turn" into high relief. The best-known exponent of this tradition is Nicholas Mirzoeff, whose popular anthologies have served many as an introduction to the field.[45] Mirzoeff conceives of visual studies in terms of an analysis of the message of visual artifacts rather than their media, being above all interested in the cultural and political functions of images in social situations. Whereas Didi-Huberman, Mitchell, and Elkins tend to stress the physical status of objects, the nature and structure of the media in question, Mirzoeff is interested in the purposes to which they are put; where the former emphasize the quality of the medium — the nature of its ability to inform and to move us — Mirzoeff concentrates on its ideological potential: "The primary function of visual culture is to try and make sense of the infinite range of exterior reality by selecting, interpreting and representing reality."[46] The centrality ascribed to the concept of representation and the need to articulate the cultural assumptions embedded in the image not only by its creator and its receiver but also those of the interpreting critic have been made explicit by Irit Rogoff. Answering criticism of visual culture as an intellectual enterprise, she writes:

> In visual culture the history becomes that of the viewer or that of the authorizing discourse rather than that of the object. By necessity this shift

in turn determines a change in the very subject of the discussion or analysis, a shift in which the necessity for having it in a particular mode and at a particular time become part of the very discussion. This conjunction of situated knowledge and self-reflexive discourse analysis accompanied by a conscious history for the viewing subject . . . [is] an opportunity for a bit of self-consciousness and a serious examination of the politics inherent in each project of cultural assessment.[47]

By drawing attention to the role of the viewer or critic rather than to the character of the visual object in question, this other approach to visual studies insists that identity matters, that every interpretation differs according to the subject position of the person in question. Far from suggesting that an explanation follows from a particular identity according to some essential or defining characteristic, these authors assume that subjectivity is forever in flux and that while all knowledge may be situated, it is never fixed.[48]

Can we then articulate the methodological differences that serve to characterize such different attitudes in the ongoing enterprise of visual studies? The very names attributed to these models are revealing. While *visual studies*, *Bildwissenschaft* (image science), or *Bildanthropologie* (anthropology of images) suggest academic objectivity customarily associated in the humanist tradition with impartiality and universality, *visual culture* adds a relativizing dimension to the project by identifying and specifying the subject position of both the producer and the receiver of images. The terms *visual studies*, *Bildwissenschaft*, and *Bildanthropologie* appear to offer the hope of establishing the mechanisms by which different media affect human perception generally so as to provide accounts of their reception, including reference to cultural context or historical circumstance; *visual culture*, on the other hand, pays less attention to the operating structures of particular media in order to focus on their social and political functions. Much hinges on whether the concept of the picture is regarded as a "placeholder," a cultural construct that is filled with meaning ascribed to the circumstances in which it is produced and received, or whether it is revered as potentially loaded with iconic presence.

These contrasting, yet overlapping, attitudes clearly depend on very different ideas of what constitutes an image, ideas that determine what the agenda of visual studies or visual culture purports to be.[49] In one version, *Bildwissenschaft* and *Bildanthropologie*, the version of visual studies theo-

rized by Mitchell and Elkins and art history according to Didi-Huberman, the image is a presentation, a source of power whose nature as an object endowed with being requires that its analysts pay careful attention to the way in which it works its magic on its viewer. In the other, visual culture, as conceived by Mirzoeff and others, the image is a cultural representation whose importance lies as much in the content with which it is invested as in its intrinsic nature. Depiction is to be studied not only for its own sake but also for the spectrum of social effects it is capable of producing. Some theorists, of course, straddle the difference. Mitchell, for example, is interested in both the ontological and the political functions of the image.[50]

Paradoxically enough, visual studies inspired by the ontological turn and its counterpart indebted more clearly to the legacy of cultural studies both affirm that the reception of visual artifacts matters. Those interested in a phenomenological response—who stress that the form or medium of an image determines its message as much as its content—tend to bracket the identity of the recipient, however, in the interest of making manifest what they believe are the artifact's inherent properties (or "pull"). In their case it is the moment that matters, the here and now of reception, more than who has that experience. Others, more concerned with the political function of images, tend to emphasize the identity of both producers and recipients over their peculiar structure. It is the content of the visual object, its role within schemes of cultural and political ideology, that is deemed more meaningful than the nature of the medium.

Both approaches, however, dramatize the contingency of interpretation. In one case, by drawing attention to the contemporaneity of experience: the specific encounter that enables subject and object to interact with each other. In the other, by describing how the distinct identities of producer and recipient both determine and shape the nature of the image that serves as a communicative bridge, a mediating third term between them. In one instance, the identity of the authorial voice is purposely elided so as to enable the voice attributed to the object to be heard; in the other, the identity of the authorial voice is made manifest by emphasizing the constructed nature of its subject position. Both approaches situate the author, but in one the gesture is implicit while in the other it is explicit. The binary opposition between that which adheres to the iconic turn and that which pursues a more overtly political agenda is clearly a heuristic one. In practice we face a spec-

trum of interpretive positions in which the two terms slide in and out of one another, often becoming indistinguishable.

Perhaps Derrida's insights about language and how its lack of referentiality constitutes the very grounds of its capacity to make the world accessible can help us think about the role of images. Words create worlds that may or may not correspond with the one in which we find ourselves. Their capacity to absorb the context in which they are enunciated fills them with presence, while ensuring that their meaning cannot be fixed. Latour and Daston, for example, suggest that language is not a medium we smear across the surface of reality in order to make it meaningful, but that it is constitutive of the very things to which it refers.[51] Language has a thickness that, while forever distorting that which it describes, nevertheless has the power to bring its referent into being—to give life to what it cannot grasp. Far from resuscitating a referential theory of language, this perspective acknowledges the inevitable slippage that occurs as a human signifying system slides over a world that antedates and exceeds its descriptive and analytical capacities, while at the same time affirming that for all intents and purposes, it structures the world as we know it. It's all we have.

Some authors associated with the iconic turn, such as Belting, tend to assume that depiction functions in ways that are analogous to the role ascribed to language in science studies: images, that is, both create and discover the real at the same time. While conceding the historical specificity and contingency of their reality effects, pictures nevertheless allegedly yield up something that resonates with the real. Thinkers engaged in a form of cultural studies, however, wedded as they are to a notion of representation rather than presentation, insist on being able to see through images in order to discern the social forces responsible for their ideological agendas. According to this view, visual artifacts can only have a fictive relation to the real. These critics are neither deceived by what objects purport to be nor fooled by their alleged existential power, for they deny objects the capacity to determine their own interpretive fate in the interest of identifying the political commitments of those who make and consume them.

Such attitudes appear grounded on incompatible and incommensurable assumptions. In one case, it is necessary to ascribe an existential value to visual artifacts, implying that they possess a meaning-laden status, something that antedates the encounter with the viewer; in the other, one must

assume a philosophical or ideological perspective that enables one to encounter the apparently chaotic and multifarious quality of visual culture as if it nevertheless possessed political meaning. Different though they appear to be, the ontological and semiotic perspectives on visual objects may in fact be reconcilable. The ways in which objects call to us, their animation, their apparent autonomy, stem only from their association with us. To insist on their secondary agency is not only a means of recognizing their independence but also their dependence on human culture. They may haunt us, but their autonomy is relative. They cannot exist without the power with which we invest them: "For better or for worse, human beings establish their collective identity by creating around them a second nature composed of images which do not merely reflect the values consciously intended by their makers, but radiate new forms of value formed in the collective, political unconscious of their beholders."[52]

Such are the animating myths on which knowledge about the visual currently depends. The recent recognition that visual artifacts have a life, that they are not inert vehicles for the transport of ideas but rather beings possessed of agency, transforms our conception of work in both art history and visual studies. The iconic turn adds the dimension of presence to our understanding of the image, calling for analyses of media and form that add richness and texture to established traditions of interpretation. Whether this scholarly enterprise is conceived of as the study of different media with special interest in their peculiar natures (Elkins), as the analysis of the way in which human intelligence uses images rather than words in the construction of meaning (Bredekamp), as a historical anthropology detailing the kinds of life with which images have been and continue to be animated (Belting), as a continuing study of the ways in which perception is affected by changes in visuality (Mitchell), as a phenomenological art history intent on acknowledging the agency of the work of art (Didi-Huberman), or all of the above and more, the range of intellectual challenges to future scholars is formidable. While I have outlined some of the methodological paradigms, the possibilities are as infinite as the objects themselves. These new approaches do not make established methods of analysis obsolete. Quite the contrary. Differing assumptions need not lead to incommensurable conclusions. An analysis of medium easily leads to political considerations, while political analysis can make use of the aura of the image as part of its rhetoric. The iconic turn reminds us that visual artifacts refuse to be confined by the in-

terpretations placed on them in the present. Objects of visual interest will persist in circulating through history, demanding radically different forms of understanding and engendering compelling new narratives as they wander.

NOTES

1. See W. J. T. Mitchell, "The Pictorial Turn," in *Picture Theory: Essays on Verbal and Visual Representation*, 11–34 (Chicago: University of Chicago Press, 1994); Gottfried Boehm, "Die Wiederkehr der Bilder," in *Was ist ein Bild?*, edited by Gottfried Boehm, 11–38 (Munich: Fink, 1994); Michael Ann Holly, *Past Looking: Historical Imagination and the Rhetoric of the Image* (Ithaca: Cornell University Press, 1996).

2. Hans-Ulrich Gumbrecht, *Production of Presence: What Meaning Cannot Convey* (Stanford: Stanford University Press, 2004).

3. The distinction corresponds with the contrast between "seeing as" and "seeing in" proposed by Richard Wollheim in *Art and Its Objects: An Introduction to Aesthetics* (New York: Harper and Row, 1971), 11–14.

4. See Gilles Deleuze and Felix Guattari, *What Is Philosophy?*, translated by Hugh Tomlinson and Graham Burchell (New York: Columbia University Press, 1991); Alain Badiou, *Handbook on Inaesthetics*, translated by Alberto Toscano (Stanford: Stanford University Press, 2005); Peter Hallward, *Badiou: A Subject to Truth* (Minneapolis: University of Minnesota Press, 2003); Gabriel Riera, ed., *Alain Badiou: Philosophy and Its Conditions* (Albany: State University of New York Press, 2005). See also Jill Bennett, *Empathetic Vision: Affect, Trauma, and Contemporary Art* (Stanford: Stanford University Press, 2005); Elizabeth Grosz, *Chaos, Territory, Art: Deleuze and the Framing of the Earth* (New York: Columbia University Press, 2008).

5. Kerstin Andermann, "Malerei im Spannungsfeld von Phänomenologie und Immanenzphilosophie," in *Kulturen des Bildes*, edited by Birgit Mersmann and Martin Schulz, 249–63 (Munich: Fink, 2006).

6. Dorothea Olkowski, *Gilles Deleuze and the Ruin of Representation* (Berkeley: University of California Press, 1998), 229.

7. Simon O'Sullivan, *Art Encounters Deleuze and Guattari: Thought beyond Representation* (London: Palgrave, 2006), 43.

8. Lorraine Daston, "Introduction: The Coming into Being of Scientific Objects," in *Biographies of Scientific Objects*, edited by Lorraine Daston, 1–14 (Chicago: University of Chicago Press, 2000). Lorraine Daston and Peter Galison, "The Image of Objectivity," *Representations*, no. 40 (1992): 81–128; Lorraine Daston and Peter Galison, *Objectivity* (New York: Zone Books, 2007); Bruno Latour, *The Pasteurization of France*, translated by Alan Sheridan and John Law (Cambridge: Harvard University Press, 1988); Bruno Latour, "Why Has Critique Run Out of Steam? From Matters of Fact to Matters of Concern," in *Things*, edited by Bill Brown, 151–73 (Chicago: University of Chicago Press, 2004).

9. Timothy Lenoir, "Inscription Practices and Materialities of Communication," in

Inscribing Science: Scientific Texts and the Materiality of Communication, edited by Timothy Lenoir, 1–19 (Stanford: Stanford University Press, 1998), 5.

10. Daniel Miller, *Material Culture and Mass Consumption* (Oxford: Blackwell, 1987). I am grateful to Severin Fowles for this reference.

11. Arjun Appadurai, "Introduction: Commodities and the Politics of Value," in *The Social Life of Things: Commodities in Cultural Perspective*, edited by Arjun Appadurai, 3–63 (Cambridge: Cambridge University Press, 1986); Nicholas Thomas, *Entangled Objects: Exchange, Material Culture, and Colonialism in the Pacific* (Cambridge: Harvard University Press, 1991), 28; Alfred Gell, *Art and Agency: An Anthropological Theory* (Oxford: Clarendon, 1998), 153.

12. Amiria Henare, Martin Holbraad, and Sari Wastell, "Introduction," in *Thinking through Things: Theorizing Artefacts Ethnographically*, edited by Amiria Henare, Martin Holbraad, and Sari Wastell, 1–31 (London: Routledge, 2007), 13.

13. Hayden White, *Metahistory: The Historical Imagination in Nineteenth-Century Europe* (Baltimore: Johns Hopkins University Press, 1974); Hayden White, *The Content of the Form: Narrative Discourse and Historical Representation* (Baltimore: Johns Hopkins University Press, 1987).

14. Frank Ankersmit, "Introduction: Experience in History and Philosophy," in *Sublime Historical Experience* (Stanford: Stanford University Press, 2005), 2, 14. For a valuable review of the concept of experience in intellectual history, see Martin Jay, *Songs of Experience: Modern American and European Variations on a Universal Theme* (Berkeley: University of California Press, 2005). See also Joan Scott's perceptive article "The Evidence of Experience," *Critical Inquiry* 17, no. 4 (1991): 773–97.

15. Eelco Runia, "Presence," *History and Theory*, no. 45 (2006): 20.

16. Roland Barthes, "The Reality Effect," in *French Literary Theory Today: A Reader*, edited by Tzvetan Todorov, translated by R. Carter, 11–17 (Cambridge: Cambridge University Press, 1982).

17. Runia, "Presence," 28.

18. For the relation of these warring impulses among the discipline's founders, see Michael Podro, *The Critical Historians of Art* (New Haven: Yale University Press, 1982).

19. Michael Baxandall, *Painting and Experience in Renaissance Italy: A Primer in the Social History of Pictorial Style* (Oxford: Clarendon, 1972); Michael Baxandall, *Patterns of Intention: On the Historical Explanation of Pictures* (New Haven: Yale University Press, 1985). For Baxandall's phenomenological side, his sensitivity to the differences between the visual and the textual, see Michael Ann Holly, "Patterns in the Shadows: Attention in/to the Writings of Michael Baxandall," in *About Michael Baxandall*, edited by Adrian Rifkin, 5–16 (Oxford: Blackwell, 1999); and Margaret Iversen and Stephen Melville, *Writing Art History: Disciplinary Departures* (Chicago: University of Chicago Press, 2010), 26–37.

20. T. J. Clark, *Image of the People: Gustave Courbet and the 1848 Revolution* (London: Thames and Hudson, 1985); T. J. Clark, *The Painting of Modern Life: Paris in the Art of Manet and His Followers* (Princeton: Princeton University Press, 1999).

21. Michel Foucault, *The Order of Things: An Archaeology of the Human Sciences* (New York: Vintage Books, 1971); Jacques Derrida, *Of Grammatology*, translated by Gayatri Spivak (Baltimore: Johns Hopkins University Press, 1976); Jacques Lacan, *The Four Fundamental Concepts of Psychoanalysis*, edited by Jacques-Alain Miller, translated by Alan Sheridan (New York: Norton, 1978). The ideas of these theorists inform the work of the following art historians: Donald Preziosi, *Rethinking Art History* (New Haven: Yale University Press, 1989); Norman Bryson, *Vision and Painting: The Logic of the Gaze* (New Haven: Yale University Press, 1983); Griselda Pollock, *Vision and Difference: Femininity, Feminism, and Histories of Art* (London: Routledge, 1987).

22. Hubert Damisch, *A Theory of /Cloud/: Toward a History of Painting*, translated by Janet Lloyd (Stanford: Stanford University Press, 2002); Wolfgang Kemp, ed., *Der Betrachter ist im Bild: Kunstwissenschaft und Rezeptionsästhetik* (Cologne: DuMont, 1985); David Freedberg, *The Power of Images: Studies in the History and Theory of Response* (Chicago: University of Chicago Press, 1989); Michael Fried, *Absorption and Theatricality: Painting and the Beholder in the Age of Diderot* (Berkeley: University of California Press, 1980); Michael Fried, *Courbet's Realism* (Chicago: University of Chicago Press, 1990).

23. Martin Heidegger, "The Origin of the Work of Art," in *Poetry, Language, Thought*, translated by Albert Hofstadter, 15–86 (New York: Harper and Collins, 1971); Maurice Merleau-Ponty, "Eye and Mind," in *The Primacy of Perception and Other Essays on Phenomenological Psychology and Philosophy of Art, History and Politics*, edited by James Edie and translated by Carleton Dallery, 159–90 (Evanston, Ill.: Northwestern University Press, 1964).

24. See Georges Didi-Huberman, *Confronting Images: Questioning the Ends of a Certain History of Art*, translated by John Goodman (University Park: Pennsylvania State University Press, 2005).

25. Georges Didi-Huberman, *L'image survivante: Histoire de l'art et temps des fantômes selon Aby Warburg* (Paris: Minuit, 2002).

26. Georges Didi-Huberman, "Has the Epistemological Transformation Taken Place?," translated by Vivian Rehberg, in *The Art Historian: National Traditions and Institutional Practices*, edited by Michael Zimmermann, 128–43 (Williamstown, Mass.: Clark Art Institute, 2003), 131.

27. Mitchell, "The Pictorial Turn."

28. W. J. T. Mitchell, *What Do Pictures Want? The Lives and Loves of Images* (Chicago: University of Chicago Press, 2005).

29. Norman Bryson, "Visual Culture and the Dearth of Images," *Journal of Visual Culture* 2, no. 2 (2003): 229–32.

30. W. J. T. Mitchell, "Showing Seeing: A Critique of Visual Culture," in *Art History, Aesthetics, Visual Studies*, edited by Michael Ann Holly and Keith Moxey, 231–50 (Williamstown, Mass.: Clark Art Institute, 2002). The rise of visual studies in the United States is usefully surveyed by James Elkins in *Visual Studies: A Skeptical*

Introduction (New York: Routledge, 2003) and Margaret Dikovitskaya in *Visual Culture: The Study of the Visual after the Cultural Turn* (Cambridge: MIT Press, 2005).

31. James Elkins, *The Domain of Images* (Ithaca: Cornell University Press, 1999), ix.

32. James Elkins, "Art History and Images That Are Not Art," *Art Bulletin* 77, no. 4 (1995): 533–71. See also James Elkins, ed., *Visual Practices across the University* (Munich: Fink, 2007).

33. Elkins, "Art History and Images That Are Not Art," 570.

34. See Gottfried Boehm and W. J. T. Mitchell, "Pictorial versus Iconic Turn: Two Letters," in *The Pictorial Turn*, edited by Neil Curtis, 8–17 (London: Routledge, 2010). For an insightful comparison of Boehm's and Mitchell's positions, see Norbert Schneider, "W.J.T. Mitchell und der 'Iconic Turn,'" *Kunst und Politik* 10 (2008): 29–37.

35. Boehm, "Die Wiederkehr der Bilder," 13–16.

36. Boehm, "Die Wiederkehr der Bilder," 23.

37. Boehm, "Die Wiederkehr der Bilder," 21. All translations are my own. "Was wir in den Bildern sehen sind Fügungen von Farbe, Form und Linien, die weder Gegenstände umschreiben noch Zeichen setzen, sondern etwas zu sehen geben. . . . Der Maler übersetzt deshalb keine innere Vorstellung ins Äussere der Farben, projiziert sie nicht auf den Schirm der Leinwand, sondern er arbeitet zwischen den Flecken, Linien, und Formen, richtet sie ein, baut sie um, ist so sehr Autor wie Medium seines Tuns."

38. Hans Belting, *An Anthropology of Images: Picture, Medium, Body*, translated by Thomas Dunlap (Princeton: Princeton University Press, 2011). See also Steffen Bogen, "Kunstgeschichte/Kunstwissenschaft," in *Bildwissenschaft: Disziplinen, Themen, Methoden*, edited by Klaus Sachs-Hombach, 52–67 (Frankfurt am Main: Suhrkamp, 2005), 60. "Das Verhältnis zwischen äusserem Bild und materiellen Trägermedium wird in Analogie zur Unterscheidung von inneren Bildern und eigenen Körper bestimmt" (The relation between the external image and the internal medium in which it is carried is determined by analogy with the distinction between internal images and their own bodies).

39. Hans Belting, "Image, Medium, Body: A New Approach to Iconology," *Critical Inquiry* 31, no. 2 (2005): 312. See also Hans Belting, *Das echte Bild: Bildfragen als Glaubensfragen* (Munich: C. H. Beck, 2005), 15–18.

40. Belting, "Image, Medium, Body," 316.

41. Horst Bredekamp, "Drehmomente—Merkmale und Ansprüche des Iconic Turn," in *Iconic Turn: Die Neue Macht der Bilder*, edited by Christa Maar and Hubert Burda, 15–26 (Cologne: Du Mont, 2004), 21. "Bilder keine Illustrationen sind, sondern Kosmen einer eigengesetzlich geschaffenen Semantik bieten, besonders aussagekräftig verkörpert." I am grateful to Friedericke Kitschen for this reference.

42. Horst Bredekamp, *Darwins Korallen: Die frühen Evolutionsdiagramme und die Tradition der Naturgeschichte* (Berlin: Wagenbach, 2005), 11. "Sobald sie Naturdinge vom

Menschen erfasst warden, bewegen sie sich grenzüberschreitend in der Trennzone zwischen Naturbilde und Kunstwerk."

43. Bredekamp, *Darwins Korallen*, 24. "Das Bild ist nicht Derivat oder Illustration, sondern active Träger des Denkprozesses." In his most recent book, *Theorie des Bildakts* (Berlin: Suhrkamp, 2010), Bredekamp argues for the performative nature of the image.

44. Horst Bredekamp, and Gabriele Werner, "Editorial," *Bilder in Prozessen: Bildwelten des Wissens*; *Kunsthistorisches Jahrbuch fur Bildkritik* 1, no. 1 (2003): 7. "Unser Begriff von Bildkritik setzt bei der Analyse der Form an, also dem, was die Spezifik von Bildern ausmacht. Wenn uns daran gelegen ist, Medialität wieder zum Formproblem zu machen, so folgt dies der Gewissheit, dass sich die visuellen Gehalte und Wirkungen, sei es im Bereich der Kunst, der Wissenschaften oder der Politik, ohne die Erörterung der Formen und ihrer Geschichte schlechterdings nicht klären lassen."

45. Nicholas Mirzoeff, *An Introduction to Visual Culture* (London: Routledge, 1999).

46. Mirzoeff, *An Introduction to Visual Culture*, 37.

47. Irit Rogoff, "Studying Visual Culture," in *The Visual Culture Reader*, edited by Nicholas Mirzoeff, 14–26 (London: Routledge, 1998), 20.

48. Donna Haraway, "Situated Knowledges: The Science Question in Feminism and the Privilege of Partial Perspective," *Feminist Studies* 14, no. 3 (1988): 575–99; also see her chapter "The Persistence of Vision" in *The Visual Culture Reader*, edited by Nicholas Mirzoeff, 191–98 (London: Routledge, 2002), 191. For a discussion of the role of identity in the interpretation of images, see Whitney Davis, "The Subject in the Scene of Representation," *Art Bulletin* 76 (1994): 570–95.

49. For a number of texts addressing the concept of the image, see, most recently, James Elkins and Maja Naef, eds., *What Is an Image?* (College Park: Pennsylvania State University Press, 2011).

50. See for example, W. J. T. Mitchell, *Cloning Terror: The War of Images. 9/11 to the Present* (Chicago: University of Chicago Press, 2011).

51. Latour, "Why Has Critique Run Out of Steam?"; Daston, "Introduction."

52. Mitchell, *What Do Pictures Want?*, 105.

BRUEGEL'S CROWS

We can never understand a picture unless we grasp the ways it shows what cannot be seen. One thing that cannot be seen in an illusionistic picture, or which tends to conceal itself, is precisely its own artificiality.

W. J. T. MITCHELL, *ICONOLOGY: IMAGE, TEXT, IDEOLOGY*

We see, then, that images not only refer to *something*, but that they can also show *themselves*. Insight and its refusal, *transparency* and *opacity*, belong to their constitutive properties.

(Wir sehen dann, dass Bilder nicht nur auf *etwas* verweisen, sondern sich dabei auch *selbst* zeigen können, Durchblick und Durchblicks-verweigerung, *Transparenz* und *Opazität*, zu ihren konstitutiven Momentum gehören.)

GOTTFRIED BOEHM, "VOM MEDIUM ZUM BILD"

What are the implications for art history and visual studies of what has been called the "iconic" or "pictorial" turn?[1] What happens when we approach the image as a presentation rather than as a representation, when paintings are ascribed a quasi-mystical existence and life of their own? The consequences of claiming that their status is equal to that of language are profound, for they challenge all our assumptions about the nature of knowledge. Visual objects do not follow linguistic conven-

tions. Unlike words, they do not depend on time to affect our understanding; they do not have to be strung together like pearls on a necklace to make meaning. Where words rely on grammar and word order, visual objects fill our perception in a moment. Images do not make "sense" in ways to which we are accustomed. If they "think," how do we decipher their codes and access their idioms, since, as my very words suggest, all we have are linguistic metaphors?

The development of *Bildwissenschaft* (image science) in Germany in the work of Gottfried Boehm, Hans Belting, and Horst Bredekamp, among others, as well as visual studies in the writing of Tom Mitchell and James Elkins in the United States described in the previous chapter, posits that visual objects possess a heightened autonomy.[2] Images are endowed anew with iconic, even existential, power. Rather than approach them as if they were coded sign systems such as languages, these authors claim that images possess "presence" and even "secondary agency."[3] Visual objects are thus alive and capable of assuming an active role in the life of culture. What roles do they assume in our everyday activities, and why can't we live without them? Such questions imply that images escape history, that they continue to act as cultural agents through time, and that their interest cannot be confined to the context of their original cultural situation or within specific historical horizons.

In this essay I want to put some of these ideas to the test and indulge in something of a thought experiment. How does the notion of the presence of the object fit within the customary parameters of the history of art, a discipline more interested in the historical location of pictures than their continuing effects and affects in the present? If the history of art often catches and freezes images in time, then these ideas promise to let them breathe and share their lives with ours. I want to explore how an alternative to stylistic, iconographic, and iconological analysis might offer something new to our understanding of the paintings of Pieter Bruegel the Elder.

Bruegel studies have been especially preoccupied with determining the cultural meaning that his enigmatic visions may have once had for those who first beheld them. In fact, a historiographic survey indicates that many Bruegel scholars have envisioned their task as above all one of historical reconstruction. They have been preoccupied with understanding the authentic meaning of the work as situated within the historical horizon of which it was once a part. Art historical scholarship in the past century encour-

aged the objectification of visual objects, all the while maintaining a rigorous distance from them in the pursuit of epistemological certainty—in search of what might legitimately and permanently be called knowledge. No doubt the product of these ambitions has been a deeper understanding of the visual symbols and metaphors used to communicate meaning in an age very different from our own. If historical knowledge is its achievement, its failure lies in its tendency to elide, even obscure, the dynamic, moving, and often poetic relation between these pictures and those of us who behold them today.

The visual, of course, has always escaped valiant attempts to capture it in language, in Bruegel's work and everywhere else. Vital as the work of translation must be—given the imperative to make sense of what we see—it often fails to do justice to the infinite potential of visual experience.[4] What is the excess that escapes? In making pictures meaningful, language necessarily restricts their signifying potential. The goal of the interpretive process has always been and probably always will be *transparency*. The struggle of the word with the obduracy of the visual gestures toward what I am calling its *opacity*, its resolute refusal to provide us with what we want or expect.

The distinction between words and images is no argument for the purity of one medium or the other. Just as language cannot operate without metaphors that invoke visuality, the visual depends on language for the very recognition of its autonomous status.[5] What intrigues me here is the tension between an awareness of the physical presence of the visual object, often reductively defined in terms of its form, and the impulse to reduce that awareness to linguistic meaning. Can we walk the tightrope of the distinction between our relation to the object as an object—a phenomenological response to its material existence—and the desire to give it significance, including that which it may never have had? Or must we accept that this distinction is a heuristic tool that often blinds us both to the nature of the encounter and to the quality of the interpretations we place on it? Can we escape Michael Baxandall's conclusion that "what one offers in a description is a representation of thinking about a picture more than a representation of a picture."[6] If description can only be accomplished in retrospect and is, therefore, dependent on memory, every account of the work of art must necessarily be filtered through an individual consciousness and bear the traits of the radical specificity of its author. All the objectifying devices of the history of art, ideas of historical distance and social context, cannot

expel the presence of the contemporary observer from an account of the past. If words will not serve to stabilize meaning on account of their capacity to negotiate the ever-shifting relation between subjects and objects, images will not do so either. Authority lies neither with images nor with words, for both function to subvert the finality of interpretation.

One of Bruegel's earliest and best-known paintings is *The Battle between Carnival and Lent*, dated 1559 (fig. 5.1). Surprising as it may seem given all the chaos and confusion — the apparent anarchy of pictorial form that enlivens the work's surface — most commentators have made prodigious efforts to provide a coherent and consistent account of its subject. Learned authors have sought to look through the work into its inner "depths" in an effort to ascribe it meaning. They tell us, for example, that the religious paintings and sculptures in the church in the background have been covered in accordance with the spirit of penance and mourning with which Lent was observed. Or they identify the costumed figures with themes in popular culture that informed the street theater of the period. Paramount to this project has been the relation of the themes of Carnival and Lent to other treatments of the same subject in literature and the theater, as well as contemporary engravings. The painting has been identified as a picture that represents the folkloric festivities that marked the transition from one moment in the ecclesiastical calendar to another.

More often than not the contrast between Carnival and Lent is discussed in moral terms. According to the values prevalent in Bruegel's time, it is argued, the confrontation of these opposites would have been regarded as a spiritual rejection of indulgence. Yet the painting is also something of a moral puzzle. If the sobriety of Lent is meant to displace the folly of Carnival, then why is she also caricatured? Are the activities of the pious — giving alms and going to church — necessarily to be preferred to those of the revelers at the inn and the costumed figures who fill the street? Carl Stridbeck, for example, went a step further when he argued half a century ago that the combat between the figures of Carnival and Lent possesses particular resonance in the context of the Reformation and the challenge to orthodox ideas. He regards the scene as an allegory of the struggle between Catholics and Lutherans as viewed by an artist who supported neither side and who regarded the entire conflict as misguided.[7] In satirizing the Lutherans as mindless hedonists indulging in drink because of their rejection of the social prescriptions of the Catholic Church, and Catholics for their dedica-

FIGURE 5.1 PIETER BRUEGEL THE ELDER, *THE BATTLE BETWEEN CARNIVAL AND LENT*, 1559. Oil on wood, 118 × 164.5 cm. Kunsthistorisches Museum, Vienna, Inv. 1016. © Kunsthistorisches Museum, Vienna

tion to the observance of ritualistic piety, such as eating fish instead of meat during Lent and the performance of "good works," Stridbeck concludes that Bruegel adopts a distanced and removed stance toward his human subjects.

Is there an art historical alternative to this tradition of finding meaning in Bruegel's paintings? How best to dramatize the continuing presence of the work of art and the creative bond that fuels the writing of the history of art? One way might be to foreground the characteristics of the physical object in question, what art historians tend to call its formal qualities — the way in which the material elements that constitute the surface of the painting have been manipulated. In 1934 Hans Sedlmayr wrote an intriguing essay on Bruegel that develops another approach to understanding the artist that has remained relatively untapped.[8] Sedlmayr invokes the word *macchia*, the Italian term for a *splotch* or *blot* of paint, to describe how Bruegel's forms tend to disintegrate into patches of unmodeled color, preventing their being integrated into the painting's overall lighting scheme:

> Without any activity on our part, simply through steady, passive viewing, and extended attention (and for some viewers immediately), the human figures of typical pictures by Bruegel begin to disintegrate, and fall to pieces and thus to lose their meaning in the usual sense. When this process has reached its peak, one sees instead of figures a multitude of flat, vivid patches with firmly enclosed contours and unified coloration that all seem to lie unconnected and unordered, beside and above each other in a plane at the front of the picture. They are, so to speak, the atoms of the image.[9]

Sedlmayr eventually recuperates these macchia, these passages of non-meaning, for his interpretation of Bruegel's art as a whole, arguing, most imaginatively, that the disjunction between the graphically rendered figures composed of blots and the illusionistically treated landscape backgrounds is intentional. The reduction of human beings to splotches of colored paint, he declares, "is the visual equivalent of spiritual detachment and isolation."[10] According to Sedlmayr, it is a formal means of suggesting their "estrangement": "What is man, when one looks at him 'from without'? A few colored planes with a bizarre contour. As this process continues, however, colors and forms, now emancipated from the sense they once bore, assume an unknown, independent life, exactly as the word emptied of meaning strikes a new and strangely enchanting chord."[11]

What are these "patches" doing here? Why have they not been erased so as to add to the persuasive power of the painting's illusionistic rhetoric? Is Sedlmayr's sensitivity to the abstract qualities of Bruegel's work merely a reflection of the modernist art of his times? If the painting lives in the present as well as the past, then an awareness of the material execution of the work is as much a part of our own response as it was of Sedlmayr's, and perhaps even of Bruegel's, original audience. In calling attention to its facture, the macchia disturb our willingness to go along with the painting's illusionism, they interfere with its "reality effect." The repression of this aspect of our response in the literature suggests that materiality must be ignored if an iconographic or iconological approach is to be pursued; the surface of naturalistic representation must be seamless and smooth if the wheels of interpretation are to function properly. The blots gesture toward what often remains unsaid, namely that the picture is composed of both language and presence. The potential for both meaning and unmeaning in the painting is what allows it to continue to provoke different reactions to its interpretation over the course of time. Sedlmayr was astute to focus on Bruegel's macchia, for these patches of color are the means by which the painting forges an intimate bond with the spectator. It is these blots and this bond that I would like to pursue, postponing for the moment any question of their meaning, while at the same time remaining acutely aware that its resolution cannot be indefinitely deferred.

The fact that all the elements of *The Battle between Carnival and Lent* are not subjected to an overall principle of organization, such as unified perspective or a coherent lighting scheme, affords us untrammeled access to its two-dimensional plane. The cursory quality of the painting's illusionism, its improbable perspective and incoherent lighting, make it hard to suspend disbelief long enough to believe in its fictive reality. The rising ground plane, in which figures are not so much placed behind as on top of one another, with very little overlap or even much diminution in scale from foreground to background, prompts viewers to search for some salient detail that might offer a clue to the painting's subject or tell us where we should be looking. The work does not offer itself up as a whole, but instead as one incident at a time, and it is not always easy to determine the significant incidents from the insignificant. As we scan the work, taking in its multifarious detail, a certain intimacy between object and viewer is forged. We are encouraged to peruse its surface with no guarantee of understanding what we have read.

Unlike a text, there is no system here on which to rely for the transmission of meaning. We cannot look forward to the denouement of a narrative that continually sputters and fails, for there is no assurance that there is a narrative there at all. Significance, apparently embodied in the figures, proves elusive. We are invited into the process of its deferral instead of being offered a resolution. This quality of Bruegel's work might well have been as striking to his contemporaries as it is to us, for he worked at a time when the theories and styles of Italian art were responsible for changing the nature of Flemish painting. Many of Bruegel's fellow artists in Antwerp adopted a pictorial style in which the laws of perspective operated along with chiaroscuro modeling in order to make the content or message of the work as accessible as possible. *The Battle between Carnival and Lent*, however, depends on no such structure. Its component elements are not organized according to any discernible hierarchy. The work solicits interpretive participation and rejects it at the same time.

What accounts for this simultaneous pictorial pull and push? Where lies the meaning in the ambivalent nature of the Bruegel's flatness? The pictorial organization, or lack of it, owes a clear debt to Bruegel's predecessor, Hieronymus Bosch, who was enjoying something of a revival among Antwerp painters of the mid-sixteenth century.[12] Bosch revolutionized Flemish painting by exploiting the traditional two-dimensionality of late-medieval Flemish art in order to replace the Christian narrative that had dominated its surface with a disturbing and highly original vision of humanity. Instead of offering the viewer a transcendental vision of sacred history, his art acts as a mirror on which to display human foibles and failings. In Bosch's painting *The Garden of Earthly Delights*, usually dated about 1510 (fig. 5.2), the surface is covered with figural interest, but the motifs are notoriously devoid of hierarchy, and their meaning continues to be endlessly debated. As Michel de Certeau put it: "The painting both seems to *provoke and frustrate* each one of these interpretative pathways. It not only establishes itself within a *difference* in relation to all meaning; it produces its difference in *making us believe that it contains hidden meaning.*"[13]

In Bosch's case the apparent lack of compositional logic, the enigmatic contrasts of scale, and the odd and incomprehensible acts of human behavior have usually been interpreted as a subversion of the world as it appears in everyday life, evidence that the eerie powers of evil have infiltrated even the most familiar objects in order to invest them with demonic significance.

FIGURE 5.2 HIERONYMUS BOSCH, *THE GARDEN OF EARTHLY DELIGHTS*, CA. 1510. Oil on wood; central panel: 220 × 195 cm; wings: 220 × 97 cm. Museo del Prado, Madrid, Spain, Cat. 2823. © Erich Lessing / Art Resource, NY

Historians working with concepts as varied as heresy, alchemy, astrology, linguistic metaphor, and folklore have argued that these perceptual inversions betray an alternate universe parallel to that we occupy. The springtime garden in which nude figures frolic, apparently free of care, is alleged to be a devastating indictment of the all-too-human capacity to be led astray by the powers of evil. Naturalism is no longer the handmaiden of religion but a pictorial mode that acts as a carnivalesque mirror of the human condition. The *Garden*'s landscape does not serve as the backdrop to a biblical narrative, a device for depicting the human implications of an eschatological narrative, but as a theater in which to exhibit the overwhelming power of forces that have nothing to do with the natural order.[14]

Bruegel manipulates and transforms this visual imagination. He preserves the surface activity of his predecessor and his defiance of perspective, but rather than use these devices to suggest a world gone awry, he dwells upon the world as it is. In *The Battle between Carnival and Lent*, the energy emanating from the costumed figures; the poor and the lame clamoring for alms; market women selling fish; infants playing games; and so forth, lend the work an air of frantic activity of quotidian inconsequentiality. Can the dynamism of the picture's surface be related to its depths, to the allegorical significance claimed for the work by scholars such as Stridbeck? For Stridbeck the figures of the man and woman walking away from the foreground led by another figure clad in the garb of a court fool are the key to an allegory of the folly of the world led astray both by the festivities of Carnival and by the penance of Lent.[15] Despite being intellectually challenging and historically satisfying, this proposal depends on identifying this part of the painted surface as laden with communicable meaning, whereas others parts are attributed no such significance. If the group with the court fool offers us the key to the work, then how are we to understand the wealth of apparently trivial incident with which the picture is filled? What do we make of the woman washing windows and the puppet seated at the window above her? What does the peeling plaster on the corner of the wall beside it have to tell us?

The failure to understand the significance of each incident within the logic of the painting as a whole is a metaphor of what cannot be captured in words. The liveliness of Bruegel's caricatures transcends their location in time and place, calling attention to what images can do and language cannot. The painting's power over the imagination is striking. The to-and-fro

between the picture and our gaze both implies meaning and withholds it. We look at the work, but to our surprise it looks back. Belting remarks that the image lies somewhere between the two: "Media use the surfaces with which they attract our gaze as an opaque screen towards the world. But images originate in our gaze on *this side* of the medium. They do not allow themselves to be situated either 'there' on the canvas or photo or 'here' in the head of the viewer. The gaze reveals images in the interval between 'here' and 'there.'"[16] Rather than attempt to rescue the window washer, the puppet, and the peeling wall for the realm of meaning, instead of forcing them into an interpretation of the painting as a whole, let us allow them, for the sake of this argument, to remain indices of the painting's refusal to participate in the exercise of meaning creation.

The capacity of the image to think for itself, or rather to think in an entirely visual manner that escapes the logical protocols of language, is perhaps best exemplified in images that Mitchell has labeled "metapictures"— pictures that reflect on their own status as pictorial events.[17] Bruegel's picture *Christ Carrying the Cross* (of 1564) offers us a prime example (fig. 5.3). Unlike the townscape in which *The Battle between Carnival and Lent* is set, where the ground appears to rise up the picture plane so as to echo the two-dimensional handling of the figural scene, the narrative of this painting unfolds in a deep landscape whose recession is carefully and illusionistically rendered by means of atmospheric, if not linear, perspective. In this vast expanse, the colors of elements discernible in the distant hills lose their identity in order to meld together into a monochromatic haze of blue and green. Nevertheless, Sedlmayr's observation about Bruegel's "blobs" holds; the colors of the crowd in the middle and foreground, particularly the striking red coats of the mounted soldiers, are not modeled by light and shade. Rather than belong to the logic of their spatial situation, they cling to the surface of the work, insisting on its two-dimensional presence. The result is that the procession of figures that winds its way through the middle ground stands out from its spatial circumstances in a way that ensures that it is the focus of the spectator's attention.

The most important moment in the story, however—Christ falling under the weight of the cross—remains hidden in the multitude. The scale of Christ's figure makes the depicted event, his collapse, just one of the many incidents that agitate the crowd. There is the attempt, for example, by the soldiers to enlist the aid of a bystander, Simon of Cyrene, to lend a helping

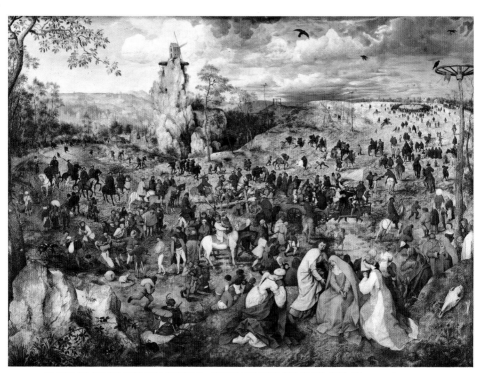

FIGURE 5.3 PIETER BRUEGEL THE ELDER, *CHRIST CARRYING THE CROSS*, 1564. Oil on panel, 124 × 170 cm. © Kunsthistorisches Museum, Vienna

hand with the cross. Far from content at the prospect of playing the role of the Good Samaritan, Simon and his wife struggle fiercely to escape their grasp. And what are we to make of the crowd gathering at the execution site where a man taunts a boy by holding his cap just out of reach, the boy who plays with his dog, or the crows that fly overhead?

The minor key in which the main subject of the work is treated, its comparative unimportance, has often been noted. Critics have contrasted the scale of this crucial incident in Christ's life with that of some figures who dominate the foreground—a group representing the Virgin, St. John the Evangelist, and other followers of Christ's—as they are traditionally depicted in scenes of the Crucifixion. The only actors in the entire composition who seem to be aware of the tragedy taking place in their midst are among this retinue, and their reactions contrast sharply with the largely unfeeling nature of the actions, as well as the vacant expressions on the faces, of the members of the crowd. These holy figures, whose elongated proportions contrast strikingly with those of the rest of the work, belong to an earlier age when devotional images served as powerful substitutes for an absent deity. Their poses, the way in which the Virgin collapses into the arms of John the Evangelist, for example, make the reference to the Crucifixion inescapable. Bruegel's picture thus conflates two moments in Christ's story, the Carrying of the Cross and the Crucifixion—the culminating moment of his Passion. These figures conflate time in another sense as well. Turning toward the viewer, the swooning Virgin suggests that Christ's sacrifice, accessible to our imaginations but otherwise invisible, is not just a historical event but one with implications for the life of the viewer.[18] While the background depicts a specific event in secular time, as Christ traverses space on his way to Golgotha, the figures in the foreground are depicted in the sacred, ever-abiding present.

Art historians have thought long about the fascinating structure of this painting but have tended to place its significance within the context of the sixteenth century.[19] Reindert Falkenburg, for example, has argued that Bruegel's contemporaries perceived the depicted anguish mingled with voyeuristic thoughtlessness as offering a moral choice.[20] Sixteenth-century viewers, he suggests, would have approached the image as one that asked them either to approve or to condemn the incidents that fill the picture. The work is thus attributed a moralizing agenda meant to activate the Christian ethics that governed the lives of its viewers. Compelling as we may find such an

interpretation, an account of the picture's reception in the past takes precedence over a reflection on its capacity to provoke a reaction in the present. To reduce its reception to the historical horizon in which it was executed overlooks the fascination it provokes in our own time — the continuing exchange of looks that marks the encounter between spectator and image. By what means does the work insist on the creation of new meaning as it rolls through time? Art historical writing cannot mortify the work by reducing it to the textual status of history. If it no longer engages our sensations as well as our intellect, we would have no have occasion to speak about it. In the absence of a vital and ongoing engagement with the work in the present, its "work" comes to an end.

The painting consists of a picture within a picture. The holy figures in the right foreground turn toward the spectator, beckoning for his or her attention, while the crowd behind them is preoccupied with its own affairs. The contrast creates a dual effect: the suffering of the Virgin and her companions inevitably colors the response to the activities of the crowd. They are privy to a tragedy of transcendental importance of which the throng is blissfully ignorant. Mitchell argues that works such as these take the viewer's presence before them into account by calling into question their understanding of what is seen. He writes: "Metapictures elicit, not just a double vision, but a double voice, and a double relation between language and visual experience. If every picture only makes sense inside a discursive frame, an 'outside' of descriptive, interpretive language, metapictures call into question the relation of language to image as an inside-outside structure. They interrogate the authority of the speaking subject over the seen image."[21] The interrogation of our spectatorial presence asserts the status of an autonomous visual experience and gestures toward an opacity that cannot be rendered transparent by means of words. Christ's eclipse in the crowd scene, the ignominy of his anonymity, is dramatically transformed by the figures in the foreground who reveal the mystery of his death. They visually suggest that what might be dismissed as the fate of an ordinary man is actually that of a god and insist on the wonder of Christ's dual nature. The visual "work" of the work necessarily escapes words as it reveals what has been hidden. A flash of revelation, more intense than the laborious and mechanical action of words, is the means by which the picture discloses itself.

The painting's discrepant, and even discordant, structure appears to illustrate its transitional status between two distinct regimes of representa-

tion: between the *presentation* of the divine mystery of Christ's life and the *representation* of its significance for the devout viewer, between the emotional immediacy of the Catholic icon and the rationalized morality of the reformed image. If, to return to Falkenburg, the painting offered its original viewers a moral lesson in Christian ethics, one in which, say, Simon's reluctance to help Christ was to be condemned in view of the unfolding tragedy of Christ's death, it also offers the viewer, both then and now, direct access to that event by means of the presence of the Virgin and her entourage. Mary's faint, occasioned by the sight of her crucified son, prompts us to re-create that vision in our mind's eye. The painting collapses time and place to rehearse and indeed to perform the central tragedy of the Christian faith before our very eyes.[22] The image is, at one and the same time, the location where material and spiritual worlds collide and a reflection on the moral significance to be drawn from that confrontation. From one perspective, the picture suggests a chiasmus in which the worshipper sees the deity and is, in turn, seen by him. From another, it becomes a mirror that illustrates the moral failings of the human condition. In one perspective Christ's presence is understood as the eternal reenactment of the drama of salvation; in the other, it is vestigial, a mere reminder of what is missing. Deeply indebted to the structures and assumptions that informed the devotional imagery of the medieval period, it is also animated by the moralizing and secularizing impulses that were expanding and enriching painting's representational potential in the course of the sixteenth century. By evoking rather than instantiating the iconic image of Christ's death, Bruegel also found a means to evade the criticism of devotional images that was rife in a culture marked by the violence of iconoclasm.

If Bruegel's painting *Christ Carrying the Cross* suggests the unique intelligence of pictorial form, with which it continues to provoke intellectual and emotional responses in the present, what happens when we use words to try to capture this visual experience, when we translate what we see into what we say? The painting *The Triumph of Death* (1562–63) can further this discussion. In this work (fig. 5.4), representatives of various classes and occupations in the social hierarchy fill the foreground: from kings and cardinals to aristocrats and pilgrims, they have little to do with the landscape represented behind. In fact, they register as outlined shapes on the surface of the painting, regardless of their locations in illusionistic space. Bruegel has little recourse to foreshortening, and his actors tend either to be depicted in

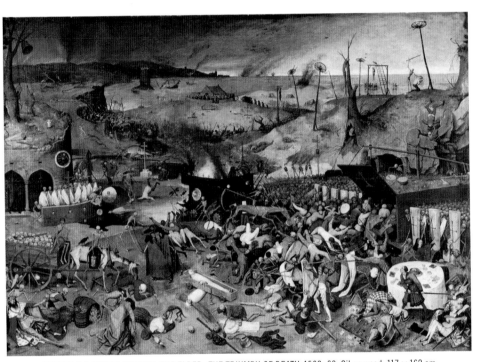

FIGURE 5.4 PIETER BRUEGEL THE ELDER, *THE TRIUMPH OF DEATH*, 1562–63. Oil on wood, 117 × 162 cm. Museo del Prado, Madrid, Spain. © Scala / Art Resource, NY

profile or seen from above so that their actions may more readily be recognized. As in *The Battle between Carnival and Lent*, the absence of perspective plunges us into a wealth of incidents that would escape perception if the principles of either linear or atmospheric perspective had been observed. Our gaze travels the picture surface looking in vain for stasis, for there is no focal point. The picture tells us how to look, or perhaps how not to look, insisting that multiplicity and difference are more important than a single act of comprehension. The work itself demands a restless movement during which incident upon incident proliferates in richly terrifying detail the manifold dimensions of the concept of death.

The oft-used analogy with tapestry comes to mind, for the blasted landscape in the background serves as a mere backdrop to the multifarious actions of the foreground. Here we simultaneously observe scenes that are both amusing and ghastly, morbid and entertaining. Attention skitters across the plane as the observer notes the plight of the king who is robbed of his crown by a skeleton who waves an hourglass before his eyes, and the cardinal overcome by another ghoul who parodies the dignity of his station by wearing an identical hat. These exalted individuals are juxtaposed to a poor woman lying face down on the ground where she has dropped her distaff and spindle, while another, her baby still clutched in her arms, is powerless to save it from the emaciated dog who licks the child's face. Contrasts of horror and amusement sometimes come fast and furious. The individual fate of the pilgrim having his throat slit takes place alongside of a grim manifestation of the universal power of death: a panicking crowd flees the onslaught of the grim reaper by rushing into an open coffin. The failure of privilege to stave off the inevitability of death is illustrated by the interrupted dinner party. Here the aristocratic members of the company draw swords in a futile attempt to defend themselves, while a skeleton dressed as a court fool (replacing the one who takes refuge under the table) brings a ghastly dish of skull and bones to the feast. The tender moment shared by the young couple playing music together, unaware of the pandemonium that goes on around them, is mocked by the skeleton who accompanies them on a stringed instrument.

The incidents that fill the foreground, the description of the death of classes and callings, are enhanced by the desolate landscape in the background. Armies of skeletons clash with the living, and men and women are hunted like wild animals. Figures of death celebrate their mastery of

the panorama while buildings burn and ships sink on the horizon. Their spindly forms gesticulate and grimace their way across the surface as they wreak havoc on human beings. Their antics draw smiles at exactly those moments when their activities appear most sinister. Mockery and parody of the powerful are mingled with the suffering they inflict on the poor—so perfectly are we caught off guard between amusement and horror. Just as the plethora of incidents cannot be hierarchized, the sensations aroused by the painting do not cohere.

But does my description actually translate something in the picture before us? Have I found apposite words with which to render the visual into the linguistic? Does ekphrasis bring the work closer or simply push it further away? Can we escape Baxandall's conclusion that words and images belong to different orders and that one can never successfully be mapped on the other? What do the theorists of ekphrasis have to say?[23] Some insist that while the distinction between words and images can never be overcome, ekphrasis is the only means we have to bring them into a productive proximity to one another. Boehm writes:

> Every good ekphrasis possesses the moment of self-transparency: it refuses to puff itself up with linguistic pride, but makes itself transparent with regard to the image. . . . They [ekphrases] should not only describe the recognizable—that which we already knew. We would not regard as insightful that which merely confirms the context of our experience, because insight means to know more, to know other things, and to know otherwise. It holds itself open so that the visual otherness of the image, to which it calls attention, always remains in view.[24]

On this view, description does not simply assign meaning to what escapes its grasp, but acts as a means of making us understand the process by which visual meaning is made. It corresponds with an observation of Joseph Koerner's, who writes: "Rather than saying *what* a visual image means, description tells us *how* an image has opened itself up to an interpretation."[25]

Mitchell, on the other hand, maintains that there is no essential difference between words and images and that both are capable of the kind of description we associate with the idea of ekphrasis. He claims that "ekphrastic hope," the belief that words make contact with the images they describe, depends on a desire to overcome their "otherness," while "ekphrastic fear" depends on the assertion of an unwarranted metaphysical difference between

the linguistic and the visual. He advocates what he calls "ekphrastic indifference," a position that subscribes to neither of the above but insists that description has a social function, that it transcends the phenomenological relation between subject and object by means of its relation to the reader. Addressing the reader must, of course, be textual rather than visual, and he admits: "Ekphrastic indifference maintains itself in the face of disquieting signs that ekphrasis may be far from trivial and that, if it is only a sham or illusion, it is one which, like ideology itself, must be worked through."[26]

Lawrence Venuti argues that ekphrasis is like translation in that it involves a process of decontextualization and recontextualization. Just as a translation tears a text out of one context and places it in another, the attempt to render the visual into the textual involves a radical transformation: "Translating rewrites a source text in terms that are intelligible and interesting to receptors, situating it in different patterns of language use, in different literary traditions, in different cultural values, in different social institutions, and often in a different historical moment."[27] The change of medium moves the wordless poetry of the image into one where its nature can find no equivalent.

One of the most insightful accounts of ekphrasis, and one that perhaps explains its ubiquitous use in the discipline of art history, is that offered by Murray Krieger. He suggests that the fascination of ekphrasis lies in the power not just to describe images but to create them. Words may slide past images as they describe them, but they create new images in the minds of those who read them: "The Western imagination . . . has sought . . . to comprehend the simultaneity, in the verbal figure, of fixity and flow, of an image at once grasped and yet slipping away through the crevices of language. This sense of simultaneity is sponsored by our capacity to respond to the verbal image as at once limitedly referential and mysteriously self-substantial."[28]

Aware that our words are responsible for constructing images out of images and translating pictures into more pictures, is meaning only a function of language? Is there a role for the image in its creation? According to Boehm, the structure of the image is itself a participant in the creation of meaning. He calls attention to the back or underside of painting. Figure and ground lie in a creative tension: the determined and defined are played off the undetermined and undefined in the imaginative construction of significance. Figure and ground work together to give the impression that images work as if they were language:

It is thus the iconic difference in which an "impossible" synthesis occurs, in which the thematic focus and an indeterminate field are transformed into a tension-filled relationship. The facticity of the material is metamorphosed into actual affects—into meaning. This is only possible when the ground *itself* can be experienced as a vehicle of *energy*. This is what we identified as the potential contained in uncertainty. . . . In it [the image], the object is transformed into the imaginary, creating that surplus of meaning that allows mere material (color, mortar, canvas, glass, etc.) to appear as a meaningful opinion.[29]

My own description of Bruegel's painting has explored the space that exists between the work's facticity, its painted surface, and that which is invisible or potentially behind it in order to transform material into meaning by way of the imagination. I have followed the artist's invitation to read the work as its illusionistic conventions demand, but I have also been acutely aware of the limits placed on the meaning created by this process—what Boehm calls the "indeterminate" quality of iconic logic. Translating the potential of the image into meaning is what ekphrasis does; it is both its enduring contribution and its fatal curse. As description attempts to bring the image to life before our eyes, it also blinds us to it, substituting a text for the image and an author for the artist. Ekphrasis, or description, is what remains when the meaning of what we see eludes us.

Bruegel's picture recedes before my eyes in a fog of words. It seems more opaque now than it did before I began. The discrepant sensations and mixed emotions aroused by the painting, in whose description language both succeeds and fails, manifest the visual power of the work, its capacity to insist on "iconic difference."[30] The multiplicity of motifs, the cascade of disturbing yet comic events, enhances the impression that the work surrounds us. The triumph of death takes place not only before our eyes but around and behind us as well. Not only is the message of the painting laid out for deliberate contemplation, but it also engulfs us in its disconcerting embrace. Linear time, the time of logic and language, is upset by the action of the visual.

One last example makes my point more emphatically. Archival research and much scholarly effort has established that Bruegel's painting known as *The Return of the Hunters* (1565) illustrates December and January as part of a series representing the months of the year (fig. 5.5).[31] His treatment of the subject owes much to the iconography of the seasons in illuminated manu-

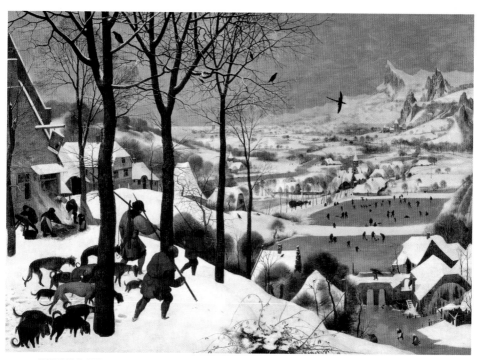

FIGURE 5.5 PIETER BRUEGEL THE ELDER, *THE RETURN OF THE HUNTERS*, 1565. Oil on panel, 117 × 162 cm. © Kunsthistorisches Museum, Vienna.

scripts of the fifteenth and sixteenth centuries. The scene on the left, for example, in which the bristles are being singed off a pig after it has been killed in preparation for butchering, is a motif that allows the work to be identified with the representation of mid-winter. The transition from manuscript page to full-size picture, however, also transforms the content. The identification of the scene as December and January does little, however, to account for the work's pictorial interest.

Many imaginative attempts have been made to find words that might convey what it is that we see. The temptation to engage in description is as irresistible as it is doomed to fail. The return of the hunters down the snowy hill in the foreground, back from stalking their quarry, echoes the concerns of those who busy themselves with the pig. The bite of winter in an age before coal, oil, or gas heating, in a world that had little access to food supplies other than what was produced locally, is something we can only imagine. Beyond the hunters, however, the painting takes on a holiday atmosphere. Here the cold has turned the landscape into a source of entertainment. People of all ages take to the ice, seeking to exploit nature's rigor in the pursuit of pleasure. Children with tops share the ice with adults soberly judging the results of a curling competition, while behind them skaters belonging to a spectrum of different abilities demonstrate their skills, or lack of them. A husband pulls his wife along while their child looks on; boys race each other across the ice; and competent skaters display their grace while the unlucky come to a crashing halt. In the distance the wintry theme is emphasized by neighbors rushing to the aid of someone whose chimney has caught fire.

This is about as far as we get if we take the work's naturalism at face value — if we reduce the presence of the image to its reality effects. The limits of ekphrasis, the product of our desire to use language to mesh with the structure of the image itself, becomes evident as the chasm between words and what they attempt to describe yawns before us. The picture itself, however, militates against the limitations of descriptive language by insisting that we go further. The deep landscape in which atmospheric perspective reduces colors to gray and white contrasts with the two-dimensional treatment of the figures in the foreground. The hunters make their way across the foreground rather than down the hill that they purportedly descend. The lack of modeling in light and shade means that their shapes remain firmly fixed to the surface of the picture instead of being enveloped in its illusionistic space. Contrasting with the snowy surface, their silhouettes call for our

attention, while the trees through which they wander do their unconvincing best to suggest a perspective view into the painting's depth.

Perhaps it is the presence of the crows that tells us most about the opacity of Bruegel's art. The crows sitting in the trees dispassionately observing the inscrutable activities of the humans below them, while a solitary magpie wings its way across the scene, echo the haphazard and quotidian nature of the narrative vignettes spread across the surface of the picture. What are these birds doing there? What purpose do they serve other than to insist on the work's insouciant visuality? In a thoughtful meditation on the relation between words and images, Mitchell concludes: "Perhaps the redemption of the imagination lies in accepting the fact that we create much of our world out of the dialogue between verbal and pictorial representations, and that our task is not to renounce this dialogue in favor of a direct assault on nature but to see that nature already informs both sides of the conversation."[32]

The tension between human beings and the circumstances in which they find themselves becomes one of the picture's themes. The hunters both belong and do not belong to the landscape in which they find themselves, just as we do and do not belong in the painting's presence. In this case the bond between picture and viewer depends on the weight of phenomenological experience. We cannot but remember (or try to imagine) the cold of a wintry day as we come face-to-face with an illusion that foregoes its power to narrate. The two-dimensionality of the figures echoes the flatness of the picture plane in such a way as to send the imagination spinning. In the contrast between the *presence* of the painted surface and the illusionary space it *represents* lies the painting's intimacy, its power to fascinate and elude, to engage, and to defy interpretation. The unmistakable evidence that the painting is an object, that its capacity for illusion is limited by our desire to believe in it, suggests that if the painting has a time, it lies not in its nonexistent narrative so much as in its capacity to provoke a response in the observer. In doing so it asserts that its presence belongs as much to the present as to the past.

Attending to the presence of the visual dramatizes the distance that separates word from image. Is this all that pictures want? Mitchell clearly believes that images want to be recognized for what they are, namely entities that cannot be confined by or reduced to language: "What pictures want in the last instance, then, is simply to be asked what they want, with the

understanding that the answer may well be, nothing at all."[33] More challeng-ingly, Mark Jarzombek questions the ideological function of ekphrasis as a humanistic enterprise. What is the fascination of these doomed attempts to reduce one medium to another, the visual into the textual?

> Is the vivid experience the functional center of a transient, intersubjec-tive truth, or is it merely a dubious flirtation in a narcissistic discourse? Is this hectic search for immediacy an immunity against dangerous meta-physical bewitchments or is it the actual disease? Is it a protection against alienation or is it a representation of this very alienation? And, finally, is it a celebration of the human significance of art or is it a circularly con-structed and self-flattering performance of humanism on its self-flattering stage?[34]

While these questions are aimed at what Jarzombek calls "aesthetic experi-entialism," they contain a critique of a phenomenological insistence on the ontological presence of the image. Their very ambivalence, however, indi-cates the importance of temporality in the work of interpretation. The rec-ognition of the "now," the historicity of the moment of understanding, af-fords insight into the ideological values that color that process and serve to remind us that it is never-ending.

An appreciation of the lack of congruence between the verbal and the visual does not therefore mean that we must abandon the rich and varied in-terpretive strategies developed to understand the world of images. Far from canceling or obviating the need for words, the recognition that visuality and language are inextricably entwined but never coincide indicates that we des-perately need all the powers of language — analytic and poetic — to explore the inexhaustible potential of their incommensurability.

Attending to the presence of the image makes us aware of the play, the to-and-fro between object and subject, past and present, that consti-tutes the very ground of meaning. It serves to lay bare the mechanisms on which meaning depends. There are some words in Jacques Lacan's *The Four Fundamental Concepts of Psychoanalysis* that might help me come to some kind of conclusion (in full recognition of the irony of uttering such a note of finality), especially with this snowy scene (and its crows) still fixed in the imagination. In this brief passage, Lacan speaks of Maurice Merleau-Ponty's phenomenological project of putting the eye back in touch with the

mind. Referring to Cézanne, he asks: "What occurs as these strokes, which go to make up the miracle of the picture, fall like rain from the painter's brush is not choice, but something else. Can we not try to formulate what that something else is?"[35] In this essay I have encouraged the pictorial rain to keep falling by resisting the interpretive urge to freeze the visuality of Bruegel's paintings into yet another triumphant declaration of iconographic or iconological meaning. Difficult as it is to keep the visual specificity of this art alive, free from the ice that clings to words predicated on the promise of transparency, I have tried to follow the lead of some contemporary theorists of the image, to restore a certain opacity to Bruegel's art. Pointing to the deep, slightly forbidding blackness of the cutout crows flitting across his landscapes, flying everywhere and nowhere, is the best that I can do. The presence of the crows that live as much *on* as *in* the illusionistic landscape before us serves as a reminder of the role of the image as an agent of historical interpretation.

NOTES

1. See Gottfried Boehm, "Die Wiederkehr der Bilder," in *Was ist ein Bild?*, edited by Gottfried Boehm, 11–38 (Munich: Fink, 1994), and W. J. T. Mitchell, "The Pictorial Turn," in *Picture Theory: Essays on Verbal and Visual Representation*, 11–34 (Chicago: University of Chicago Press, 1994). The concepts are discussed at length in chapter 4.

2. Gottfried Boehm, ed., *Was ist ein Bild?* (Munich: W. Fink, 1994); Hans Belting, *Bild-Anthropologie: Entwürfe für eine Bildwissenschaft* (Munich: W. Fink, 2001); Horst Bredekamp, *Darwins Korallen: Die frühen Evolutionsdiagramme und die Tradition der Naturgeschichte* (Berlin: Wagenbach, 2005); Horst Bredekamp, *Theorie des Bildakts* (Berlin: Suhrkamp, 2010); Mitchell, *Picture Theory*; W. J. T. Mitchell, *What Do Pictures Want? The Lives and Loves of Images* (Chicago: University of Chicago Press, 2005); James Elkins, *The Domain of Images* (Ithaca: Cornell University Press, 1999); James Elkins, *On Pictures and the Words That Fail Them* (Cambridge: Cambridge University Press, 1998).

3. The term *secondary agency* was introduced by Alfred Gell in *Art and Agency: An Anthropological Theory* (Oxford: Clarendon, 1998), 17.

4. See, for example, Nelson Goodman, *Languages of Art: An Approach to a Theory of Symbols* (Indianapolis, Ind.: Bobbs-Merrill, 1968); Michael Baxandall, *Patterns of Intention: On the Historical Explanation of Pictures* (New Haven: Yale University Press, 1985); W. J. T. Mitchell, *Iconology: Image, Text, Ideology* (Chicago: University of Chicago Press, 1986); Michael Ann Holly, "Telling a Picture," in *Past Looking: Historical Imagination and the Rhetoric of the Image*, 1–28 (Ithaca: Cornell University Press, 1996); Boehm, *Was ist ein Bild?*; Gottfried Boehm, *Wie Bilder Sinn erzeugen:*

Die Macht des Zeigens (Berlin: Berlin University Press, 2007); Elkins, *On Pictures and the Words That Fail Them*.

5. Mitchell, *Iconology*; W. J. T. Mitchell, "'Ut Pictura Theoria': Abstract Painting and the Repression of Language," *Critical Inquiry* 15, no. 2 (1989): 348–71.

6. Baxandall, *Patterns of Intention*, 5.

7. Carl Stridbeck, "'Combat between Carnival and Lent,' by Pieter Bruegel the Elder: An Allegorical Picture of the Sixteenth Century," *Journal of the Warburg and Courtauld Institutes* 19, nos. 1–2 (1956): 96–109.

8. Hans Sedlmayr, "Bruegel's *Macchia*" (1934), translated by Frederic Schwartz, in *The Vienna School Reader: Politics and Art Historical Method in the 1930s*, edited by Christopher Wood, 323–76 (New York: Zone Books, 2000). For another attempt to articulate a phenomenological response to Bruegel's art, see Edward Snow, *Inside Bruegel: The Play of Images in Children's Games* (New York: Farrar, Straus and Giroux, 1997). The two-dimensionality of Bruegel's handling of color was noted long ago by Adrian Stokes. See *The Critical Writings of Adrian Stokes*, vol. 2 (1937–58), edited by Lawrence Gowing (London: Thames and Hudson, 1978), 68–73.

9. Sedlmayr, "Bruegel's *Macchia*," 325.

10. Sedlmayr, "Bruegel's *Macchia*," 331.

11. Sedlmayr, "Bruegel's *Macchia*," 343.

12. See Gerd Unverfehrt, *Hieronymus Bosch: Die Rezeption seiner Kunst im frühen 16. Jahrhundert* (Berlin: Mann, 1980).

13. Michel de Certeau, *The Mystic Fable: The Sixteenth and Seventeenth Centuries*, translated by Michael Smith, vol. 1 (Chicago: University of Chicago Press, 1992), 51.

14. See most recently Joseph Koerner, "Impossible Objects: Bosch's Realism," RES: *Anthropology and Aesthetics* 46 (2004): 73–97; Joseph Koerner, "Wirklichkeit bei Hieronymus Bosch," in *Realität und Projektion in Antike und Mittelalter*, edited by Peter Schmidt and Martin Büchsel, 227–38 (Berlin: Mann, 2005). Needless to say the dual nature of Bosch's enigmatic pictorial signs, their capacity to draw attention to the artist's powers of imagination, his creative skill, as well as to pique our interest by implying a hidden order where none exists, has drawn the attention of scholars. See de Certeau, *The Mystic Fable*; Keith Moxey, "Making Genius," *The Practice of Theory: Poststructuralism, Cultural Politics, and Art History* (Ithaca: Cornell University Press, 1994), 111–47; Hans Belting, *Hieronymus Bosch: Garden of Earthly Delights*, translated by Ishbel Flett (Munich: Prestel, 2002).

15. Stridbeck, "'Combat between Carnival and Lent,' by Pieter Bruegel the Elder." Stridbeck's conception of Bruegel as a distant and removed observer of the "human theater" has a venerable history as well as contemporary resonance. See Joseph Koerner, "Unmasking the World: Bruegel's Ethnography," *Common Knowledge* 10, no. 2 (2004): 220–51.

16. Hans Belting, "Blickwechsel mit Bildern: Die Bildfrage als Körperfrage," in *Bilderfragen: Die Bildwissenschaften im Aufbruch*, edited by Hans Belting (Munich: W. Fink, 2007), 59. "Mit ihren Oberflächen, die unseren Blick auf sich ziehen,

schieben sich Medien wie ein opaker Bildschirm vor die Welt. Aber Bilder entstehen *diesseits* des Mediums, in unseren Blick. Sie lassen sich weder allein 'dort,' auf Leinwand oder Foto, noch 'hier' im Kopf des Betrachters verorten. Der Blick erzeugt die Bilder im Intervall zwischen 'hier' und 'dort.'"

17. Mitchell, *Picture Theory*. Mitchell's idea corresponds with Louis Marin's distinction between images that exhibit a "transitive transparence" in presenting narratives straightforwardly, and those that are marked by a "reflexive opacity," which calls attention to their role in the representation of narrative. *On Representation*, translated by Catherine Porter (Stanford: Stanford University Press, 2001), 380–81.

18. The importance of this juxtaposition was brought home to me by the late Philip de Simone.

19. See, for example, Mark Meadow, "Bruegel's *Procession to Calvary*, Aemulatio and the Space of Vernacular Style," *Nederlands Kunsthistorisch Jaarboek* 47 (1996): 181–205. For the concealment of Bruegel's subjects as a moralizing device that depends on the viewer's engagement with the foreground-background structure of his pictures, see Kenneth Lindsay and Bernard Huppé, "Meaning and Method in Bruegel's Painting," *Journal of Aesthetics and Art Criticism* 14, no. 4 (1956): 376–86. For its use for this purpose in this particular painting, see Catharina Kahane, "Das Kreuz mit der Distanz: Passion und Landschaft in Pieter Bruegels Wiener Kreuztragung," in *Gesichter der Haut*, edited by Christoph Geissmar-Brandi, Irmela Hijiya-Kirschnereit, and Satô Naoki, 189–211 (Frankfurt: Stroemfeld, 2002).

20. Reindert Falkenburg, "Pieter Bruegels *Kruisdraging*: Een proeve van 'close reading,'" *Oud Holland* 107, no. 1 (1993): 17–33.

21. Mitchell, *Picture Theory*, 68.

22. For a history of the transformations that led from devotional to aesthetic imagery in European painting see Hans Belting, *Likeness and Presence: A History of the Image before the Era of Art*, translated by Edmund Jephcott (Chicago: University of Chicago Press, 1994). See also Bruno Latour, "Opening One Eye while Closing the Other . . . a Note on Some Religious Paintings," in *Picturing Power: Visual Depictions and Social Relations*, edited by Gordon Fyfe and John Law, 15–38 (London: Routledge, 1988). Joseph Gregory addresses the transitional nature of Bruegel's picture in "Towards the Contextualization of Pieter Bruegel's *Procession to Calvary*: Constructing the Beholder from within the Eyckian Tradition," *Nederlands Kunsthistorisch Jaarboek* 47 (1996): 207–21.

23. For a recent assertion of the central importance of ekphrasis for art history as a discipline, see Jaś Elsner, "Art History as Ekphrasis," *Art History* 33, no. 1 (2010): 10–27. James Elkins offers a thoughtful reflection on the variety of ways in which the linguistic fails the visible in "The Unrepresentable, the Unpicturable, the Inconceivable, the Unseeable," in *On Pictures and the Words That Fail Them*, 241–66, while Gary Shapiro sketches a history of thinking about the text-image relation in "The Absent Image: Ekphrasis and the 'Infinite Relation,'" *Journal of Visual Culture* 6, no. 1 (2007): 13–24. Recent discussions of literary ekphrasis include James Hef-

fernan, *Museum of Words: The Poetry of Ekphrasis from Homer to Ashbery* (Chicago: University of Chicago Press, 1993); James Heffernan, "Ekphrasis and Representation," *New Literary History* 22 (1991): 297–316; James Heffernan, "Speaking for Pictures: The Rhetoric of Art Criticism," in *Cultivating Picturacy: Visual Art and Verbal Interventions*, 39–68 (Waco, Texas: Baylor University Press, 2006).

24. Gottfried Boehm, "Bildbeschreibung: Über die Grenzen von Bild und Sprache," in *Beschreibungskunst — Kunstbeschreibung: Ekphrasis von der Antike bis zur Gegenwart*, edited by Gottfried Boehm, 23–40 (Munich: W. Fink, 1995), 40. "Jede gute Ekphrasis besitzt das Moment der Selbsttransparenz: sie bläht sich in ihrer sprachlichen Pracht nicht auf, sondern macht sich durchsichtig in Hinblick auf das Bild. . . . Sie sollen nicht nur das Wiedererkennbare schildern, solches, das wir schon gewusst haben. Was den Umkreis unser Erfahrungen lediglich bestätigte, wurden wir nicht Erkenntnis nennen. Denn erkennen heisst: mehr erkennen, anderes und anders erkennen. Es hält sich offen, dabei bleibt die visuelle Andersheit des Bildes, die sich zeigt, stehts im Bild."

25. Joseph Koerner, *The Moment of Self-Portraiture in German Renaissance Art* (Chicago: University of Chicago Press, 1993), 277.

26. W. J. T. Mitchell, "Ekphrasis and the Other," in *Picture Theory*, 151–81, 163.

27. Lawrence Venuti, "Ekphrasis, Translation, Critique," *Art in Translation* 2 (2010): 139. For a critical analysis of poetic ekphrases of Bruegel's paintings, see Heffernan, *Museum of Words*, 146–69; Wendy Steiner, *The Colors of Rhetoric: Problems in the Relation between Modern Literature and Painting* (Chicago: University of Chicago Press, 1982), 75–90.

28. Murray Krieger, *Ekphrasis: The Illusion of the Natural Sign* (Baltimore: Johns Hopkins University Press, 1992), 11. For the idea that description makes images out of images, see also Louis Marin, "La description de l'image," *Communications* 15 (1970): 186–209.

29. Gottfried Boehm, "Unbestimmtheit: Zur Logik des Bildes," in *Wie Bilder Sinn erzeugen*, 199–212, 211. "Es ist also die ikonische Differenz, in der sich eine 'unmögliche' Synthese ereignet, in der in thematischer Fokus und unbestimmtes Feld in die Form einer spannungsvollen Beziehung versetzt warden. In ihr verwandelt sich die Faktizität des Materiellen in den Prozess aktueller Wirkungen, in Sinn. Dies ist nur möglich, wenn der Grund *selbst* als Träger von *Energie* erfahren warden kann. Wir haben sie in jenem Potential identifiziert, das der Unbestimmtheit innewohnt. . . . In ihr wandelt sich das Faktische ins Imaginäre, ensteht jener Überschuss an Sinn, der blosses Material (Farbe, Mörtel, Leinwand, Glas usw.) als eine bedeutungsvolle Ansicht erscheinen lässt."

30. Boehm, "Die Wiederkehr der Bilder," 29–36.

31. Iain Buchanan, "The Collection of Niclaes Jonghelinck: II. The 'Months' by Pieter Bruegel the Elder," *Burlington Magazine* 132 (1990): 541–50. For the interpretation of the painting as a moralizing statement structured by hidden religious allusions, see Reindert Falkenburg, "Pieter Bruegel's Series of the Seasons: On the Perception of

Divine Order," in *Liber Amicorum Raphaël de Smedt*, vol. 2, *Artium Historia*, edited by Joost van der Auwera, 253–76 (Louvain: Peeters, 2001).

32. Mitchell, *Iconology*, 46.

33. Mitchell, *What Do Pictures Want?*, 48.

34. Mark Jarzombek, "De-scribing the Language of Looking: Wölfflin and the History of Aesthetic Experientialism," *Assemblage* 23 (1994): 54.

35. Jacques Lacan, *The Four Fundamental Concepts of Psychoanalysis*, edited by Jacques-Alain Miller, translated by Alan Sheridan (New York: Norton, 1981), 114. I thank Michael Holly for calling my attention to this passage.

MIMESIS AND ICONOCLASM

To represent signifies to present oneself as representing something, and every representation, every sign or representational process, includes a dual dimension—a reflexive dimension, presenting oneself; a transitive dimension, representing something—a dual effect—the subject effect and the object effect.

LOUIS MARIN, "MIMESIS AND DESCRIPTION"

The image is not the expression of a code, it is the variation of a work of codification: it is not the repository of a system but the generation of systems.

ROLAND BARTHES, "IS PAINTING A LANGUAGE?"

Mimesis: that unending record of our continuing beguilement with the appearance of the world around us. Why have artists throughout the ages striven to capture the enduring poetry and power of what we call reality? What is the abiding need to find pictorial means to capture the fleeting appearance and transient sensations that constitute perceptual experience? Such questions raise deep and enduring philosophical issues. How do we relate to the world that appears to preexist and surround us? To what extent is that world distinct from our involvement in it? Can we separate ourselves enough from its embrace to know it with any degree of objectivity? What is the nature of our en-

tanglement with objects—found or created? Do we give them life by developing ways to value and understand them, or do they call us into being? Who ventriloquizes whom? Do we make objects talk by speaking for and representing them, or do they prompt and shape responses to their presence? Why, once again, try to articulate the fascination held by the mimetic encounter?[1] This chapter addresses the complex transactions inaugurated between the work of art and its beholder, both now and in the past. With Hans Holbein's portraits as its anchor, the purpose of this exercise is twofold: to confront the poetic appeal of this sixteenth-century German artist's skills at capturing the qualities of perception and to address the role that his portraits, with their intense observations of the texture of everyday life, might have played in an age in which the Reformation engendered a deep suspicion and open hostility to the traditional functions of late-medieval naturalism.

Instead of looking at the ideological agendas inscribed in the material fabric of the image, and rather than analyzing the ways that the apparently transparent surface of the illusionistic rhetoric of Renaissance painting serves both to articulate and to conceal the interests of those responsible for its creation, I want to look at the other side of the mimetic impulse: stepping through the looking glass, as it were, so as to consider its reception as much as its production. Holbein's painstaking negotiations with the real have a continuing interest that matches that which it held for those who first witnessed his pictures. There is a hauntingly affective dimension to his portraits in the way in which they address us, as much as we address them. The searing quality of their realism makes us ponder the very nature of mimesis. Where does the agency of the mimetic image lie: in its capacity to record experience in such a way as to trigger involuntary memory, in its power to create an entirely new experience—a substitute for the "real" thing—or in its ability to do both at the same time? I will argue that Holbein's mimesis contains an unconscious dimension whose eruption in what is perhaps his most famous painting, *The Ambassadors* (1533), offers us insight into the preternatural sense of presence with which his portraits continue to beguile us.

I begin this reflection on the paintings of Holbein by going backward in time—by first looking at the way the concept of mimesis is being interrogated by contemporary artists. Consider two photographs by the German artist Thomas Demand, *Window*, 1998, and *Glass*, 2002 (figs. 6.1 and 6.2).[2]

Neither of these photographs is taken of their titular objects; that is, they do not record the actual appearance of either a window or a pane of glass, but rather they are trick photographs of carefully constructed paper and cardboard models that resemble a shaded window and a piece of broken glass. Nothing in these photographs serves a referential function. The link between the most indexical of artistic media and the world to which it was once thought to be attached has been deliberately broken.

Photography has been susceptible to such manipulation since its invention, but Demand has methodically called into question assumptions about the immediacy and reliability of perception, so often regarded as the medium's quintessential characteristics. His pictures also constitute an assault on the Renaissance idea of perspective—literally representation's capacity to look through a window onto the world. Not only is Demand's window obscured by drawn blinds, but the glass is opaque. The traditional theory of mimetic representation that identifies it with the imitation of nature—so important for Holbein's reception, as well as his self-understanding—is confronted with evidence of its inadequacy. If lifelike effects can be constructed, then the game of mimesis no longer requires the imitation of nature—the rules have been changed. While these photographs do not depend on objects in the real world for their existence, the fact that they resemble such objects suggests that there might be a connection after all. What is it about our experience of the world that continues to intrigue us even when we look at representations of that world that we know have been artfully fabricated?

Holbein's work, and its status as one of the greatest documents of the mimetic impulse in Western art, has drawn the attention of several other contemporary photographers impressed with both his fact and his fiction: his apparent record of the real and the means by which he persuades us of its authenticity. The Japanese photographer Hiroshi Sugimoto, for example, has executed a series of works that refer to Holbein's paintings, but which do so indirectly (figs. 6.3 and 6.4).[3] Rather than photograph Holbein's pictures, Sugimoto photographed the waxworks based on Holbein's paintings in Madame Tussauds museum in London. These figures are deeply indebted to Holbein's characterizations of physiognomy and costume, but they alter his poses so as to suggest animation. Instead of being posed frontally or in three-quarter profile as in Holbein's portraits, the effigies assume

FIGURE 6.1 THOMAS DEMAND, *WINDOW*, 1998. Chromogenic print on Diasec, 183 × 286.5 cm. Private collection. © Artist Rights Society (ARS), New York / VG-Bild Kunst, Bonn

casual attitudes that make them appear to be in the midst of action. Sugimoto's photographs use the referential traditions associated with photography — its links to documentation and the archive — to capture the quality of Holbein's mimesis at one remove. The wax figures allow him to add life to Holbein's canonical documents of the life of his own time, thus animating images usually considered inert. Reversing Roland Barthes's conclusion that photography is the ally of death, a medium that mortifies the living by arresting their movement, Sugimoto's achievement lies in bringing at least their effigies to life.[4]

Cindy Sherman's history portraits series, based mainly on Italian Renaissance prototypes but whose quotations are often generic, also betrays a fascination with Holbein's reputation as a master of mimesis (fig. 6.5). The American artist has photographed herself in the guise of the sitters from some of the most famous portraits of the past. Transparently fake, her disguises serve not so much to conceal her identity as to reveal it. By inserting herself into these works, Sherman simultaneously mocks their canonical status and their extraordinary verisimilitude. These venerable objects of the

FIGURE 6.2 THOMAS DEMAND, *GLASS*, 2002. Chromogenic print on Diasec, 58 × 40 cm. Private collection. © Artist Rights Society (ARS), New York / VG-Bild Kunst, Bonn

art historical tradition become the objects of well-aimed parodies. Unlike Sugimoto, whose photographs of waxworks serve to endow Holbein's practice of mimesis with uncanny life, Sherman uses her chameleon powers of impersonation to reduce the canon to a series of fancy dress costumes.[5]

The work of these contemporary artists, who both admire and ridicule Holbein's mimetic achievement, encourages us to see and think about his

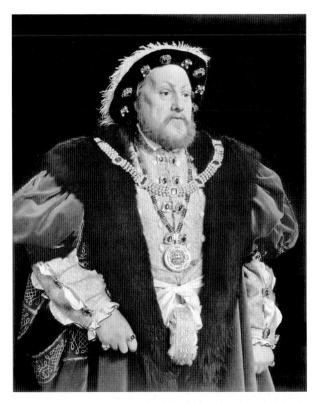

FIGURE 6.3 HIROSHI
SUGIMOTO, *HENRY VIII*,
1999. Gelatin silver print,
58¾ × 47 in. (149.2 ×
119.3 cm). Photograph
courtesy the artist and
The Pace Gallery.
© Hiroshi Sugimoto.

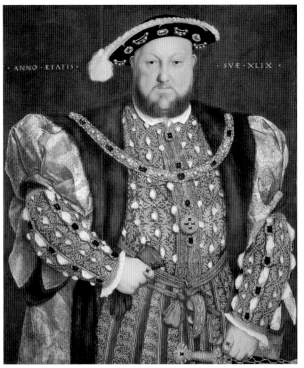

FIGURE 6.4 CIRCLE
OF HANS HOLBEIN
THE YOUNGER (1497–
1543), *PORTRAIT
OF HENRY VIII OF
ENGLAND*, 1540.
Galleria Nazionale d'Art
Antica, Rome, Italy.
© Scala / Ministero
per i Beni e le Attività
culturali / Art Resource,
NY

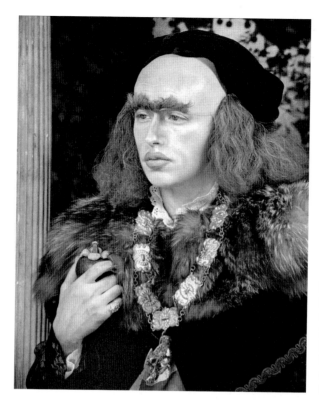

FIGURE 6.5 CINDY
SHERMAN, *UNTITLED*
#213, 1989. Color
photograph, 41½ × 33
in. (105.41 × 83.82 cm).
Edition 1/6. Courtesy
of the artist and Metro
Pictures

paintings anew. What is it about his art that prompts this kind of response? The art historical literature on the artist tends to emphasize the reception of his paintings in the historical horizon in which he lived. Recent studies, such as those of Oskar Bätschmann and Pascal Griener, or even Mark Roskill and Craig Harbison, use the historical record to emphasize the role Pliny the Elder's praise of Apelles played in his *Natural History*.[6] These authors argue, quite convincingly, that Holbein's work was dominated by allusions to this ancient text, and that it was crucial to Holbein's own conception of his talent. Holbein's art, they claim, was understood by his humanistically educated contemporaries in terms of the praise heaped on verisimilitude by the ancient author, whose authority had been endorsed by a Renaissance elite anxious to legitimate the art of their own time. These are important iconological contributions to the study of these works, but we need not restrict our analyses of art to the ideological programs that may have inspired it. Let's look elsewhere in order to draw closer to our prey—the lure

of mimesis. In a remarkable little text written in 1933, Walter Benjamin argues that the capacity for imitation was one of the most important aspects of human experience: "Nature creates similarities; one need only think of mimicry. The highest capacity for producing similarities, however, is man's. His gift of seeing similarity is nothing but a rudiment of the once powerful compulsion to become similar and to behave mimetically. There is perhaps not a single one of his higher functions in which his mimetic faculty does not play a decisive role."[7] According to this fundamental insight, pictorial mimesis is a two-way street in which human beings not only imitate the world around them but also respond to the very means by which they do so. W. J. T. Mitchell poses the striking question "What do pictures want?"[8] Believing that we tend to invest works of art with a life of their own and that they, in turn, play an important role in our cultural lives, he insists that in animating works of art we grant them a form of "secondary agency."[9] Rather than try to establish what images *mean*—as stylistic analysis, iconography, social history, feminism, queer theory, ethnic studies, postcolonialism, and other forms of contemporary art historical interpretation seek to accomplish—Mitchell is interested in what they *do*. He argues that even if we do not believe that images possess powers of their own, we gain much insight from approaching them as if they might.[10] Rather than view nature as inert, a passive ground against which the active figure of "man" makes an appearance, anthropologists have become increasingly sensitive to patterns of human behavior that appear to mimic, or analogize, aspects of the world around them. Alfred Gell, for example, develops a most suggestive theory of art that depends on a consonance between it and culture. Humans tend to project into their visual art the forms of social organization that structure their everyday interactions:

> Artworks, in other words, come in families, lineages, tribes, whole populations, just like people. They have relations with one another as well as with the people who create and circulate them as individual objects. They marry, so to speak, and beget offspring which bear the stamp of their antecedents. Artworks are manifestations of "culture" as a collective phenomenon, they are, like people, enculturated beings.[11]

If pictures indeed *do* as much as *mean*, it might be worthwhile taking a careful look at some individual examples. Several of Holbein's portraits

play explicitly with Pliny's praise of Apelles. The inscription beneath the ledge on which Derich Born (fig. 6.6) rests his arm in a portrait from 1533 reads: "When you add the voice, here is Derich himself, in such a way that you wonder whether the painter or the Creator has made him."[12] In drawing an analogy between the divine power of the Creator and that of the artist, the inscription echoes sentiments expressed by Leonardo da Vinci and Albrecht Dürer, among others. Joseph Koerner has argued that Dürer's *Self-Portrait* of 1500 (fig. 2.2) was specifically intended to invoke the tradition of the *Vera Icon* (True Likeness), the so-called portraits of Christ himself, which depend on literary traditions allegedly dating to Antiquity. It is also said to refer to devotional images in which Christ's features were miraculously imprinted, such as the cloth with which St. Veronica wiped His face on the way to Calvary.[13] The power of the icon, once worshipped because it was thought to have been made without hands and thus able to render the absent present, translates into the power — the aura — of the image in the age of "art." The substitutional status of the image that once guaranteed the sacred quality of the icon is transformed by humanist art theory into an attribute of the uniquely gifted artist.[14] The potential of the naturalistic image to act as both presentation and representation — as both presence and substitute for presence — serves to render visible and thus accessible the hidden God of Christianity and to proclaim the exalted status of the artist and the elevation of the age in which he lived.

And yet I want to argue that Holbein's portraits are not exclusively motivated by a desire to assert the art-like stature of his work. Holbein's mimesis cannot be equated with Dürer's. Holbein's portraits do more than merely exhibit a Renaissance ambition to establish his paintings as "art"; they exploit verisimilitude for anthropological purposes that are much older and deeper and that are associated with the kind of power attributed to images in spiritual practice. Consider a genre of portraiture that appears at first to have nothing to do with our artist: the highly mimetic paintings and sculptures of medieval Japanese Zen Buddhist monks. These thirteenth-century works were commissioned by their followers and used to commemorate their deaths. Originally intended for mortuary ceremonies, the dead monks' dharma or enlightenment legitimated the religious status of the monasteries to which they belonged. Treated as living substitutes, the sculptures were offered food and drink and had incense burned before them on their anni-

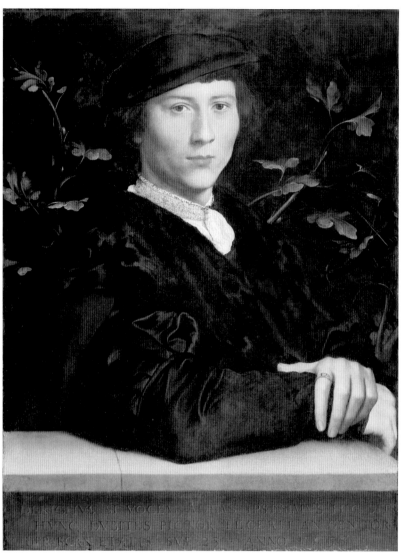

FIGURE 6.6 HANS HOLBEIN THE YOUNGER, *PORTRAIT OF DERICH BORN*, 1533. Oil on panel, 60.3 × 45.1 cm. The Royal Collection. © 2011 Her Majesty Queen Elizabeth II

versaries. Buddhist reliquaries and texts, along with lists of those respon-
sible for commissioning them, were sometimes hidden inside the sculp-
tures, adding to their mystical value. Verisimilitude is thus used to invest
these Zen portraits with powers of agency and to facilitate the transmission
of enlightenment from one generation to another.[15]

Needless to say, I am not suggesting that the religious function of Zen
portraiture has anything to do with Holbein's work. In fact, Benjamin him-
self insisted that "neither mimetic powers nor mimetic objects remain the
same in the course of thousands of years."[16] Nor, I would add, from culture
to culture. On the other hand, the pictures of Zen sages do provide us with
telling examples of how the impulse toward representational verisimilitude
serves to endow objects with "secondary agency." While there is no precise
equivalent to Zen portraits in the European Middle Ages, medieval reli-
gious portraiture often functioned in resonant ways. The so-called "devo-
tional portrait," for example, a characteristic of both illuminated manu-
scripts and panel paintings of the late Middle Ages, placed the donor before
the deity in an intimate and unmediated relationship designed to manifest
the individual's spiritual piety and desire for salvation.[17] Such devices were
extremely popular among those who could afford them in an age that saw
the ever-increasing importance of the concept of purgatory and the growing
reliance of the faithful on mechanical forms of religious observance.[18] A dip-
tych, such as *Georg Graf von Löwenstein Facing the Man of Sorrows* by Hans
Pleydenwurff (fig. 6.7), records the count's features as well as his dedication
to the Savior.[19] His pious gaze and the prayer book in his hand intimate the
eternal quality of his devotion. On the other hand, the back of the panel of
the *Man of Sorrows* (in Basel), bearing his coat of arms, also serves to estab-
lish his worldly status and power. In Jan Gossaert's diptych *Jean Carondelet
Facing the Virgin and Child* (figs. 6.8 and 6.9), several strands of Christian
thinking come together.[20] While the back of the Carondelet panel bears a
skull, a reminder of the inevitability of death that accounts for the diptych's
role in preparing a place for this man in the life to come, that of the Virgin
and Child bears Carondelet's coat of arms, thus recording his importance
as a spiritual and temporal leader. Such devotional mechanisms perpetuate
and exalt the agency of their patrons by presenting them in poses of eternal
adoration and by encouraging others to identify with them and do the same.

The intimate relation in these diptychs between the portraits of Pleyden-

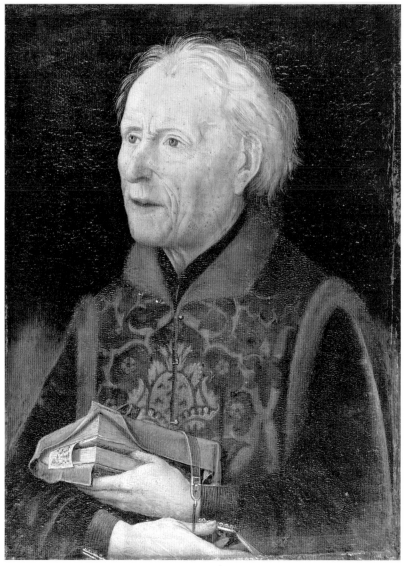

FIGURE 6.7 HANS PLEYDENWURFF, *GEORG GRAF VON LÖWENSTEIN*, CA. 1460. Oil on wood, 34 × 25 cm. Germanisches Nationalmuseum, Nuremberg. © Germanisches Nationalmuseum, Nürnberg

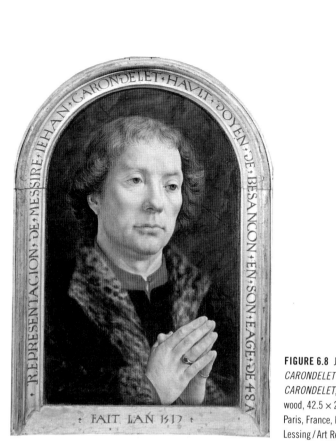

FIGURE 6.8 JAN GOSSAERT, *CARONDELET DIPTYCH: JEAN CARONDELET*, 1517. Oil on wood, 42.5 × 27 cm. Louvre, Paris, France, Inv. 1442. © Erich Lessing / Art Resource, NY

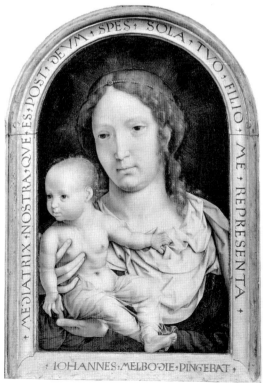

FIGURE 6.9 JAN GOSSAERT, *CARONDELET DIPTYCH: VIRGIN AND CHILD*, 1517. Oil on wood, 42.5 × 27 cm. Louvre, Paris, France, Inv. 1443. © Erich Lessing / Art Resource, NY

wurff and Carondelet and their coats of arms, which are literally attached to the back of the objects of their devotion, is illuminated by Hans Belting's argument about the historical development of the portrait in the late Middle Ages. He claims that the genealogical function of the coat of arms, its role as a legal placeholder for members of aristocratic or princely families, served as the ancestor of the later bourgeois portrait. Where the portrait once functioned as the "face" of the coat of arms, a way that the temporal existence of a particular subject might be recognized within the diachronic narrative of the history of a distinguished house, it was transformed, in the course of time, into the "coat of arms" of the self—a means of describing, through heightened naturalism, the specificity of an individual bourgeois sitter.[21] Coats of arms thus reinforce the rhetoric of presence with which these pictures are invested.

In Holbein's time the portrait served a variety of different functions, many of them represented in his own oeuvre.[22] Princely collections included portraits of genealogical importance, and during the Renaissance in Italy, even professionals, such as lawyers and jurists, formed collections of so-called "famous men."[23] In addition, the middle classes regularly commissioned portraits as records of their existence and social status. Nevertheless, donor portraits in altarpieces, devotional diptychs, ex-votos, and tomb sculpture all suggest that the history of the portrait in Holbein's time was still haunted by its role in religious practice. Indeed, Aby Warburg's famous study of portraiture in fifteenth-century Florentine religious frescoes argues that it was possible for portraits to combine apparently incompatible secular and religious functions at the same time.[24] The portraits of the Sassetti family in Domenico Ghirlandaio's *The Confirmation of the Franciscan Rule* in Santa Trinita included in this religious narrative are analogous to the donors depicted in the wings of altarpieces. Their presence both calls attention to the intensity of the spiritual bond that ties them to the scene and asserts their prominence in Florentine society.

There is more, however. Presence is embedded in the very fiber of Holbein's works. Holbein's pictorial rhetoric, his style, depends on surface rather than depth. His sitters dominate the spatial locations in which they are placed on the basis of their two, rather than three, dimensionality. His working method called for the use of full-size outline drawings that were then transferred to panel.[25] However much it seems necessary to extol Holbein's mimetic skills when speaking of our visceral reaction to them,

much of their effect depends on the way in which his powers of observation are dedicated to the plane. For Otto Pächt, planarity, or the "pictorial pattern" of a work, was a more important characteristic of late-medieval Netherlandish art than the illusionistic representation of space. His analysis is worth quoting: "Thus the pictorial world is subjected to two heteronomous ordering principles. The realm of one extends beyond the pictorial boundary, allowing the spatial context to continue across the edges of the picture; at the same time, the surface cohesiveness of the silhouette values creates a closed unity of its own. One rule system, valid only within the pictorial frame, merges with another obtaining even beyond it."[26] The coherence of the two-dimensional pattern on the surface of the image conceals the spatial distortions on which it depends. As Pächt puts it, "the contours of the silhouettes must be fitted firmly against each other," with the result that the image is endowed with a peculiar formal tension as the artist's principles of representation struggle to create a substitute for the three-dimensional sitters who confront him.[27] The perceptual consequences of this tension serve to enhance rather than diminish the illusion of reality: "Thus the viewer transfers the sensation of the uninterrupted cohesiveness of the visible world all the more spontaneously to the spatial order. The continuity of the surface connections arouses the illusion of spatial unity. It does not, at any rate, allow us to become aware of the fact that the spatial continuum we perceive is composed only of fragments."[28]

As in the Netherlands, fifteenth-century religious painting in Germany affirms the noumenal power of Christian deities and saints in the face of the popular piety of an ever-increasing naturalism by making them part of the surface of the image—that aspect of the work that is most sensitive and most accessible to the devout viewer. This strategy served to rescue their transcendental significance while at the same time enabling the Christian narrative to be made more available to a popular audience. It recuperates the divine status of the figures from an emotionally charged style that threatened to smother them in the banal paraphernalia of everyday life. In the Holbein paintings that interest us, the artist is, of course, not concerned with religious imagery. The flatness of his sitters, however—the tensile strength of the drawing that establishes the very terms by which we understand the nature of the illusion he offers us—reminds us of the sacral purposes to which portraits had so long been dedicated. The imbrication of his sitters in the very structure of the painted panel insists on their immanence.

In Holbein's oft-discussed portrait *The Ambassadors* (fig. 6.10), both of the sitters, Jean de Dinteville and Georges de Selve, look out of the composition at the spectator from a shallow but well-defined space. At first glance, their physical location appears to be a continuation of our own; the bearing and demeanor of the figures and the quality of the metals and fabrics of the instruments and textiles correspond to the qualities of objects identifiable from our own immersion in the world of material things. Holbein's concern with the surface logic of the picture, the triumph of linear over spatial rhetoric, both enhances and transforms the mimetic effect. The artist's achievement in capturing the texture of reality, Bätschmann and Griener remind us, is characterized by the reconciliation of two very different impulses: fantastic invention and dedicated imitation.[29] Mimesis, in other words, should not blind us to the selective and calculated nature of the whole impression, for we cannot help but be aware that we are offered what Roland Barthes would have called an "effect of the real."[30] Many authors have pointed out that the scene represents a carefully composed space whose brocaded drapery prevents the ambassadors from fully occupying a space that might be considered autonomous of our own, that the floor replicates the fourteenth-century mosaic that lies in the chancel of Westminster Abbey, that the astronomical instruments were borrowed from the astronomer Nicholas Kratzer, a fellow German at the court of Henry VIII, and so forth. Holbein's construction serves a double purpose. On the one hand, the picture persuades us of the presence of the figures; on the other, it serves as a demonstration of the artist's skill: the greater the degree of phenomenological persuasion, the greater the artist's talent in manipulating the pictorial codes at his disposal.

Acknowledging that the work might be nothing but a tissue of signs, however, and that such signs might be historically determined by the memory of earlier religious functions of the image, does not inhibit the viewer from responding to it as if it were a record of reality. We find ourselves in a situation curiously similar to that when confronting a photograph by Demand. The cognizance of the thoroughly artificial nature of the optical illusion does not prevent it from working as an effective duplicate of perception.[31] The figures' gazes, for example, ask to be returned. The picture triggers an involuntary impulse to animate what we see—to treat the represented beings as if they possessed the powers of agency that we ourselves enjoy. According to Benjamin, this impulse is characteristic of objects endowed with the aura of the work of art. No matter that it is we who make

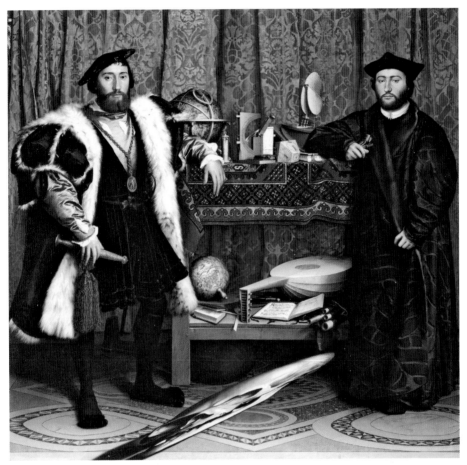

FIGURE 6.10 HANS HOLBEIN THE YOUNGER, *THE AMBASSADORS*, 1533. Oil on oak, 207 × 209.5 cm. National Gallery, London, Great Britain, NG1314. © National Gallery, London / Art Resource, NY

them come to life by treating them as if we were in their exalted presence, the painting's status as a work of art endows the figures with a social power that exceeds their status as painted images on a wooden support. Benjamin writes: "Experience of the aura thus arises from the fact that a response characteristic of human relationships is transposed to the relationship between humans and inanimate or natural objects. The person we look at, or who feels he is being looked at, looks at us in turn. To experience the aura of an object we look at means to invest it with the ability to look back at us."[32]

The intimacy of the connection between the person represented and the person looking at the representation—the way in which the representation acts as a kind of mediation between the here and now and the there and then—was no doubt recognized by both Holbein and his sitters. So why the need to include an anamorphic skull in this exhibition of social and intellectual achievement if not to play with, and even break, the spell of identification?[33] Its anamorphic distortion plays with the idea that death is simultaneously there and not there. Look askance and the world you think you know disappears. The shock of the skull's presence lies in the insertion of the symbolic, a culturally recognized convention signifying death, into the phenomenological and thus psychologically inflected experience of the work, as well as in tearing the illusion of verisimilitude with its anti-mimetic presence. The dialogue that informs our response as we become aware of the existence of these figures and our awareness of being looked at by them, while attending to the visual feast offered by the exquisitely described objects on the table—not to mention the elaborate design of the floor—is dramatically interrupted by the skull placed there to remind us of the passage of time. The beautifully dressed figures in the prime of life are not actually present, they are long dead, and their accomplishments past. In the midst of what appears to be affirmation of the *gravitas* of human existence lies a reminder of its *vanitas*. The presence of the skull, so intimately linked to portraiture in Holbein's time, adds psychic resonance to our reception of the painting. Jacques Lacan once argued that the skull makes us conscious of the "gaze" of the world; it makes us aware of being subject to light, of being "photo-graphed," and consequently reminds us of that which we cannot see.[34] The skull is there to insist that we, the viewers, are as much the products of the world that surrounds us as we are agents in its production. The picture functions as a "screen," the opaque meeting point between the "gaze" of the world and our own capacity to look back.

The skull is also a key to the power of Holbein's practice of mimesis. The violence with which it rends the fabric of the picture — its enchantment with the world shattered like Demand's broken glass (fig. 6.2) — is a metaphor of the annihilating threat posed to mimesis by the iconoclastic outbreaks of the Reformation. The presence of the skull is the trace of the cataclysm that challenged the artistic assumptions of the late Middle Ages and which Holbein's mimesis cannot entertain. It alludes to ideas that had to be rejected if painting's imaginary bond to the real were to be sustained and our perceptual dependency acknowledged. It bespeaks a familiar history that I must now briefly recount.

Beginning in the early 1520s, reformed ideas regarding the dangers of idolatry inherent in the cult of images began circulating in Basel. Luther's challenge to the authority of the Catholic Church, a challenge based on the idea that faith alone rather than good works was the guarantee of redemption, soon led to criticism of the veneration of images. His follower Andreas Karlstadt's violent treatise *On the Abolition of Images,* published in Wittenberg, Germany, in 1522, and reprinted that year in Basel, derives its condemnation of image worship from the first commandment: "You shall have no other gods before me. You shall not make yourself a graven image, or any likeness of anything that is in heaven above, or that is in the earth beneath, or that is in the water under the earth; you shall not bow down to them and serve them; for I the Lord your God am a jealous God, visiting the iniquity of the fathers upon the children to the third and fourth generation of those that hate me."[35]

These sentiments were echoed by the Swiss reformer Ulrich Zwingli, who also invoked the first commandment in his diatribe against the religious use of images. By 1524 he had persuaded the Zurich town council to supervise the systematic destruction of all religious imagery in the city. Unlike the authorities in Zurich, those in Basel only reluctantly accepted the Reformation. Rather than enforce sweeping religious change, they elected to permit both Catholic and reformed services to be offered in different churches. This ecumenical response, however, proved unsatisfactory to the more radical wing of reformed opinion, and in 1528 it led to one of the most violent outbursts of iconoclasm to take place during this period. The rage visited on images is worth calling to mind. The author of a standard history on Reformation iconoclasm, Carl Christensen, describes what took place on that day:

The altars in the Munster [cathedral]—including the high altar with its great alabaster retable depicting the crucified Christ and the twelve apostles—were hastily pulled down and demolished, statues knocked from their pedestals and smashed into pieces, painted panels slashed and hacked, lamps and candelabra dashed to the ground, stained glass broken from the windows, and even the murals or wall paintings defaced with knives. Several contemporary accounts state specifically that a huge crucifix was pulled down from the rood screen and tumultuously dragged by a rope through the streets of the city with an accompanying chorus of derision and mockery. It was finally burned in the marketplace.[36]

The violence of the animosity directed at images directly reflects the religious power once ascribed to them. As Bruno Latour reminded us not so long ago, in the *Iconoclash* exhibition, it takes an iconodule to become an iconoclast—one must endow images with power before one can destroy them.[37] The iconoclast Karlstadt, for example, revealingly acknowledges his own past addiction to images when he writes:

My heart from childhood has been brought up in the veneration of images, and a harmful fear has entered me which I would gladly rid myself of, and cannot. . . . When someone pulls someone by the hair, then one notices how firmly his hair is rooted. If I had not heard the spirit of God crying out against idols, and had not read His Word, I would have thought thus: "I do not love images." "I do not fear images." But now I know how I stand in this matter in relation to God and the images, and how firmly and deeply images are seated in my heart.[38]

The controversy over sixteenth-century iconoclasm is inseparable not only from Holbein's fate (his move from Basel to London as the prospect of further commissions of religious painting disappeared) but also from the issue of mimesis itself. One of the most striking developments associated with the creation of Lutheran imagery in the wake of iconoclasm is the systematic attenuation and destruction of late-medieval naturalism. If images were not to be smashed, as Luther, the most conservative of the reformers on this issue, advocated, they must at least acknowledge their status as belonging to a system of signification that has no bearing on the real. Working for the Lutheran court of Saxony on commissions for Lutheran religious altarpieces and devotional images, Lucas Cranach and his son achieved a

remarkable stylistic revolution, one that deliberately countered Holbein's contemporary mimetic impulse. Cranach sought to make the imagery of the new religion transparent to the biblical texts on which it was based. If salvation was to be achieved by faith alone, then pictures must sever their dependence on perception. Cranach's rejection of the "reality effects" of late-medieval and Renaissance naturalism draws attention to the arbitrary nature of the pictorial sign. Rather than gesture at a hidden God in terms that render Him accessible and intelligible, Cranach strips the visual sign of anything that might obscure its pedagogical function. In Koerner's words: "The drastically formulaic character of the painting as painting thus suits a religion where the real truth, by definition, lies not in faithfulness to a world but in faith in words."[39]

The altarpiece *Crucifixion and Allegory of Redemption* in Weimar, begun by Lucas Cranach the Elder and completed by his son in 1555 (fig. 6.11), compared with the pre-Reformation *Lamentation under the Cross* in Munich by Lucas Cranach the Elder dated 1503 (fig. 6.12), is often invoked to make this point.[40] In the later Reformation work, Christ's sacrifice has been transformed from narrative to allegory, from story to symbol, and from figuration to abstraction. Rather than record an event in Christ's life, the spectator is offered an account of its meaning within a scheme of salvation. Because of the doctrinal struggle about how redemption was to be achieved, narrative is subordinated to theological exposition. No attempt is made to render the natural setting in which the tragedy unfolded—only pared-down vestiges remain of the biblical story. The beholder discerns the cross and Christ's body to be sure, but soon realizes that he or she must approach the image in terms other than mimetic ones. Luther points to a Bible, the source of his conviction that salvation was to be realized by faith rather than by works. Beside him, John the Baptist gestures toward Christ, whom he had called the "lamb of God" at his baptism, thereby offering the viewer a clue as to the sacrificial meaning of the lamb that stands at the foot of the cross, as well as that of the figure on the cross. Between them stands none other than Cranach the Elder, whom a pious son paints as the recipient of the saving stream of blood flowing from the redeemer's side. In the background, behind the cross, an unfortunate soul is chased into Hell by the skeletal figure of Death, while Moses, holding the tablets of the Law, looks on. The scene informs the viewer that in contrast to the figures in the foreground who are

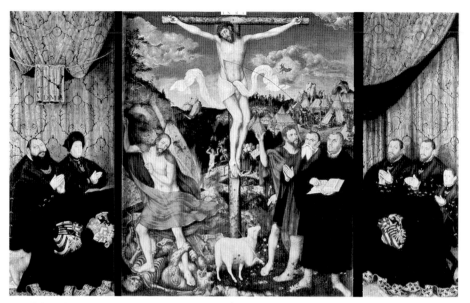

FIGURE 6.11 LUCAS CRANACH THE ELDER AND LUCAS CRANACH THE YOUNGER, *CRUCIFIXION AND ALLEGORY OF REDEMPTION*, 1555. Oil on panel, 3.6 × 3.11 m (central panel). Church of Saints Peter and Paul, Weimar. © Constantin Beyer

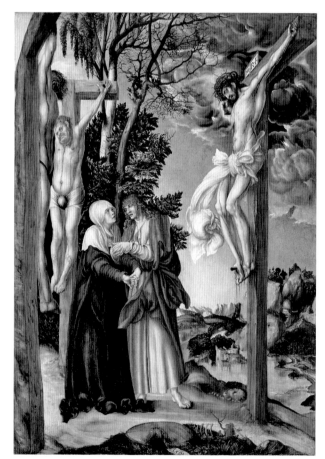

FIGURE 6.12 LUCAS CRANACH THE ELDER, *LAMENTATION UNDER THE CROSS*, 1503. Oil on wood, 138 × 99 cm. Alte Pinakothek, Bayerische Staatsgemäldesammlungen, Munich, Germany, Inv. 1416. © bpk, Berlin / Art Resource, NY

saved by their faith in Christ's sacrifice, those who place their hope of salvation in works—through the fulfillment of the commandments, equated with the teaching of the Catholic Church—have no hope of salvation.

The transformation of the pictorial vocabulary is just as important as the iconographic innovations of the Reformation. Light and shade have disappeared. The viewer is not tempted to regard the scene as one that has any reference to the world of experience. Any suggestion of presence is deliberately avoided. Lutheran painting eschews modeling in light and shade, and any other painterly effect that might suggest that its surface has more than two dimensions. Figures are crisply defined by means of line so that their roles in the allegory may be clearly deciphered. The lack of atmospheric perspective turns the landscape into a stage set, into which subsidiary scenes may be fitted without endangering their intelligibility. The contrast with Cranach's earlier work could not be greater. The pre-Reformation work makes use of radical foreshortening and a strong play of light and dark to suggest that its viewers witness a real event. Late-medieval naturalism makes the experience of the image a vivid and memorable one. In one painting the beholder is asked to relate phenomenologically to the event as if he or she might actually be part of its spatial setting; in the other the Crucifixion is reduced to pictorial semiotics in order to relay the significance of a complex allegory.

Perhaps more relevant to this discussion of Holbein's art is a consideration of the consequences of this stylistic transformation for the way that he and Cranach approached portraiture. A comparison of Cranach's portrait of Martin Luther (fig. 6.13) and Holbein's portrait of Desiderius Erasmus (fig. 6.14), painted in 1533 and 1523, respectively, enables us to draw some pertinent observations. Cranach's printed and painted portraits of Luther were created for dissemination to his followers as a form of religious propaganda, while Holbein's portraits of Erasmus were destined for a few close friends. Cranach renders the religious leader as a two-dimensional outline against a monochrome background, while Holbein uses the full panoply of his mimetic powers to add texture to the circumstances in which the scholar is located. Cranach's image brings to mind the role of line in late-medieval art as a means of asserting the immanence of supernatural power, but in this case it is used to simplify the complexity of the reformer's features, thus robbing him of the unique qualities of individuality and reducing his face to a mask. Rather than trigger an emotional response in the viewer, analogous

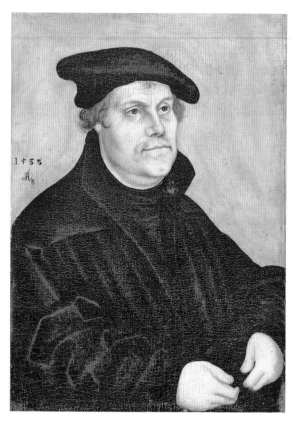

FIGURE 6.13 LUCAS CRANACH THE ELDER, *MARTIN LUTHER*, 1533. Oil on wood, 20.5 × 14.5 cm. Germanisches Nationalmuseum, Nuremberg. © Germanisches Nationalmuseum, Nürnberg

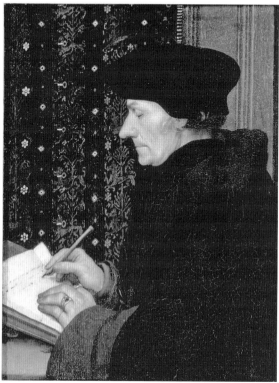

FIGURE 6.14 HANS HOLBEIN THE YOUNGER, *ERASMUS OF ROTTERDAM*, 1523. Oil on wood, 42 × 32 cm. Louvre, Paris, France, Inv. 1345. © Réunion des Musées Nationaux / Art Resource, NY

to the experience of real person, it serves merely as a prompt to memory. Hanna Kolind Poulsen argues that it was important that Cranach's portraits not be too realistic precisely to prevent them from being subjected to the kind of "abuse" or worship that Luther regarded as the unfortunate fate of traditional religious images: "For each portrait has a fixed iconography, a specific 'mask.' Luther, Melancthon, Electors and their ladies always look the same in the various portraits. Luther's 'mask,' for instance, was fixed at the end of the 1520's and only changed once, from a 'young' to an 'older' version around 1540."[41] In Cranach's picture, presence is deliberately suppressed. The image invokes its referent by means of signs, whose complexity has been systematically simplified to ensure their legibility. Holbein's portrait, however, is specifically intended to suggest an absent presence. In a letter to Sir Thomas More concerning the gift of his own portrait by Quentin Massys, Erasmus explicitly states that it is to stand in his stead. As he is unable to visit England himself, the portrait is to act as his substitute.[42] In one, the material support, the physical object offered by the painting, is intrinsically bound to its meaning. In the other, the link between the physical presence of the object and its absent referent is broken.

Cranach's anti-illusionistic art swept away the innovations such as one-point perspective and classical anatomical proportions once introduced into late-medieval German painting by Dürer as a means of endowing it with the status of art, and it deprived sacred pictures of the power ascribed them by their religious function as aids to devotion. Here is a list of what religious representation lost when deprived of mimesis. Images cannot be regarded as possessing a life of their own (they are no longer meant to come alive in the mind's eye); they no longer act as a vehicle that enables those humans represented in them to be redeemed from purgatory; they no longer invite the identification of worshipper with what is worshipped; they no longer make the Christian narrative perceptually accessible in naturalistic terms; and, last but by no means least, they refuse the aesthetic interest recently attributed to them by a cultured humanist elite.

Although Holbein escaped the iconoclasm of the Reformation in the German-speaking lands, he lived long enough to see it become a reality in his adopted home. Reformed challenges to orthodox teaching on images from Erasmus to Luther found widespread response in a population that had been exposed to the heretical teaching of John Wycliffe and the Lollards in the fourteenth century.[43] Beginning in the mid-1530s, isolated acts of image

smashing were transformed into a systematic strategy when iconoclasm became identified with government policy in the wake of Henry VIII's struggle with the papacy over the direction of the English church.[44] The dissolution of the monasteries and the gradual and often contradictory reforms of religious teaching and ritual practice that ensued allowed ample scope for acts of official and unofficial violence against religious imagery. The assault on images taking place in the years that preceded Holbein's death in 1543 makes the intensity with which he engages in the play of mimesis, the subtle to and fro between subject and object, constructed representation and experienced perception, particularly striking. Unlike many of his contemporaries in Germany, who adapted their art to suit the dictates of the new theory of the image, Holbein found in portraiture a means to preserve the magic with which the surfaces of religious painting had once been endowed.[45] Conventionally classified as secular rather than religious in subject, his portraits are nevertheless haunted by the religious function they once performed. As Belting indicates, they serve as much as a record of the dead as a means by which to conjure their presence: "Images traditionally live from the *body's absence*, which is either temporary (that is, spatial) or, in the case of death, final. . . . *Iconic presence* still maintains a body's absence and turns it into what must be called *visible absence*. Images live from the paradox that they perform the *presence of an absence* or vice-versa."[46]

The anti-mimetic presence of the skull in *The Ambassadors* is indeed a reminder of death's threat, not only to human life but also to the capacity of illusionism to contain that which the eye cannot see. Holbein's mimesis affirms the work of art's status as something independent of language in the face of the Lutheran attempt to reduce it to a form of instruction that is transparent and dependent on the word. Holbein continued to traffic in an art committed to an idea of the image that maintained the imaginative and imaginary exchange with its viewers at a time when Cranach and his followers were intent on eliminating all traces of illusionism from their work. The contrast between the "execution" of mimesis at the hands of Cranach and the execution of mimesis by Holbein—the vital sense of presence with which the latter invests the surface of his paintings—could not be more forceful. Its demise in one location is countered by its apotheosis in another.

Mimesis manipulates the wealth of associations that our perception derives from its encounter with the world. The intimacy of that process makes it impossible to say where and how our capacity to know the world deter-

mines our knowledge of it. Do we project a series of representations about its presence, or do we simply respond to it in ways that are predetermined? Is this the mystery with which mimesis confronts us? Is this what illusionistic images *do*? Benjamin's definition of the "aura" of the work of art in terms of experience, a point where collective and personal experience coincide, where involuntary memory is triggered by an object so as to ensure "a strange weave of space and time," seems relevant to what I want to argue.[47] The skull that so spectacularly falls out of the construction of *The Ambassadors* both enhances and disrupts the "effect of the real." It insists that we recognize the preternatural play between the seen and the unseen, between the artist's perception and the artist's hand. Cognizance of the artificial and constructed quality of the versions of the real offered us in pictorial mimesis does not prevent us from being seduced by our senses. Demand's photographs bring with them a heightened awareness of how the process of artistic imitation is itself a response to perception—that in mimesis agency is doubly specular. Just as the artist creates a substitute for the world while tracing his own presence, we marvel at the substitution's hold on our perception as we recognize the ingenuity that realized it. Paradoxically enough, the referential break on which these photographs depend dramatizes the strength of their attachment to the real, and in doing so emphasizes that, for them as for Holbein's *Ambassadors*, the "time" of the work is the time in which the miracle of mimesis entrances the beholder with its magic. These twenty-first-century photographs may not intend to do so, but they nevertheless urge us to approach Holbein's sixteenth-century portraits with a renewed sense of wonder.

NOTES

1. For fascinating insights into the enduring power of mimesis, see, among others, Ernst Gombrich, *Art and Illusion: A Study in the Psychology of Pictorial Representation* (Princeton: Princeton University Press, 1969); Norman Bryson, *Vision and Painting: The Logic of the Gaze* (New Haven: Yale University, 1983); David Freedberg, *The Power of Images: Studies in the History and Theory of Response* (Chicago: University of Chicago Press, 1989); and Hans Belting, *Likeness and Presence: A History of the Image before the Era of Art*, translated by Edmund Jephcott (Chicago: University of Chicago Press, 1994).

2. Roxana Marcoci, *Thomas Demand* (New York: Museum of Modern Art, 2005); Michael Fried, "Without a Trace," *Artforum*, March 2005, 199–203. For a psychoanalytic interpretation of Demand's work, see Parveen Adams, "Out of Sight, Out

of Body: The Sugimoto/Demand Effect," *Grey Room*, no. 22 (2005): 86–104. I am grateful to Branden Joseph for this reference.

3. See Kerry Brougher and David Elliott, *Hiroshi Sugimoto* (Washington: Hirshhorn Museum, 2006); Michelle Legro, "Wanted Dead or Alive: How We Experience Sugimoto's Portraits," BA thesis, Barnard College, 2005; Norman Bryson, "Hiroshi Sugimoto's Metabolic Photography," *Parkett*, no. 46 (1996): 120–31; Thomas Killein, *Hiroshi Sugimoto: Time Exposed* (London: Thames and Hudson, 1995).

4. Roland Barthes, *Camera Lucida: Reflections on Photography*, translated by Richard Howard (New York: Hill and Wang, 1981).

5. Rosalind Krauss, *Cindy Sherman, 1975–1993* (New York: Rizzoli, 1993), 174. See also Norman Bryson's essay "House of Wax" in Krauss, *Cindy Sherman, 1975–1993*, 216–23; Arthur Danto, *Cindy Sherman: History Portraits* (New York: Rizzoli, 1991), 5–13.

6. Oskar Bätschmann and Pascal Griener, "Holbein-Apelles: Wettbewerb und Definition des Kunstlers," *Zeitschrift für Kunstgeschichte* 57 (1994): 625–50; Oskar Bätschmann and Pascal Griener, *Hans Holbein*, translated by Cecilia Hurley and Pascal Griener (Princeton: Princeton University Press, 1997), chapter 1; Mark Roskill and Craig Harbison, "On the Nature of Holbein's Portraits," *Word and Image* 3, no. 1 (1987): 1–26.

7. Walter Benjamin, "On the Mimetic Faculty" (1933), in *Walter Benjamin: Selected Writings*, vol. 2, *1927–1934*, edited by Michael Jennings, 720–22 (Cambridge: Harvard University Press, 2005), 720. See also Susan Buck-Morss, *The Dialectics of Seeing: Walter Benjamin and the Arcades Project* (Cambridge: MIT Press, 1989), 266–68. For a study that develops Benjamin's ideas on mimesis, see Michael Taussig, *Mimesis and Alterity: A Particular History of the Senses* (New York: Routledge, 1993).

8. W. J. T. Mitchell, *What Do Pictures Want? The Loves and Lives of Images* (Chicago: University of Chicago Press, 2005). Similar questions have been posed about sculpture by Kenneth Gross in *The Dream of the Moving Statue* (Ithaca: Cornell University Press, 1992).

9. The phrase is Alfred Gell's; see his *Art and Agency: An Anthropological Theory* (Oxford: Clarendon, 1998), 17.

10. One of the most moving demonstrations of the literary and artistic value of walking the tightrope of this paradox is Barthes's book *Camera Lucida*. While affirming that photography is the medium of death, he nevertheless finds that there are certain photographs in which a detail (the *punctum*) allows the viewer phenomenological access, or unmediated communication, with the subject represented.

11. Gell, *Art and Agency*, 153. See also Gell, "The Technology of Enchantment and the Enchantment of Technology," in *Anthropology, Art, and Aesthetics*, edited by Jeremy Coote and Anthony Shelton, 40–63 (Oxford: Clarendon, 1992); Gell, "Vogel's Net: Traps as Artworks and Artworks as Traps," in *The Anthropology of Art: A Reader*, edited by Howard Morphy and Morgan Perkins, 219–35 (Oxford: Blackwell, 2006). For a discussion of his theories, see Matthew Rampley, "Art History and Cultural Difference: Alfred Gell's Anthropology of Art," *Art History* 28, no. 4 (2005): 525–51.

12. Bätschmann and Griener, *Hans Holbein*, 31.

13. Joseph Koerner, *The Moment of Self-Portraiture in German Renaissance Art* (Chicago: University of Chicago Press, 1993).

14. For an exploration of the relation between "substitutional" and "performative" images in the Renaissance, see Alexander Nagel and Christopher Wood, *Anachronic Renaissance* (New York: Zone Books, 2010).

15. T. Griffith Foulk and Robert H. Sharf, "On the Ritual Use of Ch'an Portraiture in Medieval China," *Cahiers d'Extreme Asie*, no. 7 (1993): 197. Also see their chapter "Religious Functions of Buddhist Art in China" in *Cultural Intersections in Later Chinese Buddhism*, edited by Marsha Weidner, 13–29 (Honolulu: University of Hawai'i Press, 2001). Further insights concerning this fascinating portrait genre are found in Bernard Faure, *The Rhetoric of Immediacy: A Cultural Critique of Chan/Zen Buddhism* (Princeton: Princeton University Press, 1991); Bernard Faure, *Visions of Power: Imagining Medieval Japanese Buddhism*, translated by Phyllis Brooks (Princeton: Princeton University Press, 1996); Helmut Brinker and Hiroshi Kanazawa, *Zen Masters of Meditation in Images and Writings*, translated by Andreas Leisinger (Zurich: Artibus Asiae, 1996); Gregory Levine, *Daitokuji: The Visual Cultures of a Zen Monastery* (Seattle: University of Washington Press, 2005). I am grateful to Yukio Lippit for drawing my attention to these paintings in a lecture at the Clark Art Institute. This talk has now been published as Yukio Lippit, "Negative Verisimilitude: The Zen Portrait in Medieval Japan," in *Asian Art History in the Twenty-First Century*, edited by Vishaka Desai, 64–95 (Williamstown, Mass.: Clark Art Institute, 2007).

16. Benjamin, "On the Mimetic Faculty," 720.

17. For a discussion of this genre, see Laura Gelfand and Walter Gibson, "Surrogate Selves: The Rolin Madonna and the Late-Medieval Devotional Portrait," *Simiolus* 29 (2002): 119–38; John Hand and Ron Spronk, eds., *Essays in Context: Unfolding the Netherlandish Diptych* (Cambridge: Harvard University Art Museums, 2006).

18. Jacques Le Goff, *The Birth of Purgatory*, translated by Arthur Goldhammer (Chicago: University of Chicago Press, 1984); Jean Delumeau, *Sin and Fear: The Emergence of a Western Guilt Culture, 13th–18th Centuries*, translated by Eric Nicholson (New York: St. Martin's Press, 1983).

19. Angelica Dülberg, *Privatporträts: Geschichte und Ikonologie einer Gattung im 15. und 16. Jahrhundert* (Berlin: Mann, 1990), catalogue no. 100. The left half of the diptych (which is not illustrated here) represents Christ as "Man of Sorrows" against golden rays surrounded by dark blue clouds decorated with golden stars (Basel, Kunstmuseum, Inv. No. 1651).

20. Dülberg, *Privatporträts*, catalogue no. 16.

21. Hans Belting, *Bild-Anthropologie: Entwurfe für eine Bildwissenschaft* (Munich: W. Fink, 2001), 115–42. For a reflection on the role of Byzantine icons in the development of the portrait in European painting of the fifteenth century, see Nagel and Wood, *Anachronic Renaissance*, 109–22.

22. For a compelling meditation on the aesthetics of early modern portraiture, see Harry Berger Jr., *Fictions of the Pose: Rembrandt against the Italian Renaissance* (Stanford: Stanford University Press, 2000).

23. Linda Klinger Aleci, "Images of Identity: Italian Portrait Collections of the Fifteenth and Sixteenth Centuries," in *The Image of the Individual: Portraits of the Renaissance*, edited by Nicholas Mann and Luke Syson, 67–79 (London: Trustees of the British Museum, 1998).

24. Aby Warburg, "The Art of Portraiture and the Florentine Bourgeoisie," in *The Renewal of Pagan Antiquity: Contributions to the Cultural History of the European Renaissance*, translated by David Britt, 185–221 (Los Angeles: Getty Research Center, 1999). Warburg's essay has been analyzed by Georges Didi-Huberman, "The Portrait, the Individual, and the Singular: Remarks on the Legacy of Aby Warburg," in *The Image of the Individual: Portraits in the Renaissance*, edited by Nicholas Mann and Luke Syson, 165–85 (London: British Museum Press, 1998). See also Hugo van der Velden, "Medici Votive Images and the Scope and Limits of Likeness," in *The Image of the Individual: Portraits of the Renaissance*, ed. Mann and Syson, 126–37.

25. Maryan Ainsworth, " 'Paternes for Phiosioneamyes': Holbein's Portraiture Reconsidered," *Burlington Magazine* 132 (1990): 173–86; Susan Foister, *Holbein in England* (London: Tate Publishing, 2006), 103.

26. Otto Pächt, "Design Principles of Fifteenth-Century Northern Painting" (1933), translated by Jacqueline Jung, in *The Vienna School Reader: Politics and Art Historical Method in the 1930s*, edited by Christopher Wood, 243–321 (New York: Zone Books, 2003), 250.

27. Pächt, "Design Principles of Fifteenth-Century Northern Painting," 254.

28. Pächt, "Design Principles of Fifteenth-Century Northern Painting," 259.

29. Bätschmann and Griener, "Holbein-Apelles," 630.

30. Roland Barthes, "The Reality Effect," in *French Literary Theory Today: A Reader*, edited by Tzvetan Todorov, translated by R. Carter, 11–17 (Cambridge: Cambridge University Press, 1982).

31. Or, in the idiom of neuroaesthetics, the scene reveals the operation of the brain's "mirror neurons" that cause humans to respond to representations in ways that are analogous to how they react to perceptual experience. See David Freedberg and Vittorio Gallese, "Motion, Emotion and Empathy in Esthetic Experience," *Trends in Cognitive Science* 11, no. 5 (2007): 197–203.

32. Walter Benjamin, "On Some Motifs in Baudelaire" (1939), in *Walter Benjamin: Selected Writings*, vol. 4, *1938–1940*, edited by Michael Jennings, 313–55 (Cambridge: Harvard University Press, 2005), 338. For valuable discussions of Benjamin's concept of aura as an aesthetics of intersubjective communication, see Georges Didi-Huberman, *Ce que nous voyons, ce qui nous regarde* (Paris: Minuit, 1992); Diarmuid Costello, "Aura, Face, and Photography: Re-reading Benjamin Today," in *Walter Benjamin and Art*, edited by Andrew Benjamin, 164–84 (London: Continuum, 2005).

33. For a history of the development of anamorphic perspective in the Renaissance and its use in Holbein's *The Ambassadors*, see Jurgis Baltrusaitis, *Anamorphic Art*, translated by W. J. Strachan (Cambridge: Chadwyck-Healey, 1977), 91–114.

34. Jacques Lacan, *The Four Fundamental Concepts of Psychoanalysis*, edited by Jacques-Alain Miller, translated by Alan Sheridan (New York: Norton, 1981), 106.

35. Andreas Bodenstein von Karlstadt, *Von abtuhung der Bylder* (Wittenberg, 1522), 7, cited by Carl Christensen, *Art and the Reformation in Germany* (Athens: Ohio University Press, 1979), 29.

36. Christensen, *Art and the Reformation in Germany*, 100.

37. Bruno Latour, "What Is Iconoclash? Or Is There a World beyond the Image Wars?," in *Iconoclash: Beyond the Image Wars in Science, Religion, and Art*, exhibition catalogue, edited by Bruno Latour and Peter Weibel, 14–38 (Karlsruhe: Center for Art and Media, 2002).

38. Karlstadt, *Von abtuhung der Bylder*, 19, cited by Christensen, *Art and the Reformation in Germany*, 25.

39. Joseph Koerner, "The Icon as Iconoclash," in *Iconoclash: Beyond the Image Wars in Science, Religion, and Art*, edited by Bruno Latour and Peter Weibel, 164–213 (Karlsruhe, Germany: Center for Art and Media, 2002), 212.

40. This comparison has become common since it was used by Charles Talbot in "An Interpretation of Two Paintings by Cranach in the Artist's Late Style," in *Report and Studies in the History of Art*, 67–88 (Washington: National Gallery of Art, 1967); see also Koerner, *The Moment of Self-Portraiture in German Renaissance Art*, 363–410. For Koerner's most recent discussion of Lutheran painting, see *The Reformation of the Image* (Chicago: University of Chicago Press, 2004).

41. Hanne Kolind Poulsen, ed., *Cranach*, exhibition catalogue (Copenhagen: Statens Museum for Kunst, 2002), 87.

42. See Bätschmann and Griener, *Hans Holbein*, 155–58; Aloïs Gerlo, *Erasme et ses portraitistes: Metsijs, Durer, Holbein* (Brussels: Cercle d'Art, 1950).

43. Margaret Aston, *England's Iconoclasts*, vol. 1 (Oxford: Clarendon, 1988), 96–159.

44. Aston, *England's Iconoclasts*, 222–46. See also Margaret Aston, "Iconoclasm in England: Official and Clandestine," in *Faith and Fire: Popular and Unpopular Religion 1350–1600*, 261–89 (London: Hambledon, 1993); Eamonn Duffy, *The Stripping of the Altars: Traditional Religion in England ca. 1400–ca. 1580* (New Haven: Yale University Press, 1992), 379–447; and John Phillips, *The Reformation of Images: Destruction of Art in England, 1535–1660* (Berkeley: University of California Press, 1973), 41–81.

45. Holbein's personal religious views have been much discussed. The subject matter of some of his works and his association with known supporters of Desiderius Erasmus and Martin Luther suggest his sympathy for the reformed cause. See Bätschmann and Griener, *Hans Holbein*, 88–119, and Foister, *Holbein in England*, 125–41. Jeanne Nuechterlein's *Translating Nature into Art: Holbein, the Reformation, and Renaissance Rhetoric* (University Park: Pennsylvania State University Press, 2011) appeared too late to be taken into consideration.

46. Hans Belting, "Image, Medium, Body: A New Approach to Iconology," *Critical Inquiry* 31, no. 2 (2005): 312.

47. Walter Benjamin, "The Work of Art in the Age of Its Technological Reproducibility" (1936), in *Walter Benjamin: Selected Writings*, vol. 3, *1935–1938*, edited by Michael Jennings, 101–33 (Cambridge: Harvard University Press, 2002), 104–5. See also Costello, "Aura, Face, Photography."

IMPOSSIBLE DISTANCE

If it is too close, the object runs the risk of being no more than a peg to hang phantasms on; if it is too distant, it is in danger of being no more than a positive, posthumous residue, put to death in its very "objectivity" (another phantasm). What is required is neither to fix nor to try to eliminate this distance, but to make it work within the differential tempo of the moments of empathic, unexpected, and unverifiable juxtapositions, with the reverse moments of scrupulous critique and verification.

GEORGES DIDI-HUBERMAN, "BEFORE THE IMAGE, BEFORE TIME: THE SOVEREIGNTY OF ANACHRONISM"

The role played by the object that is the focus of art historical speculation cannot be ignored. The aesthetic power of works of art, the fascination of images and their capacity to shape our response in the present, argues against treating them as if they were simply documents of particular historical horizons. Works of art can appear so present, so immediately accessible, that it is often difficult to keep in mind that they are as opaque as any other historical trace. The very appeal of the artifacts we call "art," images that seem to enhance and enrich the human condition as aesthetic experience, can blind us to the alienating power of time. Can we think dispassionately about objects that compel a phenomenological reaction? Is not the intensity of our confrontation with the art of the past such that we cannot easily

articulate the nature of our relation to it?[1] The present imperative of the objects of art historical fascination inevitably conditions the way we think about their roles in their own historical horizons. This reminder is not to suggest that art historians can do without a concept of temporal distance — far from it — but to propose that every attempt at definition betrays our incapacity to stabilize its meaning.

By way of a case study of the changing historiographic fortunes of Albrecht Dürer and Matthias Grünewald, this chapter reflects on an important assumption underlying the disciplinary activities of art history — the idea of *historical distance*.[2] The rich literature on this subject in the philosophy of history has prompted this consideration as to whether, and to what extent, the special circumstances of specifically art historical writing demand a different approach to its analysis. Art historical literature offers a number of ways in which the distance between the historical horizon under consideration and the interpreting historian might be conceived, and these ideas in turn have offered the discipline enduring models of methodological procedure.[3] My purpose here is not to evaluate these paradigms of historical distance, but rather to consider their function. What is their nature, what purpose do they serve, and how do they change over time?

My argument depends for its force on remembering the historiography of German Renaissance art during the 1930s and 1940s. Because the period is justifiably regarded as an aberration, a reprehensible occasion when the history of art was distorted by ideologues, this chapter in intellectual history has been obliterated from the consciousness of contemporary art historians, and thus tends to be forgotten. The use of the German past by the National Socialists, the conflation of historical horizons in the interest of nationalist propaganda, is an extreme example of the rejection of an objectifying distance between past and present. As a necessary reaction to the way the art of German Renaissance artists, such as Dürer and Grünewald, had been identified with the nationalist and racist doctrines of National Socialism, postwar historians emphasized the distance that separated the past from the present. The history of art had to be purged of its relation to the present so as to ensure an "untainted" view of the past. The success of this distancing project allowed many postwar historians to imagine that they were separated from the historical horizons they studied by an absolute and unbridgeable gulf, and that as a consequence the "truths" of history were available for definitive representation.

The question of historical distance is made more complex in light of re-

cent work on Dürer and Grünewald that reflects the increasingly varied conceptions of historical time now subscribed to by art historians. Whereas the discipline once largely accepted a Hegelian philosophy of history, according to which something meaningful made its way through time following a necessary teleological progression, contemporary contributions to the literature have attempted to escape this model by insisting on the immediacy of phenomenological response. What happens to the idea of historical distance in these circumstances? How can a response that appears to escape time be related to an overarching temporal system? How can historical distance be reconciled with the anachronic demands of works of art?

But I am getting ahead of myself here. Before we delve into the historiography of Dürer and Grünewald, I want to frame the argument in terms of the role of memory in historical writing. Changing conceptions of historical distance are related to the function of remembering and forgetting. How do we keep the objects of the past at bay while simultaneously insisting on their contemporary relevance? An insistence on access to the past is as important a feature of historical writing as an acknowledgment of its absence, especially if it is to be a cultural medium for enabling the present to come to terms with the past. Like remembering and forgetting, historical writing appears to depend on the paradox of asserting the presence of meaning in the past while simultaneously recognizing that its articulation by the contemporary historian transforms that meaning beyond recognition.

Since the work of Pierre Nora, Patrick Hutton, and others—especially those interested in the history of the Holocaust—the concept of memory has seemed to offer historians a notion more flexible than that of history, yet it is just as capable of suggesting the meaning of the events of the past.[4] Because memory depends on the informality of oral tradition and because it has a continuing life among ordinary people, the living power of memory has been preferred to the dead textuality of history. Memory's capacity to gesture toward the effects of presence that lie outside the normative conventions of historical writing, as well as its capacity to do justice to a greater diversity of experience, accounts for its fascination among contemporary historians. The appeal to memory, as Gabrielle Spiegel argues, has often resulted from a reluctance to conceive of the truths of history as beyond our reach:

> I believe that the turn to memory so pervasive in academic circles today
> forms part of an attempt to recuperate presence in history—a form of

backlash against postmodernist/poststructuralist thought, with its insistence on the mediated, indeed constructed, nature of all knowledge, and most especially knowledge of the past. In a sense, I am tempted to claim that memory has displaced deconstruction as a *lingua franca* of cultural studies. Memory, by becoming virtually hypostatized as a historical agent . . . makes it possible to essentialize and hypostatize the "reality" which it narrates.[5]

As Freud suggested long ago, however, memories are themselves recast every time they are called to mind. Memory, like history, cannot escape the effects of the context in which it is rehearsed. Both memory and history can be characterized as acts of will, impositions on the chaos of the past of an order and significance that cannot be found in so-called reality. Just as the meaning of a text depends on a Derridean "supplement" to convince us of its absent presence, both memories and histories depend on the illusion of being found rather than made in order to repress the creative role of agency in their construction.[6] Freud's purpose in attacking the Aristotelian theory of memory as the imprint of experience on the mind is not to suggest that experience leaves no traces, but to argue that far from being mechanically summoned to consciousness in its original condition, memory actually transforms experience in the process of recreating it. Rather than a memory cure—rather than simply enabling the patient to recall the traumas of childhood—psychoanalysis offers the patient a means of making those traumas accessible to consciousness, thus encouraging the formation of narratives that can enable him or her to come to terms with the past. In this manner, traumas can lose their debilitating, indeed paralyzing, hold on the present. The purpose of remembering is to offer the patient the capacity to forget.[7]

Yet memory will not leave us alone. However much we may be aware of the vagaries and the uncertainties of its testimony, it continues to afford us a disconcerting awareness that the past is different from the present. In what follows I want to draw an analogy between the haunting role of memory and the function of works of art in the art historical imagination. Despite our appreciation of the presentness of the task of interpretation and our consciousness of the fleeting validity of even the most persuasive historical analyses, we continue to try to grasp what cannot and will not be pinned down. Perhaps it is the knowledge that something escapes our understanding that makes both memories and works of art so fascinating. How can historians of

art ignore objects that are so patently tangible and immediate, so apparently available to our powers of understanding, even when they have proven to be so elusive and distant? While engaging with their contemporary presence, to what extent should we acknowledge that the nature of their difference lies in the realm of the imagination, that it is malleable, and that it is constantly subject to redefinition?

The continuing urge to construct historical distance in the face of the impossibility of ever keeping past and present wholly distinct is clearly exemplified in the historiography of German Renaissance art, particularly the writing on the two canonical artists of the period, Dürer and Grünewald. The literature on these artists is so immense, however, that it will be sampled rather than systematically reviewed. The political implications of the following story cannot be overlooked. This reflection on the impossibility of achieving any sense of historical distance necessary to distinguish adequately past from present in historical narratives is meant to enhance, not diminish, the task of the historian. The excesses of the nationalist historiography that I am about to review suggest the political dangers of approaching the past as if it can be reduced to the political interests of our own day. They indicate not just the continuing need to insist on the difference between past and present but also that both memories and works escape a full accounting in any particular moment in time. This chapter, therefore, is not about the relativity of historical writing, the inevitable conclusion that this literary genre can never offer us a conclusive account of the past (that goes without saying); it is rather a reflection on our need to treat the past as different in the full awareness that that very difference is constructed in the present.

During the Weimar Republic and the period of National Socialism, Dürer and Grünewald were often compared and contrasted as a means of articulating the competing agendas of different nationalist groups. Whereas Dürer had been appreciated and studied since the sixteenth century, an interest in the art of Grünewald only surfaced in the late nineteenth. This neglect obviously had something to do with the fact that nothing was known about the artist of the *Isenheim Altarpiece* beyond a name. All knowledge of Grünewald's identity had been lost by the seventeenth century. When Joachim von Sandrart, himself a leading German painter, published his two-volume history on the history of German art in 1675, he confessed that he had little to convey about this painter but hearsay. Indeed the name he bestowed on him, "Mattheus Grünewald," or "Mattheus von Asschaffenburg," has

never been documented in archival sources.[8] A more telling reason for this oblivion, however, may have been the fact that the *Isenheim Altarpiece* was located in Alsace, a German-speaking province of France that only became part of Germany following the Franco-Prussian War of 1870–71.[9] It was thus in the context of the nationalist movement that led to the foundation of Germany as a nation-state that German scholars turned their attention to this little-known artist.

Wilhelm Worringer claimed that there was an essential quality of German art that distinguished it from that of all other countries, a quality he discerned in the expressive linearity of German art of the Middle Ages.[10] Similarly, the first monograph on the artist, Heinrich Schmid's two-volume work of 1911, argued that Grünewald was a quintessentially German spirit. His work supposedly united late-Gothic art with the Baroque, thus ignoring or circumventing the "foreign" (i.e., Italian) Renaissance.[11] Yet in contrast to Worringer, who had regarded Dürer and Hans Holbein as the supreme artists of the German Renaissance, Schmid insisted that Grünewald was a more fitting example of the German spirit because he had evaded the influence of Italy.

In the nationalist tradition of art writing that followed, the historical distance separating the age of Dürer and Grünewald from the present was invoked only to collapse it in the interest of a political ideology. The difference between the Germany of the sixteenth century and that of the early twentieth was brought to mind only to be sacrificed on the altar of an alleged continuity of national identity. The alterity of the past was elided in the interest of a transhistorical narrative that dramatized the essential nature, the inalterable constancy of the German spirit. This new reading of Grünewald opened the doors to a flood of nationalist criticism that ultimately made his reputation equal, if not superior, to Dürer's. Heinrich Wölfflin, for example, was caught up in the desire to compare the two artists in terms of their Germanness. Writing in 1905, Wölfflin insinuated that Dürer's concern with the theory and practice of Italian art constituted a betrayal of his Germanic heritage, for Wölfflin believed that Dürer's art was riven by conflicting impulses arising from the clash of his native training with his cosmopolitanism: "After so many basic objections one hardly dares ask the question: can Dürer be extolled by us as *the* German painter? Rather must it not finally be admitted that a great talent has erred and lost its instincts by imitating foreign characteristics? Without doubt there is much in Dürer's art, and

not only in his early art, that is original and delicious. But his work is interspersed with things which are alien to us. Samson lost his locks in the lap of the Italian seductress."[12] Comparing Dürer to Grünewald, Wölfflin engineered an art historical hydraulics. As one rose in his esteem, the other fell, according to a scale of values that depended on the relative intensity of their Germanic spirit:

> New conceptions of the nature of German art have been formed and Grünewald has moved from the periphery to the center. He has indeed become the mirror in which the majority of Germans recognize themselves and his isolation has ended. . . . Now it is rather Dürer who appears to be the exception. His fame seems to have been made possible only by the coincidence of Grünewald's disappearance for centuries from the nation's view. Beside Grünewald's abundances and elemental force Dürer's artistry appears to be one-sided, sometimes almost scholarly and academic, and his cult of Italianate form seems to have undermined his inborn German character in a fatal way. We demand living colour. Not the rational but the irrational. Not structure but free rhythm. Not the fabricated object but one that has grown as if by chance.[13]

This binary opposition depends on the formal characteristics of the two artists: on the opposition, say, of Dürer's concern for the clarity of two-dimensional form, a feature of his work particularly evident in the graphic media for which he is most famous, and Grünewald's use of a palette that often exceeds the limits of the naturalistic artistic traditions of his time. Dürer's interest in the Italian revival of ancient theories of human proportion, as well as in Albertian perspective, marks his works not only as foreign-inspired but as more careful, rational, and theoretical than the bolder, more colorful, and flagrantly fantastic nature of the creations of his contemporary.

Critical attention to Grünewald increased during the First World War, when Franco-German hostilities threatened the city of Colmar. In 1917, against the wishes of the city's government, the German military authorities had the *Isenheim Altarpiece* transported to Munich for safekeeping.[14] Once there, it was restored and cleaned before being put on exhibition, when it immediately became the object of pilgrimage. According to Ann Stieglitz, "Special tours to see the altar were arranged for those coming from out of town, and wounded soldiers, many limbless, were wheeled in front of it, where religious services were held."[15] At war's end, the *Isenheim Altarpiece's*

return to France was accompanied by effusions of nationalist outrage on the part of the German press and by self-congratulatory cheer on the part of the Allies. An anonymous article in a Munich newspaper, dated September 28, 1919, captured the emotional intensity of the scene of impending loss:

> Schoolboys of ten or twelve with colored caps, or bare heads; workers; citizens; . . . painters; old people; children. Like a procession, a stream flowed regularly passed [sic] the back of the altar, where St. Anthony's visit to the Hermit and the Temptation were to be seen—and the awesome drama of the split Golgotha picture: the one arm of the Crucified Christ detached from the crossbeam into the air. . . . The red removal van stood below. A wretched reality: like a coffin and grave. The lost war. One cannot keep back this thought; and it is neither unobjective nor sentimental. A piece of Germany is being cut away, the most noble part: Alsace, Alemmania. Grünewald.[16]

The opening of the outer panels of the altarpiece (fig. 7.1), in which Christ's body appears to be torn apart, his arm rent from his torso—a feature that had caught the attention of many earlier (and later) commentators—was here invested with new meaning. A formal quality of the image, Grünewald's portrayal of Christ's figure, was the catalyst of emotional response. This rare reference to the structure of the image, as well as to the observer's phenomenological response, affords us insight into the psychological background to much of this criticism. The identification of Grünewald as a German artist, an anachronistic projection back into the past of the idea of the nation-state that did not exist in the sixteenth century, allowed this material vestige of the past, the *Isenheim Altarpiece*, to be invested with particular poignancy in the wake of the German defeat in the First World War. Rather than being the object of antiquarian interest, the image had become a means by which national identity could be crystallized and defined in the present. Grünewald's Crucifixion became a symbol of Germany's agony, the Passion the country suffered as a consequence of its defeat in the First World War.

Just as the altar was capable of being used for nationalist purposes, it also proved amenable to those who rejected German militarism. In 1928 George Grosz was prosecuted for blasphemy for his published drawing of a crucified Christ wearing a gas mask and boots (fig. 7.2). The illustration, captioned *"Shut Up and Do Your Duty,"* played off the national obsession with

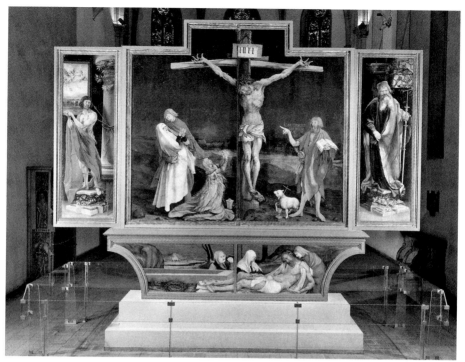

FIGURE 7.1 MATTHIAS GRÜNEWALD, *CRUCIFIXION* (EXTERIOR OF THE *ISENHEIM ALTARPIECE*), CA. 1512. Oil on panel. Musée Unterlinden, Colmar, Inv. 88.RP.139. © Musée Unterlinden, Colmar

the *Isenheim Altarpiece* in order to mock the Catholic Church for support of the military. In this drawing, and in the photolithograph "*Silence!*," from 1935–36 (fig. 7.3), the emaciated body, the nail-torn hands, the twisted legs, and the ripped loincloth of the *Isenheim Altarpiece* are juxtaposed with the gas mask and boots of trench warfare to produce a devastating commentary on the function of the clergy in times of war. Grosz's trial, which dragged on until 1931, eventuated in his unexpected acquittal, though the German Supreme Court vented its frustration at the outcome by decreeing that the artist's illustrations for the series, along with the photolithographic plates from which they had been printed, be confiscated and destroyed.[17]

These sensational events indicate that the nationalist rhetoric of German art historians is far more than a purely textual phenomenon. The social and cultural circumstances in which the rediscovery of Grünewald took place are part and parcel of the attitudes manifested in art historical criticism. In fact, they are inextricably meshed into a coherent worldview. Anyone writ-

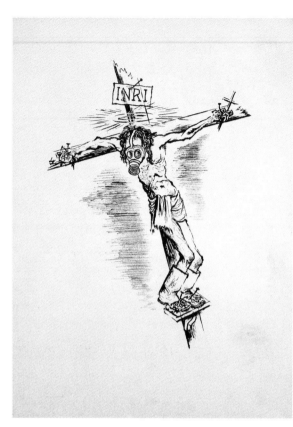

FIGURE 7.2 GEORGE GROSZ, *"SHUT UP AND DO YOUR DUTY,"* 1927. Drawing. Stiftung Archiv der Akademie der Künste, Berlin. Art © Estate of George Grosz / Licensed by VAGA, New York, NY

FIGURE 7.3 GEORGE GROSZ, *"SILENCE!,"* 1935–36. Photolithograph. Stiftung Archiv der Akademie der Künste, Berlin. Art © Estate of George Grosz / Licensed by VAGA, New York, NY

ing on this subject in Germany at this time would have found it difficult to avoid the nationalist rhetoric with which discussions of German culture had been invested. The counter-example provided by the works of Grosz, which cast an ironic glance at the nationalist appropriation of Grünewald, proves the power of the dominant tradition.

One of the few dissenting voices in the art historical apotheosis of Grünewald as the most German of German artists was predictably that of a French scholar, Louis Réau. In his monograph of 1920 on the artist, he acknowledged the role ascribed to Grünewald by German art historians but argued that his importance transcends national borders. Far from involving himself in the controversy as to whether or not Grünewald could be claimed to represent any one national identity, a debate he called puerile, Réau argued that Grünewald's true significance lay in his status as a "modern" artist, that is, as a precursor to the modernist movement of Réau's own times. Having been cast into oblivion as a consequence of art history's Italocentrism, Grünewald now ran the risk of being misunderstood because of art history's "Germanocentrism."[18] Réau refused to allow his artist to be trapped within the confines of what he clearly regarded as an art historical dead end, namely the debate regarding the virtues of northern art in relation to those of Mediterranean. Instead, Réau argued that the very qualities that make Grünewald's art the antipode of that of Dürer—the freedom of his drawing, his flouting of the rules of perspective, his willful distortion of color—all marked him as an artist who transcended the boundaries of space and time. Réau's national sympathies were, nevertheless, apparent: his book is dedicated to both his wife and "French Alsace," and he welcomed the return of the *Isenheim Altarpiece* to French soil after what he regarded as a regrettable sojourn in Germany.[19]

According to Réau, Grünewald properly belonged neither to the Middle Ages nor to the Renaissance, but rather to the Baroque period. In Grünewald's art Réau claimed to see the plasticity and movement that Wölfflin had asserted were the hallmarks of that age, as well as the conscious use of dissonance and asymmetry.[20] In his conclusion, he accuses the nationalist critics of a blindness that serves to diminish the true grandeur of Grünewald: "These blind men do not realize that their praises diminish the idol they intend to exalt because it is in the nature of a really great artist to address the intelligence and sensibility of the people of all nations and all races."[21]

This cosmopolitan voice was ignored or perhaps drowned in the nation-

alist rhetoric that characterized German writing on the artist in the years that followed. Perhaps the most outspoken of the nationalist writers of the times was Oskar Hagen. Deeply resentful at the return of the *Isenheim Altarpiece* in 1918, he claimed that in neglecting Grünewald art historians distorted the history of German painting. While Dürer represented objectivity, Grünewald stood for intuition, a distinctively German characteristic. His art represented the uniquely German power responsible for the outbreak of the Reformation. Far from being a mere epigone of Dürer, Grünewald was identified with what was most vitally and quintessentially German in this period: "If today the history of art should be revised, one should above all be clear about the error that needs correction: the established history of German painting has been an account that left what is German out of consideration as if it were something insignificant!"[22]

Unlike the Italian masters who had been content to pursue a naturalistic art based in part on ancient models and theories, Dürer and Grünewald understood that the point of naturalism was to penetrate the surface of appearances in order to find the reality that lay beneath. In Grünewald's case, his grasp of reality served the religious ideas of his time. Far from his being a devout Catholic, as most have assumed, Hagen claimed that Grünewald's work embodied the spirit of the Reformation that was yet to come. Luther's language and Grünewald's imagery registered the realities of the spiritual life in the same way.[23] Whereas Dürer's mature work was dedicated to the concept of beauty, Grünewald's art was never limited by a desire to be faithful to appearances. Echoing Worringer's claim that the basic characteristic of German art was its dedication to line, Hagen suggested that Grünewald's line should be regarded as a metaphor. The artist exploited the hidden potential of line's power to invest even the smallest silhouette with the expressive and poetic power of fantasy.[24] If Dürer's art was one of representation, in which the role of mimesis is paramount, Grünewald's was an expressive art akin to poetry or music.

Friedrich Haak's 1928 book on *Dürer: Deutschlands grösster Künstler* specifically invoked Grünewald as the patron saint of Expressionism, the most important German modernist movement of the period: "The present moment always reaches back into the deep well of the past in order to draw out that which corresponds with its own demands and requirements as well as its desires and ambitions. This modern Expressionism has chosen a relatively unknown German painter, a contemporary of Albrecht Dürer, the great and

mighty Matthias Grünewald, to be both its sworn companion and patron saint."[25] The Expressionists, according to Haak, found their inspiration in Grünewald, for he bequeathed them a model of immediacy, rapture, and delirium, as well as a "glowing, scintillating, orgasmic, symphony of color."[26] The expressive quality of Grünewald's color and the artist's willingness to bend the rules of mimesis — the spiritual freedom and the inner necessity that fueled this fantasy — were revived by contemporary artists as metaphors of national identity.

Nationalist criticism during the 1920s had favored Grünewald over Dürer as the most genuine representative of the German tradition in art, but nevertheless there were many authors who continued to plead Dürer's case in the nationalist cause. The fervor with which his candidacy was pursued intensified in the years preceding the Second World War, when the Expressionist movement came under fire from theorists within National Socialism. Until 1933–34, the party by and large subscribed to the view that the German Expressionists constituted a manifestation of eternal German values. After that date, however, the party turned its back on all aspects of modernism, a development that led to the infamous *Degenerate Art* exhibition held in Munich in 1937, at which both Expressionist art and artists were held up to ridicule.[27] Because Grünewald's status depended on the fate of Expressionism, both hung in the balance of National Socialist party politics. The revival of interest in Dürer in the late 1930s and during the war, therefore, represented a rejection of Grünewald, an artist too intimately associated with degenerate modernism.

Many authors of this period approached Dürer's iconography with an eye to its nationalist potential. A striking feature of German writing on Dürer in the years before and during the Second World War was the prominence ascribed to his famous engraving *Knight, Death, and the Devil* (fig. 7.4). Although the work had already been associated with German national identity in the nineteenth century, it had also been identified as a representation of the Christian Knight.[28] Wilhem Waetzold, the author of an influential book on Dürer, delivered a lecture on this image in 1936 in which he made it an icon of nationalist sentiment:

> True, Knight, Death and Devil does not speak equally loud and clear to all times and all persons. Dürer's high-thinking epoch perceived the triumphant organ sound of the print. Fainthearted generations on the other

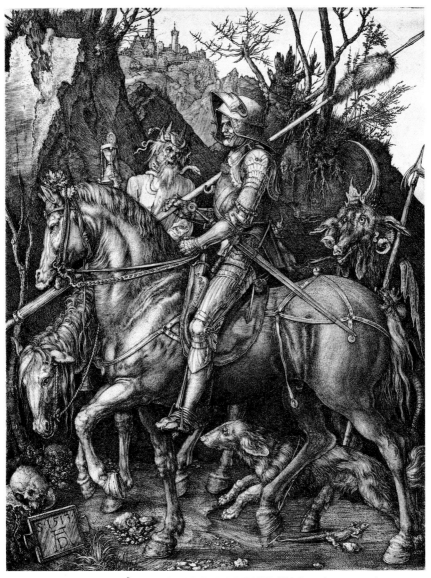

FIGURE 7.4 ALBRECHT DÜRER, *KNIGHT, DEATH, AND THE DEVIL*, 1513. Engraving on paper; image: 9⅝ × 7⅜ in. (24.4 × 18.7 cm). Sterling and Francine Clark Art Institute, Williamstown, Massachusetts, USA, 1978.18. Image © Sterling and Francine Clark Art Institute, Williamstown, Massachusetts (photo by Michael Agee)

hand heard more the harmonies of *memento mori*. Heroic souls love this engraving as Nietzsche did and as Adolf Hitler does today. They love it because it personifies victory. It is of course true that death will one day conquer us all, but it is equally true that a heroic man wins a moral victory over death. This is the eternal message of this print, the spiritual bond that unites Dürer's time and ours. Dürer's clarion call sounds to us across the centuries and finds once more an echo in our German hearts.[29]

The role of the past in this kind of rhetoric was to justify and validate the present. It was only "fainthearted generations" that failed to see the print's reference to the victory of the German cause. The print was ascribed a transhistorical essence whose "truth" proscribed interpretive disagreement.

In 1937 the racial theorist Hans Günther, a National Socialist party favorite and friend of Hitler's who had been appointed to a chair of social anthropology at the University of Jena, dedicated an entire book to the topic of heroism in German culture, using Dürer's *Knight, Death, and the Devil* as its frontispiece. Günther was not an art historian, but he offers an example of the kind of writing with which Dürer's images were associated in these sinister years, as well as insight into their cultural function. In his eccentric book, the nineteenth century was condemned as an era that saw the rise of liberal democracies, socialist ideas, and evolutionary theories of human development. That retrograde culture was to be swept away by a heroic conception of the fate of the individual, an ordered society, and a belief in national destiny. In terms of art, Impressionism was rejected in favor of Rembrandt and the art of the German Middle Ages. Needless to say, Expressionism was dismissed as a manifestation of the degenerate life of the metropolis, and it was Dürer rather than Grünewald who was granted pride of place in a pantheon of German heroes that included Luther, Leibniz, Bismarck, and Kant.[30]

Rather than dwell on this sorry moment in the history of scholarship of the German Renaissance—rather than add further examples of its service in the cause of a racist nationalism—I want now to reflect on what we can learn from this historiographic review. To what extent has the fate of subsequent interpretation in this field depended on forgetting that this episode ever took place? How does postwar writing on this subject differ from that of the preceding period? What ideological purposes have the figures of Dürer and Grünewald subsequently served? What has happened to the binary opposition that animated the evaluation of Dürer and Grünewald in

nationalist criticism? How can we characterize the approaches to these artists taken by art historians working today?

The extremism of the nationalist moment, the unconscionable brutality of its excess, led to a disavowal of the values and concerns of the present in accounts of the past. The postwar historiography of the German Renaissance deliberately turns its back on politics, and the historical significance of Dürer and Grünewald is no longer assessed in nationalist terms. The goal of these historians has been to insist that historical distance, the difference between the past and the present, is a safeguard to the infection of the past by the present. The past had proven too powerful a tool in the hands of the present and needed once more to be banished to its proper historical horizon.

The great architect of the new order is Erwin Panofsky. Having lost his professorship at the University of Hamburg because he was Jewish, Panofsky made his home in the United States. This exiled scholar is responsible for developing the most influential and lasting theory of historical distance in postwar art historical writing. According to Panofsky, the concept of historical distance only appeared in the Renaissance, because earlier periods had been incapable of fully integrating the visual forms and literary traditions of antiquity into the stylistic vocabularies of their own times. This integration is the great achievement of the later age: "the two medieval renascences were limited and transitory; the Renaissance was total and permanent."[31] A powerful metaphor for the ability of the Renaissance to "see" the past correctly is, of course, linear perspective. It is no accident that Panofsky also argues that one of the greatest achievements of the Renaissance was to have established the principles of the most persuasive system for representing space illusionistically: "In the Italian Renaissance the classical past began to be looked upon from a fixed distance, quite comparable to the distance 'between the eye and the object' in that most characteristic invention of this very Renaissance, focused perspective. As in focused perspective, this distance prohibited direct contact—owing to the interposition of an ideal 'projection plane'—but permitted a total and rationalized view."[32] In fusing the capacity of Renaissance culture to build a distance between itself and the past, with its development of a geometric system that enabled a convincing depiction of space, Panofsky gives this historical moment an unusually privileged place in European history. Both the claim to an "objective" notion of historical distance and the claim that Renaissance

perspective corresponds with the perception of space, serves to endow this period with an ideal quality that is ideologically motivated. According to Stephen Melville:

> The way to Panofsky's understanding of the objectivity of art history lies through the Renaissance because the Renaissance provides the means to elide questions of the becoming historical of art; his valorization of perspective forges an apparently nonproblematic access of the rationalized space of the past. We are freed then to imagine ourselves henceforth as scientists of a certain kind, and within this imagination the grounds of privilege become invisible and profoundly naturalized.[33]

The spatial rationality of the Renaissance thus becomes a metaphor of objectivity. The new paradigm of art historical method achieved by these means is no less powerful because its metaphoric status is more often ignored than acknowledged.

Though Panofsky could not consciously have recognized this investment, his notion of historical distance is a defense of humanist culture and a means of keeping history safe from "ideologues." The need to keep civilization out of the hands of barbarians made him view his scholarship in the United States as a means of ensuring the survival of values that had been threatened with obliteration in fascist Europe.[34] Whereas for the nationalist historians the conflation of historical horizons was a way of claiming the continuity of national identity, for Panofsky historical distance is a means of validating the purportedly universal values of the humanist tradition. If nationalist critics working in a Hegelian tradition had exploited Hegel's view that the unfolding of the "Spirit" was best observed in the art of different peoples or nations, Panofsky's debt to this philosopher may be discerned in exalting the Renaissance as a decisive moment in the self-realization of humanity.[35] Investing the past with meaning by means of a teleological theory of history allows him to ennoble modernity as the fulfillment of the humanist ideals of Renaissance culture.

Panofsky's book on Dürer, *The Life and Art of Albrecht Dürer*, has fundamentally structured the course of postwar studies on this artist.[36] The nationalist epic of Dürer's encounter with Italy, the tragedy of the adulteration of his Germanic spirit with the imported values of Italian culture, is inverted and replaced with a more personal dichotomy. Rather than abandon

his own artistic tradition in light of foreign models, Dürer is now seen as torn between the artisanal naturalism of his Nuremberg training, with its dedication to empirical observation, and an interest in Italian theory as a way of producing forms whose aesthetic guarantee lies in the realm of ideas rather than experience. The role of Italy in Panofsky's account of Dürer's work not only ruptures the alleged continuity of the German national spirit but also symbolizes the enlightened tradition of humanist rationality.

Panofsky rejects and recasts the binary opposition of the nationalist account so as to offer a different narrative altogether. The moral to be drawn from the life of the artist is not about the German essence of Dürer's personality but the agonizing conflict between two aspects of his artistic genius. Instead of *Knight, Death, and the Devil*, once again interpreted as an allegory of the Christian life, Panofsky's emblem for Dürer becomes *Melencolia I* (fig. 7.5). The émigré art historian reads the print as an allegory not only of the emerging Renaissance consciousness of the artist as an exceptionally gifted individual but also of Dürer's own struggle with competing dimensions of his personality.[37] The conflict between tradition and theory in Dürer's art is analogous to the clash of ideologies in Panofsky's own day. Dürer's inability to reconcile theory and mimesis, characterized by Panofsky as a failure, may be regarded as a metaphor of the art historian's own alienation from German culture, and Dürer's defeat at the hands of tradition an emblem of the rout of Enlightenment values in Nazi Germany. Panofsky's tale is thus supported by a double "supplement": on the one hand, its implicit criticism of the nationalist historiography—its insistence on historical distance—represents a political alternative to what had gone before; on the other, its expression of his melancholy at the loss of the ideals that inspired the German culture of his youth affords us access to the motives that inspired his narrative.[38]

Panofsky's views on historical distance have not gone unchallenged in an age that has called Enlightenment humanism into question. Taking issue with the objectivist and quasi-scientific tradition of art historical writing that has its origins in Panofsky's work, Georges Didi-Huberman argues that art history is necessarily an "anachronistic" discipline. While purporting to be about the past, it cannot escape its involvement with objects in the present: "It is better to recognize the necessity of anachronism as something positive: it seems to be internal to the objects themselves—the images—whose

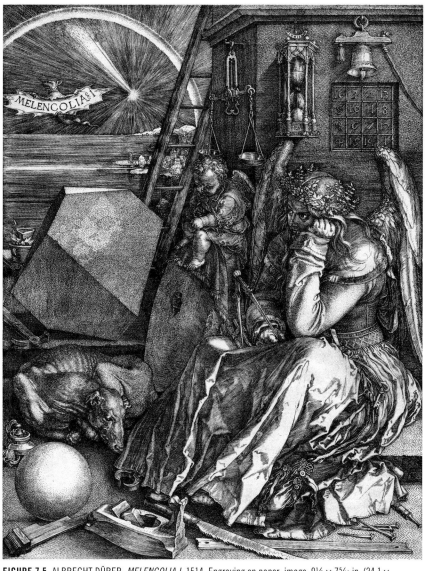

FIGURE 7.5 ALBRECHT DÜRER, *MELENCOLIA I*, 1514. Engraving on paper; image: 9½ × 7⁵⁄₁₆ in. (24.1 × 18.6 cm). Sterling and Francine Clark Art Institute, Williamstown, Massachusetts, USA, 1968.88. Image © Sterling and Francine Clark Art Institute, Williamstown, Massachusetts (photo by Michael Agee)

history we are trying to reconstruct. In a first approximation, then, anachronism would be the temporal way of expressing the exuberance, complexity, and overdetermination of images."[39] Far from denying the possibility of historical distance, Didi-Huberman recognizes that art history fundamentally depends on it. This distance, however, cannot be fixed, for it is forever subject to a negotiation between past and present.[40] Didi-Huberman's comments recognize the tension between the lure of the object—the aesthetic demands of the work of art in the present—and the need to register the alterity of the past. In his attempt to do justice to the past, Panofsky fails to acknowledge the inherent anachronism of the discipline to which he contributed so much.

Postwar German scholars follow Panofsky in regarding Dürer's art as a biographical rather than a national allegory. The relation of the artist's life to his work, the Vasarian paradigm in which art history was born, is resuscitated as the most effective means to combat the ideological forces that had employed these works as part of a sinister narrative of national identity. Both Peter Strieder and Fedja Anzelewsky, for example, who have produced learned contributions to the Dürer literature, emphasize the artist's life as the driving force behind his art. While affording the reader a great amount of information and insight into the social and cultural circumstances in which he lived, this material becomes a means of dramatizing Dürer's artistic achievements. These accomplishments are characterized as personal and timeless rather than historical and collective.[41] By emphasizing the role of the individual, by stressing Dürer's incomparable gifts—gifts that set him apart from mere mortals—these authors, consciously or unconsciously, supported the political agenda of a democratic and capitalist West Germany. Dürer's power of agency, his capacity to transform the artistic conventions of his time, becomes an allegory of the value of the individual over the collective, while simultaneously justifying the commodity status of the aesthetic constituents of the canon. Anzelewsky's debt to Panofsky may also be traced in his insistence on Dürer's interest in Neoplatonism. Just as Panofsky's interpretation of *Melencolia I* depends on Dürer's access to the new concept of melancholy that had been forged in the philosophical context of Renaissance Florence, Anzelewsky's contributions to our understanding of Dürer's iconography depend on the claim that Dürer was aware of the ideas of Marsilio Ficino.[42] The suggestion that Dürer's works are to be approached as learned allegories characterizes them as spiritual achieve-

ments. It removes them from the context of communal life so as to embed them more deeply in his personal consciousness.

Panofsky's theory of historical distance, so effective a means of containing the political and ideological in the unconscious of historical texts, however, could not prevent Dürer from being appropriated once again for political purposes. The eruption of political interests into the historical appreciation of Dürer is most evident in the context of the celebrations in 1971 that marked the four-hundredth anniversary of his birth.[43] Both East and West Germany felt a compulsion to celebrate Dürer as a great German artist. In West Germany the government supported an extensive exhibition under the patronage of the nation's president, its chancellor, the vice president of the Bundestag, and the mayor of Nuremberg.[44] The location of the exhibition was certainly no accident. Nuremberg was not only Dürer's native city but it had long been associated with the Holy Roman Empire, having housed the Hapsburg crown jewels until the eighteenth century, when they were transferred to Vienna. While Nuremberg's prestige as the city linked with medieval German majesty had been tarnished by the events of the Third Reich (Hitler had held some of his major rallies there, and it was, of course, the site of the war-crimes tribunal), its history was clearly important to the creation of a new sense of national identity.[45] Flattened by Allied bombing at the end of the Second World War, the city had been lovingly restored in the postwar years. In contrast to the national purpose discernible in the nature and location of West Germany's celebration of the anniversary of Dürer's birth, the exhibition's catalogue offers an encyclopedic account of Dürer's life and times in which empirical information sometimes appears to outweigh an interpretative agenda. Because of its moral force, the basic outlines of Panofsky's interpretation remain unchallenged. His treatment of Dürer's life as an allegory of the struggle between reason and unreason, blind tradition and enlightened innovation, coincided with the political need to provide West German national life with an ideology that was both progressive and inspiring.

Panofsky's thesis, however, did not coincide with the motives of the East German celebration. Beginning in the 1960s, both Dürer and Grünewald became increasingly identified with what came to be known as "the early bourgeois revolution." Marxist theorists argued that the German Peasants' War of 1525 had been an important precursor of class war, which they considered the inevitable outcome of the capitalist system of their own time.

Because of the intimate connection between the demands of the serfs for both spiritual and economic freedom, it was possible to suggest that the Reformation and the peasant movement were one, and that there was unity between the spiritual transformations of the age and theories of historical materialism.[46] Both the German Democratic Republic's major exhibition, which took place in Berlin, and its official publications fêted Dürer as an artist with a social conscience. The preface to a collection of essays published by the Karl Marx University in Leipzig claims that Dürer's genius stems from his consciousness of the artist's responsibility for social progress and his utopian vision of the future of humanity.[47] According to Ernst Ullmann, Dürer identified with the progressive forces that were responsible for the religious and social transformations of his time:

> For Dürer the beautiful also included the true and the good, a proper understanding, and an educational and uplifting effect on the viewer. Thus Dürer, himself one of the heroes of his age, did not just passively mirror one of the greatest revolutionary processes in the transition from the Middle Ages to Modernity, but through his work he took an active role in it—in freeing the individual from the chains of class that characterized the old feudal society and in the formation of autonomous individuals.[48]

Comparing and contrasting Dürer and Grünewald in the manner to which we have become accustomed, Wolfgang Hütt argues that while both artists identified with the peasant cause, Dürer followed the humanist tradition of Italy, but Grünewald rejected all things Italian because of his opposition to the Catholic Church.[49] Grünewald's image of the Crucifixion represents his belief in the ideals for which the peasants struggled: "For Gothardt Neithardt [Grünewald], the crucified Christ embodied a belief in the justice for which the peasants of 1525 had fought against the powerful of this world. The peasants, the proletariat, the intellectuals, and the artists, proved too weak, and the historical situation not yet ready, for them to realize the justice for which they strove."[50] Finally, Peter Feist hails Dürer as a forerunner of socialist realism, an artistic policy adopted by the East German Communist Party after 1945 and only abandoned in the course of the 1960s. Feist argues that Dürer represents a synthesis of naturalism and idealism that offers an example to contemporary artists.[51]

These scholars trade Panofsky's interpretation for another of the "mas-

ter narratives" of their own time. Rather than see Dürer as engaged in a personal struggle of reason and unreason, virtue and vice, he becomes a hero of the class struggle. Once more historical distance is sacrificed in the interest of a transhistorical principle. Dürer's role in asserting the value of the individual, as well his prescience in choosing the style best suited to the demands of a socialist culture, allow him to be identified with the values of the Marxist narrative. Not only did the teleology of this narrative promise a utopian future to those who recognized and supported its message, but it also served to enhance the national prestige of the East German state that sponsored it.

This brief analysis of the cultural function of the concept of historical distance in the historiography of German Renaissance art in the twentieth century cannot close without a look at the texts that could be said to define the critical situation in which the literature on Dürer and Grünewald currently finds itself (at least in the English-speaking world). What methodological tools do contemporary authors deploy in their writing, and how do these differ from those of the past? What is the relation between the immediacy of aesthetic response and the objectifying impulse of the historian?

Among the most influential recent studies on Albrecht Dürer is that by Joseph Koerner.[52] In an ambitious analysis of Dürer's self-portrait of 1500 (fig. 2.2), Koerner claims that Dürer consciously asserts the unique status of the artist as a divinely gifted creator. The artist emerges as the architect of a new age, one who calls into being a new era of art. Grounding himself in a phenomenological approach to his subject, Koerner self-consciously hints that he is as incapable of articulating the philosophical motivation of his narrative any more than Dürer was capable of articulating his. In other words, Koerner explicitly acknowledges the problem with which we have been grappling, namely, the necessity of historical blindness in the pursuit of historical insight. He offers us an argument for the idea that it is the power of the image, the immediacy of our response, that prevents us from ever fully articulating the grounds that animate the narratives we choose to spin around them: "Dürer proposes himself as origin; and in placing him at the start, indeed in arguing that he has already prefaced what I shall say about him, I underwrite his proposal."[53]

Koerner's answer to the problem of historical distance is thus the antithesis of Panofsky's. Instead of emphasizing the gulf that separates his-

torical horizons—one that can only be surmounted by a Kantian "symbolic form" (in this case the metaphor of Renaissance perspective)—he collapses the distinction.[54] Art historical access to the past is not to be accomplished by eliminating all traces of the present that might possibly affect our encounter with the past, but rather, scholars can afford us access by allowing a phenomenological experience of the work to prompt their own representations about its meaning. Koerner responds to the representations created by a lost world as if they were presentations that demanded an unmediated response. Engaging the past becomes the means of asserting the role of the present in the process of interpretation. In affirming personal aesthetic response as the basis of interpretation, Koerner's gesture could not be further from that of the German historians of the prewar era. Far from suggesting a reductive similarity between present and past—that ethnic continuities, for example, might elide the differences that mark distinct historical moments—he uses experience as the grounds on which to attempt to capture that which must necessarily escape definition—the unique nature of the work of art. It is the work's protean capacity to solicit different reactions as it travels through time that imbues it with lasting aesthetic appeal.

Koerner's perspective introduces a new basis for art historical writing. Rather than share Panofsky's belief in the objective power of reason to discern the nature of what happened in the past, Koerner collapses the subject/object distinction in order to make the works speak for "themselves." An Enlightenment trust in rational objectivity is abandoned in favor of subjective engagement. Like Panofsky's, Koerner's strategy tends to elide the philosophical, cultural, and political stakes of interpretation. Rather than being explicitly articulated, these remain, perhaps necessarily, embedded in the act of interpretation. This approach need not prevent us from speculating about the values that may inform the writing. Koerner writes at a historical moment that has witnessed a challenge to the positivistic idea that scholarly objectivity can be guaranteed by a unified and autonomous subjectivity.[55] It seems only appropriate that Koerner should have written a paean of praise to the creation of this mythic subject of the humanist tradition at the moment of its dissolution. His invocation of theorists of reception history and reception aesthetics, such as Hans Robert Jauss and Wolfgang Iser, who emphasize the ever-changing nature of aesthetic response between the moment of the work's inception and its reception, is crucial to the idea of the "fusion" of historical horizons.[56]

Koerner's attitude serves to sabotage the biographical paradigm on which so much of the postwar scholarship has been based. The epoch-making quality he finds in Dürer's art is located as much in the work as in the figure of the artist. In Dürer's *Self-Portrait* of 1500, both artist and work merge as they call the age of art into being. While Koerner's book could be (and probably has been) used to support the value ascribed to Dürer's work in the marketplace, Koerner is more interested in the philosophical stakes of characterizing art history as a transpersonal process in which the role played by the aesthetic object is at least as important as that played by its scholarly author.

As a methodological foil to Koerner's Dürer book, we might refer to Andrée Hayum's on Grünewald. Citing Michael Baxandall's celebrated work on Florentine art of the fifteenth century, Hayum indicates that her concern is to develop an anthropological approach to the interpretation of Grünewald's *Isenheim Altarpiece*.[57] Baxandall envisions the social history of art as a way of understanding a work of art within the full complexity of its cultural and social relations. In doing so he emphasizes the alterity of the past, the way in which it exceeds our powers of comprehension. Fully aware that the visual nature of works of art means that they escape capture by the power of language, Baxandall nevertheless creates a critical distance between the historical horizon in question and the interpreting historian in order to legitimate the validity of historical interpretation.[58] If the past could be encountered in its totality, undistorted by the values of the present, then the essential "truth" of history might be established. Like Panofsky, Baxandall's vision of the relation between the horizon of the past and the horizon of interpretation is meant to ensure that historical accounts are un-tainted by values extraneous to it.

Hayum's debt to Baxandall is principally evident in her discussion of the possible function of the altarpiece as part of the healing program of the Anthonite order. She suggests that the work's graphic depiction of pain was the focus of an empathetic identification. According to Hayum, the altarpiece permitted those afflicted with skin diseases (St. Anthony's fire) to relate their own suffering to that of Christ in a way that enhanced its promise of salvation (fig. 7.1). Her discussion of the altar's subject matter emphasizes the sacramental and therefore the Catholic program of the image, a conclusion that contradicts some of the earlier nationalist literature claiming that Grünewald was the pictorial equivalent of Martin Luther. Hayum's inter-

pretation attempts to offer us an objective account of the role of the altar in its original cultural circumstances, one that focuses on the content of the work and its effects on the sixteenth-century viewer rather than on its continuing impact on the spectator in the present. Unlike Koerner, who foregrounds the importance of the historian's response to the image, Hayum does not draw attention to her own role in the creation of her narrative.

The contemporary literature on Dürer and Grünewald therefore presents us with two distinct ways of dealing with the issue of historical distance. Attempting to characterize the difference between their approaches in the full realization that the enterprise must necessarily be reductive, we might say the following: if Koerner fuses the temporal location of the historian with that of the past by responding to the presence of the image rather than fit the work into a pre-established historical context, then Hayum focuses on the historical circumstances that led to the work's creation in a manner that emphasizes the distance that separates the historical horizon under consideration from the altar's aesthetic reception in the present. One gesture offers us a historically informed response to the work as a *presentation*, as an artifact with a continuing life in the present, while the other approaches it as a *representation* in order to analyze its historical cultural and social function, putting aside issues of aesthetic response in the interests of "objectivity." The gesture that naturalizes our access to Dürer's image and that elides historical distance also calls attention to the work of interpretation by demonstrating that the response in question is that of a particular historian working at a specific moment in time. Paradoxically enough, by insisting on the personal nature of his response to Dürer's compelling self-portrait, Koerner locates himself in time. His text draws attention as much to the age of his own response as it does to the time of the creation of the image. Hayum's method tends, on the other hand, to efface the identity of the interpreting historian. In an effort to be "true" to the historical horizon under investigation, the individuality of her own critical response is elided.

Whereas in one case (Koerner) the moment of response is dramatized, in the other (Hayum) it is unremarked. In one (Hayum), an appeal to reason, objectivity, and a notion of subjectivity as something distinct and autonomous is used to locate a moment of the past in a historical narrative that transcends the personality of the interpreting historian. In the other (Koerner), an appeal to the aesthetic power of the work of art is used to disturb an enlightened concept of history by negating the autonomy of the in-

terpreter's subjectivity and to insist on the role of the object in calling forth its own historical response. In this case the past overflows its boundaries and replaces a continuous and intelligible vision of history with one that is characterized by unfathomable caesuras.

One conclusion to this chapter might be that in the history of art the power of its objects of interpretation significantly affects the historian's notion of historical distance. Rather than depend on documentary traces located in archives, the art historian confronts images that have been invested with power both in the past and the present. If the religious and magical functions they once served are no longer with us — if the power they once possessed for the cultures that created them has been diluted and obliterated by the passage of time — they now possess the power invested in them by the idea of the aesthetic.[59] The relation between the art historian and the art of the past appears to be one of mutual attraction. Undoubtedly there is something about the art of the past that calls for the attention of the present. The art historian's evidence is at once more engaging and more demanding than that of documents in an archive, or even the literary historians' books on the shelf. Insofar as they encounter images at a glance, rather than images mediated through the distancing devices of language and narrative, they meet the intellectual character and the imaginative quality of the past with particular force.

The demands of past art — the continuing need for interpretation and reinterpretation — returns us to the question of memory. Regardless of how much we may detest the uses to which historical writing was put by historians of the Nazi era, we should recall the episode in order to reflect on the role of the concept of historical distance in our accounts of the past. Art history's hermeneutic enterprise must somehow do justice to the work's appeal — its apparently transcendental quality as art — as well as to its status as a historical artifact. Can this double agenda be served by the same discipline? Is it possible to relativize the intensity of aesthetic experience by locating its historical context without losing the immediacy of its appeal? Like the patient in psychoanalysis, the historian must remember in order to forget and forget in order to remember. New meaning can only be made of the past if the patterns discerned there can be reworked in the context of the present. Yet the value of the current patterns will only be revealed if those earlier traces can still be brought to mind. In the writing of art history, the tension brought about by the past's power to shape us and our power

to shape the past—the power of the work and our need to tame it (so as to constitute the narratives by which we organize our lives)—finds one of its most fascinating manifestations.

NOTES

1. See, for example, Michael Baxandall, "Introduction: Language and Explanation," in *Patterns of Intention: On the Historical Explanation of Pictures*, 1–11 (New Haven: Yale University Press, 1985); and, more recently, David Carrier, *Writing about Visual Art* (New York: Allworth Press, 2003).

2. The issue of historical distance became especially important for historical writing during the "linguistic turn." The view that language constitutes a mediating filter that separates an author from the object of study dramatizes the opacity of the historical record and emphasizes the constructive role of historical writing in its accounts of the past. See, for example, Roland Barthes, "The Discourse of History" (1968), in *The Rustle of Language*, translated by Richard Howard, 127–41 (Berkeley: University of California Press, 1989); Michel Foucault, *The Order of Things: An Archaeology of the Human Sciences* (New York: Vintage Books, 1973); Hayden White, *Tropics of Discourse: Essays in Cultural Criticism* (Baltimore: Johns Hopkins University Press, 1978); Hayden White, *The Content of the Form: Narrative Discourse and Historical Representation* (Baltimore: Johns Hopkins University Press, 1987); Dominick LaCapra, *Rethinking Intellectual History: Texts, Contexts, Language* (Ithaca: Cornell University Press, 1983); Dominick LaCapra, *History and Criticism* (Ithaca: Cornell University Press, 1985); Frank Ankersmit, *Narrative Logic: A Semantic Analysis of the Historian's Language* (The Hague: Martinus Nijhoff, 1983); Lionel Gossman, *Between History and Literature* (Cambridge: Harvard University Press, 1990); Stephen Bann, *The Inventions of History: Essays on the Representation of the Past* (Manchester: Manchester University Press, 1990); Phillipe Carrard, *Poetics of the New History: French Historical Discourse from Braudel to Chartier* (Baltimore: Johns Hopkins University Press, 1992); Robert Berkhofer Jr., *Beyond the Great Story: History as Text and Discourse* (Cambridge: Harvard University Press, 1995); Michael Roth, *The Ironist's Cage: Memory, Trauma, and the Construction of History* (New York: Columbia University Press, 1995); Michel-Rolph Trouillot, *Silencing the Past: Power and the Production of History* (Boston: Beacon Press, 1995); Carlo Ginzburg, *Wooden Eyes: Nine Reflections on Distance* (New York: Columbia University Press, 2002); Mark Phillips, "Distance and Historical Representation," *History Workshop Journal* 57, no. 1 (2004): 123–41; Mark Phillips, "Rethinking Historical Distance: From Doctrine to Heuristic," *History and Theory* 50 (December 2011): 11–23; and the essays included in the special issue of *History and Theory* 50 (December 2011), edited by Jaap den Hollander, Herman Paul, and Rik Peters, dedicated to the metaphor of historical distance. The linguistic turn has, perhaps predictably, been followed by a tendency to insist on historical presence to affirm that it is possible for the historian to tran-

scend language in order to have an unmediated experience of the past. See, for example, Frank Ankersmit, *Sublime Historical Experience* (Stanford: Stanford University Press, 2005); Eelco Runia, "Presence," *History and Theory*, no. 45 (2006): 1–29; Eelco Runia, "Spots of Time," *History and Theory*, no. 45 (2006): 305–16.

3. The most influential theory of historical distance in art history is that proposed by Erwin Panofsky; see his *Perspective as Symbolic Form*, trans. Christopher Wood (New York: Zone Books, 1991); and *Renaissance and Renascences in Western Art* (New York: Harper and Row, 1969). Panofsky's crucial role in building art history's model of temporal objectivity is discussed by Margaret Iversen and Stephen Melville in *Writing Art History: Disciplinary Departures* (Chicago: University of Chicago Press, 2010), 15–26. Influential approaches to historical distance are implicit in the work of Michael Baxandall; see his *Painting and Experience in Fifteenth Century Italy: A Primer in the Social History of Pictorial Style* (Oxford: Clarendon, 1972); and *Patterns of Intention: On the Historical Explanation of Pictures* (New Haven: Yale University Press, 1985). See also the work of T. J. Clark: *Image of the People: Gustave Courbet and the 1848 Revolution* (London: Thames and Hudson, 1973); and *The Painting of Modern Life: Paris in the Art of Manet and His Followers* (London: Thames and Hudson, 1985). For approaches that argue the essential "anachronism" of art history, see Georges Didi-Huberman, *Fra Angelico: Dissemblance and Figuration*, translated by Jane Marie Todd (Chicago: University of Chicago Press, 1995); Georges Didi-Huberman *Confronting Images: Questioning the Ends of a Certain History of Art*, translated by John Goodman (University Park: Pennsylvania State University Press, 2005); Georges Didi-Huberman, "Has the Epistemological Transformation Taken Place?," translated by Vivian Rehberg, in *The Art Historian: National Traditions and Institutional Practices*, edited by Michael Zimmermann, 128–43 (Williamstown, Mass.: Clark Art Institute, 2003); Hubert Damisch, *The Judgment of Paris* (Chicago: University of Chicago Press, 1996); Mieke Bal, *Quoting Caravaggio: Preposterous History* (Chicago: University of Chicago Press, 1999); Alexander Nagel and Christopher Wood, *Anachronic Renaissance* (New York: Zone Books, 2010). For efforts to think about the nature of the "agency" of images, see Alfred Gell, *Art and Agency: An Anthropological Theory* (Oxford: Clarendon, 1998); W. J. T. Mitchell, *Picture Theory: Essays on Verbal and Visual Representation* (Chicago: University of Chicago Press, 1994); W. J. T. Mitchell, *What Do Pictures Want? The Lives and Loves of Images* (Chicago: University of Chicago Press, 2005).

4. Pierre Nora, "Between Memory and History: *Les Lieux de mémoire*," *Representations*, no. 26 (1989): 7–24; Patrick Hutton, *History as an Art of Memory* (Hanover, N.H.: University Press of New England, 1993); Jacques Le Goff, *History and Memory*, translated by Steven Rendall and Elizabeth Claman (New York: Columbia University Press, 1992). For accounts of the memory moment in historical studies, see Kerwin Klein, "On the Emergence of Memory in Historical Discourse," *Representations*, no. 69 (2000): 127–50.

5. Gabrielle Spiegel, "Memory and History: Liturgical Time and Historical Time," *History and Theory*, no. 41 (2002): 149–50.

6. Jacques Derrida, *Of Grammatology*, translated by Gayatri Spivak (Baltimore: Johns Hopkins University Press, 1976).

7. See, among others, Edward Casey, *Remembering: A Phenomenological Study* (Bloomington: Indiana University Press, 1987); Edward Casey, "Forgetting Remembered," *Man and World* 25, nos. 3–4 (1992): 281–311; Umberto Eco and Marilyn Migiel, "An *Ars Oblivionalis*? Forget It!," *Publications of the Modern Language Association* 103 (1988): 254–60; Suzanne Küchler and Walter Melion, eds., *Images of Memory: On Remembering and Representation* (Washington: Smithsonian Institution, 1991); Adrian Forty and Suzanne Küchler, eds., *The Art of Forgetting* (Oxford: Berg, 1999); Gary Smith and Hinderk Emrich, eds., *Vom Nutzen des Vergessens* (Berlin: Akademie, 1996); Robert Scheller, "Concluding Remarks: Some Reflections on Tribal Gossip and Other Metaphors," in *Memory and Oblivion: Proceedings of the 29th International Congress of the History of Art*, edited by Wessel Reinink and Jeroen Stumpel, 19–23 (Dordrecht: Kluwer Academic, 1999); Daniel Schacter, *Searching for Memory: The Brain, the Mind, and the Past* (New York: Basic Books, 1996); Daniel Schacter, *The Seven Sins of Memory: How the Mind Forgets and Remembers* (New York: Houghton Mifflin, 2001); Marita Sturken, "The Remembering of Forgetting: Recovered Memory and the Question of Experience," *Social Text*, no. 57 (1998): 103–25. For an analysis of trauma's relation to historical writing, see Cathy Caruth, *Unclaimed Experience: Trauma, Narrative, and History* (Baltimore: Johns Hopkins University Press, 1996); Dominick LaCapra, *History and Memory after Auschwitz* (Ithaca: Cornell University Press, 1998); Dominick LaCapra, *Writing History, Writing Trauma* (Baltimore: Johns Hopkins University Press, 2001).

8. Joachim von Sandrart, *Teutsche Academie der Bau- Bild- und Mahlerey-Kunste*, edited by Christian Klemm, 2 vols. (Nordlingen: Dr. Alfons Uhl, 1994), vol. 2, 236–37.

9. For accounts of German art history in the nineteenth and twentieth centuries, see Hans Belting, *Identität im Zweifel: Ansichten der deutschen Kunst* (Cologne: DuMont, 1999); Hans Belting, *The Germans and Their Art: A Troublesome Relationship*, translated by Scott Kleager (New Haven: Yale University Press, 1998). For the history of art and art production in Germany under National Socialism, see Hildegard Brenner, *Die Kunstpolitik des Nationalsozialismus* (Rembeck bei Hamburg: Rohwolt, 1963); Reinhard Merker, *Die bildende Kunste im Nationalsozialismus: Kulturideologie–Kulturpolitik–Kulturproduktion* (Cologne: DuMont, 1983); Heinrich Dilly, *Deutscher Kunsthistoriker, 1933–1945* (Munich: Deutscher Kunstverlag, 1988); Bettina Preiss, "Eine Wissenschaft wird zur Dienstleistung: Kunstgeschichte im Nationalsozialismus," in *Kunst auf Befehl?*, edited by Bazon Brock and Achim Preiss, 41–58 (Munich: Klinckhardt and Biermann, 1990); Jonathan Petropoulos, *Art as Politics in the Third Reich* (Chapel Hill: University of North Carolina Press, 1996); Jonathan Petropoulos, *The Faustian Bargain: The Art World in Nazi Germany* (Oxford: Oxford University Press, 2000). For the Dürer historiog-

raphy during this period, see Jan Białostocki, *Dürer and His Critics* (Baden-Baden, Germany: Valentin Koerner, 1986); Jane Campbell Hutchison, *Albrecht Dürer: A Biography* (Princeton: Princeton University Press, 1990); Paul Munch, "Changing German Perceptions of the Historical Role of Albrecht Dürer," in *Dürer and His Culture*, edited by Dagmar Eichberger and Charles Zika, 181–99 (Cambridge: Cambridge University Press, 1998). For Grünewald, see Andrée Hayum, *The Isenheim Altarpiece: God's Medicine and the Painter's Vision* (Princeton: Princeton University Press, 1989), 118–49; Ingrid Schulze, *Die Erschütterung der Moderne: Grünewald in 20. Jahrhundert* (Leipzig: E. A. Seemann, 1991); Brigitte Schad and Thomas Ratzka, *Grünewald in der Moderne: Die Rezeption Matthias Grünewald im 20. Jahrhundert* (Cologne: Wienand, 2003).

10. Wilhelm Worringer, *Form in Gothic*, translated by Herbert Read (New York: Schocken Books, 1957). For the racist dimension of Worringer's ideas, see Carlo Ginzburg, "Style as Inclusion, Style as Exclusion," in *Picturing Science, Producing Art*, edited by Caroline Jones and Peter Galison, 27–54 (New York: Routledge, 1998), 41–42.

11. Heinrich Schmid, *Die Gemälde und Zeichnungen von Matthias Grünewald*, 2 vols. (Strasbourg: Heinrich, 1907–1911). Schmid was a student of Jacob Burckhardt and a classmate of Heinrich Wölfflin, whose chair at the University of Basel he inherited when Wölfflin was called to Berlin in 1901. See Hayum, *The Isenheim Altarpiece*, 120–22.

12. Heinrich Wölfflin, *The Art of Albrecht Dürer*, translated by Alastair and Heide Grieve (London: Phaidon, 1971), 18. In his later, racially inflected account of Italian and German art, Wölfflin nuanced this position by arguing that Dürer had borrowed what he needed from Italian art, while never abandoning the quintessentially German nature of his work. See Heinrich Wölfflin, *Italien und das deutsche Formgefühl* (Munich: F. Bruckmann, 1931), 6.

13. Wölfflin, *The Art of Albrecht Dürer*, 10.

14. For an account of the *Isenheim Altarpiece*'s stay in Munich, see Ann Stieglitz, "The Reproduction of Agony: Toward a Reception-History of Grünewald's Isenheim Altar after the First World War," *Oxford Art Journal* 12, no. 2 (1989): 87–103; see also Hayum, *The Isenheim Altarpiece*, 140–41. For Grünewald's reputation in German art historical writing during these years, see Margarethe Hausenberg, *Matthias Grünewald im Wandel der deutschen Kunstanschauung* (Leipzig, Germany: J. J. Weber, 1927), 103.

15. Stieglitz, "The Reproduction of Agony," 93.

16. Quoted in Stieglitz, "The Reproduction of Agony," 99.

17. Stieglitz, "The Reproduction of Agony," 99. See also Beth Irwin Lewis, *George Grosz: Art and Politics in the Weimar Republic* (Princeton: Princeton University Press, 1991), 219–25; Ralph Jentsch, *George Grosz: The Berlin Years* (Milan: Editori Associati, 1997), 167–73.

18. Louis Réau, *Mathias Grünewald et le retable de Colmar* (Nancy, France: Berger-Levrault, 1920), xli. The translations are my own.

19. Réau, *Mathias Grünewald et le retable de Colmar*, xv.

20. Réau, *Mathias Grünewald et le retable de Colmar*, 320.

21. Réau, *Mathias Grünewald et le retable de Colmar*, 337.

22. Oskar Hagen, *Matthias Grünewald* (Munich: R. Piper, 1923), 17.

23. Hagen, *Matthias Grünewald*, 23.

24. Hagen, *Matthias Grünewald*, 27.

25. Friedrich Haak, *Albrecht Dürer: Deutschlands grosster Kunstler* (Leipzig: Quelle and Meyer, 1928), 11. Grünewald's role in the history of expressionism has been acknowledged by, for example, Peter Selz: "Grünewald . . . became the ideal of the new generation, which saw in his Isenheim altarpiece a freedom of creation following the intrinsic logic of content and composition rather than nature. Grünewald, it was felt, penetrated to the core of human emotion and created a truth that went far beyond the doubtful truth of reality. Young artists recognized in Grünewald the fervent religious faith for which many of them had been searching" (*German Expressionist Painting* [Berkeley: University of California Press, 1957], 17).

26. Haak, *Albrecht Dürer*, 12.

27. For the fate of Expressionism in National Socialist party politics, see Brenner, *Die Kunstpolitik des Nationalsozialismus*, 63–86; Stephanie Barron, "1937: Modern Art and Politics in Prewar Germany," in *"Degenerate Art": The Fate of the Avant-Garde in Nazi Germany*, 9–23 (Los Angeles: Los Angeles County Museum, 1991); Katharina Heinemann, "Entdeckung und Vereinahmung: Zur Grünewald-Rezeption in Deutschland bis 1945," in *Grünewald in der Moderne: Die Rezeption Matthias Grünewald im 20. Jahrhundert*, edited by Brigitte Schad and Thomas Ratzka, 8–17 (Cologne: Wienand, 2003); and Peter Paret, *An Artist against the Third Reich: Ernst Barlach, 1933–1938* (New York: Cambridge University Press, 2003). I am grateful to Lionel Gossman for the Paret reference.

28. Hans Schwerte, *Faust und das Faustische: Ein Kapitel deutscher Ideologie* (Stuttgart: Ernst Klett Verlag, 1962), 243–78. For a review of the literature on this print, see Pierre Vaisse, *Reître ou chevalier? Dürer et l'idéologie allemande* (Paris: Maison des sciences de l'homme, 2006); and Martin Ruehl, "A Master from Germany: Thomas Mann, Albrecht Dürer, and the Making of a National Icon," *Oxford German Studies* 38, no. 1 (2009): 61–106. The methodologies used by art historians in the print's interpretation, particularly those of Wölfflin and Panofsky, are illuminatingly discussed by Whitney Davis in "Visuality and Pictoriality," in *A General Theory of Visual Culture*, 230–74 (Princeton: Princeton University Press, 2011).

29. Quoted in Białostocki, *Dürer and His Critics*, 240.

30. Hans F. K. Günther, *Ritter, Tod, und Teufel: Der Heldische Gedanken* (Munich: J. F. Lehmann, 1937).

31. Panofsky, *Renaissance and Renascences in Western Art*, 106. See also his *Perspective as Symbolic Form*.

32. Panofsky, *Renaissance and Renascences in Western Art*, 108.

33. Stephen Melville, "The Temptation of New Perspectives," *October* 52 (1990): 11. See also Iversen and Melville, *Writing Art History*, 15–26.

34. Erwin Panofsky, "The History of Art as a Humanistic Discipline," in *Meaning in the Visual Arts*, 1–25 (Garden City, N.J.: Doubleday, 1955), 2.

35. For Panofsky's Hegelianism, see Ernst Gombrich, *In Search of Cultural History* (Oxford: Clarendon, 1969), 28.

36. Erwin Panofsky, *The Life and Art of Albrecht Dürer*, 2 vols. (Princeton: Princeton University Press, 1955).

37. Panofsky, *The Life and Art of Albrecht Dürer*, 171.

38. See Keith Moxey, "Panofsky's Melancolia," in *The Practice of Theory: Poststructuralism, Cultural Politics, and Art History*, 65–78 (Ithaca: Cornell University Press, 1994).

39. Georges Didi-Huberman, "Before the Image, Before Time: The Sovereignty of Anachronism," translated by Peter Mason, in *Compelling Visuality: The Work of Art in and out of History*, edited by Claire Farago and Robert Zwijnenberg, 31–44 (Minneapolis: University of Minnesota Press, 2003), 37.

40. Didi-Huberman, "Before the Image, Before Time," 41–42.

41. Peter Strieder, *The Hidden Dürer*, translated by Vivienne Menkes (Chicago: Rand McNally, 1978); Peter Strieder, *Albrecht Dürer: Paintings, Prints, Drawings* (New York: Abaris Books, 1982); Fedja Anzelewsky, *Albrecht Dürer: Das malerische Werk* (Berlin: Deutscher Verlag für Kunstwissenschaft, 1971); Fedja Anzelewsky, *Dürer: His Art and Life*, translated by Heide Grieve (New York: Alpine Fine Arts Collection, 1981); Fedja Anzelewsky, *Dürer-Studien: Untersuchungen zu den ikonographischen und geistesgeschichtlichen Grundlagen seiner Werk zwischen beiden Italienreisen* (Berlin: Deutscher Verlag für Kunstwissenschaft, 1983).

42. Anzelewsky, *Dürer-Studien*.

43. An overview of the events with which this anniversary was commemorated in both West and East Germany is included in Günther Bräutigam and Matthias Mende, "'Mähen mit Durer': Literatur und Ereignisse im Umkreis des Dürer-Jahres 1971; Teil 1," *Mitteilungen des Vereins für Geschichte der Stadt Nürnberg* 61 (1974): 204–82.

44. *Albrecht Dürer, 1471–1971*, exhibition catalogue, Germanisches Nationalmuseum, Nuremberg (Munich: Prestel, 1971).

45. Ines Bach et al., eds., *Ausstellungsdidaktik im Albrecht Dürer-Jahr 1971* (Berlin: Lehrstuhl für Kunstgeschichte, Technische Universität Berlin, 1972); Dieter Wuttke, *Nuremberg: Focal Point of German Culture and History; A Lecture* (Bamberg, Germany: H. Kaiser, 1987).

46. Rudolph Kober and Gerd Lindner, "Paradigma Grünewald: Zur Erbe-Rezeption in der bildende Kunst der DDR," in *Grünewald in der Moderne: Die Rezeption Matthias Grünewald im 20. Jahrhundert*, edited by Brigitte Schad and Thomas Ratzka, 32–43 (Cologne: Wienand, 2003), 35.

47. Ernst Ullmann, Günter Grau, and Rainer Behrends, eds., *Albrecht Dürer: Zeit und Werk* (Leipzig: Karl Marx Universität, 1971), vii.

48. Ernst Ullmann, "Albrecht Dürer und die frühbürgerliche Revolution in Deutschland," in *Albrecht Dürer: Zeit und Werk*, edited by Ernst Ullmann et al., 55–90 (Leipzig, Germany: Karl Marx Universität, 1971), 82.

49. Wolfgang Hütt, *Deutsche Malerei und Graphik der frühbürgerlichen Revolution* (Leipzig: E. A. Seemann, 1973), 334.

50. Mathis Hütt, *Gothardt-Neithardt gennant "Grünewald": Leben und Werk im Spiegel der Forschung* (Leipzig: E. A. Seemann, 1968), 89–90.

51. Peter Feist, "Albrecht Dürer: Seine Bedeutung fur die sozialistische Nationalkultur in der DDR," in *Albrecht Dürer: Zeit und Werk*, edited by Ernst Ullmann, Günther Grau, and Rainer Behrends, 173–78 (Leipzig, Germany: Karl Marx Universität, 1971), 178.

52. Joseph Koerner, *The Moment of Self-Portraiture in German Renaissance Art* (Chicago: University of Chicago Press, 1993).

53. Koerner, *The Moment of Self-Portraiture in German Renaissance Art*, xix.

54. For Panofsky's use of Cassirer's concept of "symbolic forms," see Michael Ann Holly, *Panofsky and the Foundations of Art History* (Ithaca: Cornell University Press, 1984), chapter 5.

55. For a history of the concept of objectivity see Lorraine Daston and Peter Galison, *Objectivity* (New York: Zone Books, 2007).

56. Koerner, *The Moment of Self-Portraiture in German Renaissance Art*, xvi, fn. 4.

57. Hayum, *The Isenheim Altarpiece*, 1–12. For Baxandall's approach to a "social history of art," see *Painting and Experience in Fifteenth Century Italy*, and *Patterns of Intention*. Baxandall self-reflexively addresses the strengths and limitations of his method in "Art, Society, and the Bouguer Principle," *Representations* 12 (1985): 32–43. His notion of the "period eye" is discussed by Allan Langdale in "Aspects of the Critical Reception and Intellectual History of Baxandall's Concept of the Period Eye," in *About Michael Baxandall*, edited by Adrian Rifkin, 17–35 (Oxford: Blackwell, 1999).

58. See Michael Ann Holly, "Patterns in the Shadows: Attention in/to the Writings of Michael Baxandall," in *About Michael Baxandall*, edited by Adrian Rifkin, 5–16 (Oxford: Blackwell, 1999).

59. Hans Belting, *Likeness and Presence: A History of the Image before the Era of Art*, translated by Edmund Jephcott (Chicago: University of Chicago Press, 1994). Belting's ideas are extended and developed by Nagel and Wood in *Anachronic Renaissance*. For the argument that works of art determine their own reception, see Michael Ann Holly, *Past Looking: Historical Imagination and the Rhetoric of the Image* (Ithaca: Cornell University Press, 1996). The philosophical foundation for the claim that works create their own histories can be traced to Martin Heidegger's "The Origin of the Work of Art," in *Poetry, Language, Thought*, translated by Albert Hofstadter, 15–86 (New York: Harper and Row, 1971). See also Iversen and Melville, *Writing Art History*.

The chapters in this book address two ways in which time affects the study of the visual arts. These axes are the heterochronic and the anachronic: time as multiple and asynchronic, in which its nature depends on the location in which it takes place, and time as ineluctably particular and personal, involving moments that appear to break the orderly sequence of events. Both call into question diachrony and chronology and they problematize synchrony. Yet they also work at cross-purposes to one another.

Heterochrony: These essays claim that the challenges posed to historicist time gain added urgency in the face of local temporalities that have been marginalized and misunderstood by Western colonialism. The histories of non-Western cultures cannot simply be assimilated into an evolutionary narrative that privileges the Euro-American past without distorting the meaning that time may have had in other contexts. Efforts to construct so-called world art histories, for example, often depend on an allegedly universal time. I have argued here for an awareness of heterochrony, the sense that different cultures have distinct notions of time and that these are not easily related to one another. Heterochrony relativizes the significance attributed to Western history and encourages the creation of narratives that are contemporary but not synchronous. Historicism is here identified as a form of dominant time, a time associated with the colonial powers not only in the eighteenth and nineteenth centuries but today. If power imbalances associated

with the haunting vestiges of colonialism continue to inform the power relations among the time zones of the world, then that hierarchy is rendered ever more visible with every non-Western intervention in the contemporary artistic landscape.

Anachrony: I am also claiming that works of art, or indeed many images, have the capacity to create their own time for attentive beholders. Affective response, however, is shaped by the temporal situation in which it occurs. But as with other fragments of the past, works of art cannot be kept at bay on the assumption that they belong to periods and places other than the present. The intensity and complexity of response is as embedded in time as are the works themselves. Visual objects disturb and disrupt chronology rather than organize it. It is this anarchic sense of temporality that I characterize as anachronic. Anachronic time cannot be reconciled with the historicist architecture that steadfastly structures the history of art. Too often the discussion of works of art has been limited to their significance within a particular historical horizon rather than acknowledging their roles in subsequent periods, including the present. Images have traditionally been dignified with the status of "art" precisely because they are capable of affecting those who experience them. Failure to recognize the power of that aesthetic experience robs them of their hold over the viewer.

Mine is far from an ahistorical historical argument. Rather than abolish a sense of time, it asks that the temporal relation between past and present be thought anew so as to escape the deadening effect of the "periodic table" that currently organizes this discipline's view of the past. Ironically enough, this argument also asserts the need for periodization as a fundamental aspect of the work of the historian. The fascination of the past depends on difference, in the full awareness that ascribed alterities are subject to continual redefinition. What is at stake here is the acknowledgment that periods are necessary historical myths created by and for historians as they attempt to attribute meaning to the past.

Do these two temporal axes intersect? Heterochrony suggests that there is no natural hierarchy of times, that the inequalities that inform power relations among cultures are neither fixed nor final but ever shifting and changing. Anachrony is a perpetual reminder of the tenuous nature of time's envelope. When images arrest attention and flood consciousness, they disrupt the orderly progression of instants into which duration has been plotted by cultural convention. Because the history of art depends equally on both

historical and aesthetic time, it needs to be flexible and capacious enough to accommodate the demands of both. What are the implications of these incongruous senses of time? In view of time's heterochrony, it is most unlikely that anachronic time will create the same responses in viewers from different ages and cultures. Awed, overwhelmed, and even moved by works from cultures belonging to different temporalities—such reactions must inevitably differ according to cultural context. Temporal difference, the consequence of either heterochrony or chronology, may well leave some unmoved by works to which others ascribe enormous significance. Even if works have the capacity to escape the temporalities to which they belong in order to create their own time, anachronic responses will necessarily differ. What one world deems aesthetic may not appear so to another. Even within a single culture, what is considered art in one moment may become an unremarkable image at another, and vice versa. Heterochrony and anachrony thus work at cross-purposes to one another. They serve to make an understanding of the artistic past, as well as the artistic present, more complex and hermeneutically demanding than might have been imagined.

Translation: Finally, translation is a fragile, possibly utopian, but nevertheless necessary metaphor with which to negotiate the gulf that distinguishes the visual from the textual, on one hand, and one time from another, on the other. The apparent failure of ekphrases to encounter the objects they address, the way that words slide past the images they seek to capture, parallels the evident incompatibility of different time systems. The enduring tension that characterizes text-image relations finds a striking parallel in incongruities of time. Just as the visual struggles to escape the ever-encroaching embrace of language, so local forms of time fight, often in vain, to free themselves from universal time. If the experience of the anachronic power of images insists that we temporarily suspend the systems in which we locate works of art, then heterochrony reminds us that such temporal structures are not only desirable but inevitable as we try to understand the images of cultures other than our own.

Adams, Parveen. "Out of Sight, Out of Body: The Sugimoto/Demand Effect." *Grey Room*, no. 22 (2006): 86–104.

Agamben, Giorgio. "What Is Contemporary?" In *What Is an Apparatus? And Other Essays*, translated by David Kishik and Stefan Pedatella, 39–54. Stanford: Stanford University Press, 2009.

Ainsworth, Maryan. " 'Paternes for Phiosioneamyes': Holbein's Portraiture Reconsidered." *Burlington Magazine* 132 (1990): 173–86.

Alberro, Alexander. "Periodizing Contemporary Art." In *Crossing Cultures: Conflict, Migration and Convergence; The Proceedings of the 32nd International Congress of the History of Art*, edited by Jaynie Anderson, 935–39. Melbourne: Melbourne University Publishing, 2009.

Albrecht Dürer, 1471–1971. Exhibition catalogue. Germanisches Nationalmuseum, Nuremberg. Munich: Prestel, 1971.

Aleci, Linda Klinger. "Images of Identity: Italian Portrait Collections of the Fifteenth and Sixteenth Centuries." In *The Image of the Individual: Portraits of the Renaissance*, edited by Nicholas Mann and Luke Syson, 67–79. London: Trustees of the British Museum, 1998.

Alpers, Svetlana. "Is Art History?" *Daedalus* 6, no. 3 (1977): 1–13.

Andermann, Kerstin. "Malerei im Spannungsfeld von Phanomenologie und Immanenzphilosophie." In *Kulturen des Bildes*, edited by Birgit Mersmann and Martin Schulz, 249–63. Munich: Fink, 2006.

Ankersmit, Frank. *Narrative Logic: A Semantic Analysis of the Historian's Language*. The Hague: Martinus Nijhoff, 1983.

———. *Sublime Historical Experience*. Stanford: Stanford University Press, 2005.

Anzelewsky, Fedja. *Albrecht Dürer: Das malerische Werk*. Berlin: Deutscher Verlag für Kunstwissenschaft, 1971.

———. *Dürer: His Art and Life*, translated by Heide Grieve. New York: Alpine Fine Arts Collection, 1981.

————. *Dürer-Studien: Untersuchungen zu den ikonographischen und geistesgeschicht-lichen Grundlagen seiner Werk zwischen beiden Italienreisen.* Berlin: Deutscher Verlag für Kunstwissenschaft, 1983.

Appadurai, Arjun. "Introduction: Commodities and the Politics of Value." In *The Social Life of Things: Commodities in Cultural Perspective,* edited by Arjun Appadurai, 3–63. Cambridge: Cambridge University Press, 1986.

Araeen, Rasheed, Sean Cubitt, and Ziauddin Sardar, eds. *The Third Text Reader on Art, Culture and Theory.* London: Continuum, 2002.

Aston, Margaret. *England's Iconoclasts,* vol. 1, *Laws against Images.* Oxford: Clarendon, 1988.

————. *Faith and Fire: Popular and Unpopular Religion 1350–1600.* London: Hamble-don, 1993.

Augé, Marc. *Non-places: An Introduction to an Anthropology of Supermodernity,* trans-lated by John Howe. London: Verso, 1995.

Bach, Ines, et al., eds. *Ausstellungsdidaktik im Albrecht Dürer-Jahr 1971.* Berlin: Lehr-stuhl für Kunstgeschichte, Technische Universität Berlin, 1972.

Badiou, Alain. *Handbook on Inaesthetics,* translated by Alberto Toscano. Stanford: Stanford University Press, 2005.

Bakhtin, Mikhail. "Forms of Time and the Chronotope in the Novel" (1930s). In *The Dialogic Imagination,* translated by Caryl Emerson and Michael Holquist, 84–258. Austin: University of Texas Press, 1981.

Bal, Mieke. *Quoting Caravaggio: Contemporary Art, Preposterous History.* Chicago: University of Chicago Press, 1999.

————. "Heterochrony in the Act: The Migratory Politics of Time." In *Art and Visi-bility in Migratory Culture: Enacting Conflict and Resistance, Aesthetically,* edited by Mieke Bal and Miguel Angel Hernandez-Navarro, 211–38. Amsterdam: Rodopi, 2011.

Baltrusaitis, Jurgis. *Anamorphic Art,* translated by W. J. Strachan. Cambridge: Chadwyck-Healey, 1977; 1st ed. 1955.

Bann, Stephen. *The Inventions of History: Essays on the Representation of the Past.* Manchester: Manchester University Press, 1990.

————. *Romanticism and the Rise of History.* New York: Twayne Publishers, 1995.

Barringer, Tim, and Tom Flynn, eds. *Colonialism and the Object: Empire, Material Culture and the Museum.* London: Routledge, 1998.

Barron, Stephanie. "1937: Modern Art and Politics in Prewar Germany." In *"Degener-ate Art": The Fate of the Avant-Garde in Nazi Germany,* edited by Stephanie Barron, 9–23. Los Angeles: Los Angeles County Museum, 1991.

Barthes, Roland. *Camera Lucida: Reflections on Photography,* translated by Richard Howard. New York: Hill and Wang, 1981.

————. "The Reality Effect." In *French Literary Theory Today: A Reader,* edited by Tzvetan Todorov, translated by R. Carter, 11–17. Cambridge: Cambridge University Press, 1982.

———. "The Discourse of History" (1968). In *The Rustle of Language*, translated by Richard Howard, 127–41. Berkeley: University of California Press, 1989.

Bätschmann, Oskar, and Pascal Griener. "Holbein-Apelles: Wettbewerb und Definition des Kunstlers." *Zeitschrift für Kunstgeschichte* 57 (1994): 625–50.

———. *Hans Holbein*, translated by Cecilia Hurley and Pascal Griener. Princeton: Princeton University Press, 1997.

Baxandall, Michael. *Painting and Experience in Fifteenth Century Italy: A Primer in the Social History of Pictorial Style*. Oxford: Clarendon, 1972.

———. "Art, Society, and the Bouguer Principle." *Representations* 12 (1985): 32–43.

———. *Patterns of Intention: On the Historical Explanation of Pictures*. New Haven: Yale University Press, 1985.

Belting, Hans. *The End of the History of Art*, translated by Christopher Wood. Chicago: University of Chicago Press, 1987.

———. *Likeness and Presence: A History of the Image before the Era of Art*, translated by Edmund Jephcott. Chicago: University of Chicago Press, 1994; 1st ed. 1990.

———. *Das Ende der Kunstgeschichte: Eine Revision nach zehn Jahren*. Munich: Beck, 1995.

———. *The Germans and Their Art: A Troublesome Relationship*, translated by Scott Kleager. New Haven: Yale University Press, 1998.

———. *Identität im Zweifel: Ansichten der deutschen Kunst*. Cologne: DuMont, 1999.

———. *An Anthropology of Images: Picture, Medium, Body*, translated by Thomas Dunlap. Princeton: Princeton University Press, 2011; 1st ed. 2001.

———. *Hieronymus Bosch: Garden of Earthly Delights*, translated by Ishbel Flett. Munich: Prestel, 2002.

———. *Das echte Bild: Bildfragen als Glaubensfragen*. Munich: C. H. Beck, 2005.

———. "Image, Medium, Body: A New Approach to Iconology." *Critical Inquiry* 31, no. 2 (2005): 302–19.

———. "Blickwechsel mit Bildern: Die Bildfrage als Körperfrage." In *Bilderfragen: Die Bildwissenschaften im Aufbruch*, edited by Hans Belting, 49–75. Munich: W. Fink, 2007.

———. "Contemporary Art as Global Art: A Critical Estimate." In *The Global Art World*, edited by Hans Belting and Andrea Buddensieg, 38–73. Ostfildern: Hatje Cantz, 2009.

Benjamin, Walter. "On the Mimetic Faculty" (1933). In *Walter Benjamin: Selected Writings*, vol. 2, *1927–1934*, edited by Michael Jennings, 720–22. Cambridge: Harvard University Press, 1999.

———. "The Work of Art in the Age of Its Technological Reproducibility" (1936). In *Walter Benjamin: Selected Writings*, vol. 3, *1935–1938*, edited by Michael Jennings, 101–33. Cambridge: Harvard University Press, 2002.

———. "On Some Motifs in Baudelaire" (1939). In *Walter Benjamin: Selected Writings*, vol. 4, *1938–1940*, edited by Michael Jennings, 313–55. Cambridge: Harvard University Press, 2005.

Bennett, Jill. *Empathetic Vision: Affect, Trauma, and Contemporary Art*. Stanford: Stanford University Press, 2005.

Berger, Harry, Jr. *Fictions of the Pose: Rembrandt against the Italian Renaissance*. Stanford: Stanford University Press, 2000.

Berkhofer, Robert, Jr. *Beyond the Great Story: History as Text and Discourse*. Cambridge: Harvard University Press, 1995.

Białostocki, Jan. *Dürer and His Critics, 1500–1971: Chapters in the History of Ideas, Including a Collection of Texts*. Baden-Baden, Germany: Valentin Koerner, 1986.

Bloch, Ernst. "Non-contemporaneity and Contemporaneity, Philosophically." In *Heritage of Our Times*, translated by Neville and Stephen Plaice, 104–16. Cambridge: Polity Press, 1991.

Boehm, Gottfried. "Die Wiederkehr der Bilder." In *Was ist ein Bild?*, edited by Gottfried Boehm, 11–38. Munich: W. Fink, 1994.

———, ed. *Was ist ein Bild?* Munich: W. Fink, 1994.

———. "Bildbeschreibung: Über die Grenzen von Bild und Sprache." In *Beschreibungskunst—Kunstbeschreibung: Ekphrasis von der Antike bis zur Gegenwart*, edited by Gottfried Boehm, 23–40. Munich: W. Fink, 1995.

———. *Wie Bilder Sinn erzeugen: Die Macht des Zeigens*. Berlin: Berlin University Press, 2007.

Boehm, Gottfried, and W. J. T. Mitchell. "Pictorial versus Iconic Turn: Two Letters." In *The Pictorial Turn*, edited by Neil Curtis, 8–17. London: Routledge, 2010.

Bogen, Steffen. "Kunstgeschichte/Kunstwissenschaft." In *Bildwissenschaft: Disziplinen, Themen, Methoden*, edited by Klaus Sachs-Hombach, 52–67. Frankfurt am Main: Suhrkamp, 2005.

Boucher, Bruce. "Jacob Burckhardt and the 'Renaissance' North of the Alps." In *Time and Place: The Geohistory of Art*, edited by Thomas DaCosta Kaufmann and Elizabeth Pilliod, 21–35. London: Ashgate, 2005.

Bourriaud, Nicolas. "Altermodern." In *Altermodern*, edited by Nicolas Bourriaud. Exhibition catalogue. London: Tate Publishing, 2009.

Boym, Svetlana. *The Future of Nostalgia*. New York: Basic Books, 2001.

Bräutigam, Günther, and Matthias Mende. "'Mähen mit Durer': Literatur und Ereignisse im Umkreis des Dürer-Jahres 1971; Teil 1." *Mitteilungen des Vereins für Geschichte der Stadt Nürnberg* 61 (1974): 204–82.

Bredekamp, Horst. "Editorial." *Bilder in Prozessen: Bildwelten des Wissens; Kunsthistorisches Jahrbuch fur Bildkritik* 1, no. 1 (2003): 7–8.

———. "Drehmomente—Merkmale und Ansprüche des Iconic Turn." In *Iconic Turn: Die Neue Macht der Bilder*, edited by Christa Maar and Hubert Burda, 15–26. Cologne: Du Mont, 2004.

———. *Darwins Korallen: Die frühen Evolutionsdiagramme und die Tradition der Naturgeschichte*. Berlin: Wagenbach, 2005.

———. *Theorie des Bildakts*. Berlin: Suhrkamp, 2010.

Brenner, Hildegard. *Die Kunstpolitik des Nationalsozialismus*. Rembeck bei Hamburg: Rohwolt, 1963.

Brinker, Helmut, and Hiroshi Kanazawa. *Zen Masters of Meditation in Images and Writings*, translated by Andreas Leisinger. Zurich: Artibus Asiae, 1996.

Brotton, Jerry. *The Renaissance Bazaar: From the Silk Road to Michelangelo*. Oxford: Oxford University Press, 2002.

Brougher, Kerry, and David Elliott. *Hiroshi Sugimoto*. Washington: Hirshhorn Museum, 2006.

Brown, Marshall. "Periods and Resistances." *Modern Language Quarterly* 62, no. 4 (2001): 309–16.

Bryson, Norman. *Vision and Painting: The Logic of the Gaze*. New Haven: Yale University Press, 1983.

———. "House of Wax." In *Cindy Sherman, 1975–1993*, by Rosalind Krauss, 216–23. New York: Rizzoli, 1993.

———. "Hiroshi Sugimoto's Metabolic Photography." *Parkett*, no. 46 (1996): 120–31.

———. "Visual Culture and the Dearth of Images." *Journal of Visual Culture* 2, no. 2 (2003): 229–32.

Buchanan, Ian. "The Collection of Niclaes Jonghelinck: II. The 'Months' by Pieter Bruegel the Elder." *Burlington Magazine* 132 (1990): 541–50.

Buck-Morss, Susan. *The Dialectics of Seeing: Walter Benjamin and the Arcades Project*. Cambridge: MIT Press, 1989.

Bullen, J. B. *The Myth of the Renaissance in Nineteenth-Century Writing*. Oxford: Oxford University Press, 1994.

Burke, Peter. *The Renaissance*. Atlantic Highlands, N.J.: Humanities Press International, 1987.

———, ed. *The Writing of World Histories*. Copenhagen: Akademisk Forlag, 1989.

Burckhardt, Jacob. *The Civilization of the Renaissance in Italy: An Essay*. London: Phaidon, 1965; 1st ed. Leipzig, 1869.

Carrard, Phillipe. *Poetics of the New History: French Historical Discourse from Braudel to Chartier*. Baltimore: Johns Hopkins University Press, 1992.

Carrier, David. *Writing about Visual Art*. New York: Allworth Press, 2003.

———. *A World Art History and Its Objects*. University Park: Pennsylvania State University Press, 2008.

Caruth, Cathy. *Unclaimed Experience: Trauma, Narrative, and History*. Baltimore: Johns Hopkins University Press, 1996.

Casey, Edward. *Remembering: A Phenomenological Study*. Bloomington: Indiana University Press, 1987.

———. "Forgetting Remembered." *Man and World* 25, nos. 3–4 (1992): 281–311.

Chakrabarty, Dipesh. *Provincializing Europe: Postcolonial Thought and Historical Difference*. Princeton: Princeton University Press, 2000.

Christensen, Carl. *Art and the Reformation in Germany*. Athens: Ohio University Press, 1979.

Clark, John. *Modern Asian Art*. Sydney: Craftsman House; Honolulu: University of Hawai'i Press, 1998.

———. "Modernities in Art: How Are They Other?" In *World Art Studies: Exploring Concepts and Approaches*, edited by Kitty Zijlmans and Wilfried van Damme, 401–18. Amsterdam: Valiz, 2008.

Clark, T. J. *Image of the People: Gustave Courbet and the 1848 Revolution*. London: Thames and Hudson, 1973.

———. *The Painting of Modern Life: Paris in the Art of Manet and His Followers*. London: Thames and Hudson, 1985.

Costello, Diarmuid. "Aura, Face, and Photography: Re-reading Benjamin Today." In *Walter Benjamin and Art*, edited by Andrew Benjamin, 164–84. London: Continuum, 2005.

Crow, Thomas. "The Practice of Art History in the United States." *Daedalus* 135, no. 2 (2006): 7–91.

D'Amico, Robert. *Historicism and Knowledge*. London: Routledge, 1989.

Damisch, Hubert. *A Theory of /Cloud/: Toward a History of Painting*, translated by Janet Lloyd. Stanford: Stanford University Press, 2002; 1st ed. 1972.

———. *The Judgment of Paris*. Chicago: University of Chicago Press, 1996; 1st ed. 1992.

Danto, Arthur. *Cindy Sherman: History Portraits*. New York: Rizzoli, 1991.

———. "Introduction: Modern, Postmodern, and Contemporary." In *After the End of Art: Contemporary Art and the Pale of History*, 3–19. Princeton: Princeton University Press, 1997.

Daston, Lorraine. "Introduction: The Coming into Being of Scientific Objects." In *Biographies of Scientific Objects*, edited by Lorraine Daston, 1–14. Chicago: University of Chicago Press, 2000.

Daston, Lorraine, and Peter Galison, "The Image of Objectivity." *Representations*, no. 40 (1992): 81–128.

———. *Objectivity*. New York: Zone Books, 2007.

Davis, Whitney. "The Subject in the Scene of Representation." *Art Bulletin* 76 (1994): 570–95.

———. "Visuality and Pictoriality." In *A General Theory of Visual Culture*, 230–74. Princeton: Princeton University Press, 2011.

de Certeau, Michel. *The Writing of History*, translated by Tom Conley. New York: Columbia University Press, 1988.

———. *The Mystic Fable: The Sixteenth and Seventeenth Centuries*, translated by Michael Smith. Vol. 1. Chicago: University of Chicago Press, 1992.

Deleuze, Gilles, and Felix Guattari. *What Is Philosophy?*, translated by Hugh Tomlinson and Graham Burchell. New York: Columbia University Press, 1991.

Delumeau, Jean. *Sin and Fear: The Emergence of a Western Guilt Culture, 13th–18th Centuries*, translated by Eric Nicholson. New York: St. Martin's Press, 1983.

Derrida, Jacques. *Of Grammatology*, translated by Gayatri Spivak. Baltimore: Johns Hopkins University Press, 1976; 1st ed. 1967.

Didi-Huberman, Georges. *Confronting Images: Questioning the Ends of a Certain History of Art*, translated by John Goodman. University Park: Pennsylvania State University Press, 2005; 1st ed. 1990.

———. *Ce que nous voyons, ce qui nous regarde*. Paris: Minuit, 1992.

———. *Fra Angelico: Dissemblance and Figuration*, translated by Jane Marie Todd. Chicago: University of Chicago Press, 1995.

———. "The Portrait, the Individual, and the Singular: Remarks on the Legacy of Aby Warburg." In *The Image of the Individual: Portraits in the Renaissance*, edited by Nicholas Mann and Luke Syson, 165–85. London: British Museum Press, 1998.

———. "Obscures survivances, petits retours et grande Renaissance: Remarque sue les modèles de temps chez Warburg et Panofsky." In *The Italian Renaissance in the Twentieth Century: Acts of an International Conference, Florence, Villa I Tatti, June 9–11, 1999*, edited by Allen Grieco et al., 207–22. Florence: Olschki, 1999.

———. *L'image survivante: Histoire de l'art et temps des fantômes selon Aby Warburg*. Paris: Minuit, 2002.

———. "Before the Image, Before Time: The Sovereignty of Anachronism," translated by Peter Mason. In *Compelling Visuality: The Work of Art in and out of History*, edited by Claire Farago and Robert Zwijnenberg, 31–44. Minneapolis: University of Minnesota Press, 2003.

———. "History and Image: Has the 'Epistemological Transformation' Taken Place?" Translated by Vivian Rehberg. In *The Art Historian: National Traditions and Institutional Practices*, edited by Michael Zimmermann, 128–43. Williamstown, Mass.: Clark Art Institute, 2003.

Dikovitskaya, Margaret. *Visual Culture: The Study of the Visual after the Cultural Turn*. Cambridge: MIT Press, 2005.

Dilly, Heinrich. *Deutscher Kunsthistoriker, 1933–1945*. Munich: Deutscher Kunstverlag, 1988.

Duffy, Eamonn. *The Stripping of the Altars: Traditional Religion in England ca. 1400–ca. 1580*. New Haven: Yale University Press, 1992.

Dülberg, Angelica. *Privatporträts: Geschichte und Ikonologie einer Gattung im 15. und 16. Jahrhundert*. Berlin: Mann, 1990.

Dumoulin, Olivier, and Raphaël Valéry, eds. *Periodes: La construction du temps historique*. Paris: Histoire au Present, 1991.

Eco, Umberto, and Marilyn Migiel. "An *Ars Oblivionalis*? Forget It!" *Publications of the Modern Language Association* 103, no. 3 (1988): 254–61.

Elkins, James. "Art History without Theory." *Critical Inquiry* 14, no. 2 (1988): 354–78.

———. "Art History and Images That Are Not Art." *Art Bulletin* 77, no. 4 (1995): 533–71.

———. *On Pictures and the Words That Fail Them*. Cambridge: Cambridge University Press, 1998.

———. *The Domain of Images*. Ithaca: Cornell University Press, 1999.

———. *Visual Studies: A Skeptical Introduction*. New York: Routledge, 2003.

———. "Art History as a Global Discipline." In *Is Art History Global?*, edited by James Elkins, 3–23. New York: Routledge, 2007.

———. "Introduction." In *Visual Practices across the University*, edited by James Elkins, 9–57. Munich: W. Fink, 2007.

———. "On David Summers's *Real Spaces*." In *Is Art History Global?*, edited by James Elkins, 41–71. New York: Routledge, 2007.

———, ed. *Visual Practices across the University*. Munich: Fink, 2007.

———. "Introduction to an Abandoned Book." In *Renaissance Theory*, edited by James Elkins and Robert Williams, 29–46. New York: Routledge, 2008.

Elkins, James, and Maja Naef, eds. *What Is an Image?* College Park: Pennsylvania State University Press, 2011.

Elsner, Jaś. "Art History as Ekphrasis." *Art History* 33, no. 1 (2010): 10–27.

Enwezor, Okwui, ed. *The Short Century: Independence and Liberation Movements in Africa, 1945–1994*. Munich: Prestel, 2001.

———. "Modernity and Postcolonial Ambivalence." In *Altermodern*, edited by Nicolas Bourriaud. Exhibition catalogue. London: Tate Publishing, 2009.

Errington, Shelly. *The Death of Authentic Primitive Art and Other Tales of Progress*. Berkeley: University of California Press, 1998.

Eyene, Christine. "Sekoto and Negritude: The Ante-room of French Culture." *Third Text* 24 (2010): 423–35.

Fabian, Johannes. *Time and the Other: How Anthropology Makes Its Object*. New York: Columbia University Press, 1983.

Falkenburg, Reindert. "Pieter Bruegels *Kruisdraging*: Een proeve van 'close reading.'" *Oud Holland* 107, no. 1 (1993): 17–33.

———. "Pieter Bruegel's Series of the Seasons: On the Perception of Divine Order." In *Liber Amicorum Raphaël de Smedt*, vol. 2, *Artium Historia*, edited by Joost van der Auwera, 253–76. Louvain, Belgium: Peeters, 2001.

Farago, Claire, ed. *Reframing the Renaissance: Visual Culture in Europe and Latin America, 1450–1650*. New Haven: Yale University Press, 1995.

Faure, Bernard. *The Rhetoric of Immediacy: A Cultural Critique of Chan/Zen Buddhism*. Princeton: Princeton University Press, 1991.

———. *Visions of Power: Imagining Medieval Japanese Buddhism*, translated by Phyllis Brooks. Princeton: Princeton University Press, 1996.

Feist, Peter. "Albrecht Dürer: Seine Bedeutung fur die sozialistische Nationalkultur in der DDR." In *Albrecht Dürer: Zeit und Werk*, edited by Ernst Ullmann, Günther Grau, and Rainer Behrends, 173–78. Leipzig, Germany: Karl Marx Universität, 1971.

Ferguson, Wallace. *The Renaissance in Historical Thought: Five Centuries of Interpretation*. Cambridge, Mass.: Riverside Press, 1948.

Foister, Susan. *Holbein in England*. London: Tate Publishing, 2006.

Forty, Adrian, and Suzanne Küchler, eds. *The Art of Forgetting*. Oxford: Berg, 1999.

Foster, Hal, Rosalind Krauss, Yve-Alain Bois, and Benjamin Buchloh, eds. *Art since*

1900: Modernism, Antimodernism, Postmodernism. New York: Thames and Hudson, 2004.

———. "Roundtable: The Predicament of Contemporary Art." In *Art since 1900: Modernism, Antimodernism, Postmodernism*, edited by Hal Foster, Rosalind Krauss, Yve-Alain Bois, and Benjamin Buchloh, 671–79. New York: Thames and Hudson, 2004.

Foucault, Michel. *The Order of Things: An Archaeology of the Human Sciences*. New York: Vintage Books, 1971; 1st ed. 1966.

Foulk, T. Griffith, and Robert H. Sharf. "On the Ritual Use of Ch'an Portraiture in Medieval China." *Cahiers d'Extrême Asie*, no. 7 (1993): 149–219.

———. "Religious Functions of Buddhist Art in China." In *Cultural Intersections in Later Chinese Buddhism*, edited by Marsha Weidner, 13–29. Honolulu: University of Hawai'i Press, 2001.

Freedberg, David. *The Power of Images: Studies in the History and Theory of Response*. Chicago: University of Chicago Press, 1989.

Freedberg, David, and Vittorio Gallese. "Motion, Emotion and Empathy in Esthetic Experience." *Trends in Cognitive Science* 11, no. 5 (2007): 197–203.

Fried, Michael. *Absorption and Theatricality: Painting and the Beholder in the Age of Diderot*. Berkeley: University of California Press, 1980.

———. *Courbet's Realism*. Chicago: University of Chicago Press, 1990.

———. "Without a Trace." *Artforum*, March 2005, 199–203.

Galison, Peter. *Einstein's Clocks, Poincare's Maps: Empires of Time*. New York: Norton, 2003.

Geiger, Jason. "Hegel's Contested Legacy: Rethinking the Relation between Art History and Philosophy." *Art Bulletin* 93, no. 2 (2011): 178–94.

Gelfand, Laura, and Walter Gibson. "Surrogate Selves: The Rolin Madonna and the Late-Medieval Devotional Portrait." *Simiolus* 29 (2002): 119–38.

Gell, Alfred. *Art and Agency: An Anthropological Theory*. Oxford: Clarendon, 1998.

———. "The Technology of Enchantment and the Enchantment of Technology." In *Anthropology, Art, and Aesthetics*, edited by Jeremy Coote and Anthony Shelton, 40–63. Oxford: Clarendon, 1992.

———. "Vogel's Net: Traps as Artworks and Artworks as Traps." In *The Anthropology of Art: A Reader*, edited by Howard Morphy and Morgan Perkins, 219–35. Oxford: Blackwell, 2006.

Gerlo, Aloïs. *Erasme et ses portraitistes: Metsijs, Dürer, Holbein*. Brussels: Cercle d'Art, 1950.

Gilbert, Felix. *History or Culture? Reflections on Ranke and Burckhardt*. Princeton: Princeton University Press, 1990.

Ginzburg, Carlo. "Style as Inclusion, Style as Exclusion." In *Picturing Science, Producing Art*, edited by Caroline Jones and Peter Galison, 27–54. New York: Routledge, 1998.

———. *Wooden Eyes: Nine Reflections on Distance*. New York: Columbia University Press, 2002.

Gombrich, Ernst. "Vogue for Abstract Art." In *Meditations on a Hobby Horse*, 143–50. London: Phaidon, 1965.

———. *Art and Illusion: A Study in the Psychology of Pictorial Representation*. Princeton: Princeton University Press, 1969.

———. *In Search of Cultural History*. Oxford: Clarendon, 1969.

———. "Norm and Form: The Stylistic Categories of Art History and Their Origins in Renaissance Ideals." In *Norm and Form: Studies in the Art of the Renaissance*, 81–98. London: Phaidon, 1971.

———. "The Father of Art History: A Reading of the Lectures on Aesthetics of GWF Hegel (1770–1831)." In *Tributes: Interpreters of Our Cultural Tradition*, 51–69. Ithaca: Cornell University Press, 1984.

Goodman, Nelson. *Languages of Art: An Approach to a Theory of Symbols*. Indianapolis, Ind.: Bobbs-Merrill, 1968.

Gossman, Lionel. *Basel in the Age of Burckhardt*. Chicago: University of Chicago Press, 2000.

———. *Between History and Literature*. Cambridge: Harvard University Press, 1990.

Greenberg, Clement. *Art and Culture: Critical Essays*. Boston: Beacon, 1989.

Gregory, Joseph. "Towards the Contextualization of Pieter Bruegel's *Procession to Calvary*: Constructing the Beholder from within the Eyckian Tradition." *Nederlands Kunsthistorisch Jaarboek* 47 (1996): 207–21.

Gross, Kenneth. *The Dream of the Moving Statue*. Ithaca: Cornell University Press, 1992.

Grosz, Elizabeth. *Chaos, Territory, Art: Deleuze and the Framing of the Earth*. New York: Columbia University Press, 2008.

Guha, Ranajit. *History at the Limits of World History*. New York: Columbia University Press, 2002.

Gumbrecht, Hans Ulrich, and Ursula Link-Heer, eds. *Epochenschwellen und Epochenstrukturen im Diskurs der Literatur- und Sprachhistorie*. Frankfurt am Main: Suhrkamp, 1985.

———. *Production of Presence: What Meaning Cannot Convey*. Stanford: Stanford University Press, 2004.

Günther, Hans F. K. *Ritter, Tod, und Teufel: Der Heldische Gedanken*. Munich: J. F. Lehmann, 1937.

Haak, Friedrich. *Albrecht Dürer: Deutschlands grösster Künstler*. Leipzig, Germany: Quelle and Meyer, 1928.

Hagen, Oskar. *Matthias Grünewald*. Munich: R. Piper, 1923.

Hallward, Peter. *Badiou: A Subject to Truth*. Minneapolis: University of Minnesota Press, 2003.

Hamilton, Paul. *Historicism*. London: Routledge, 1996.

Hand, John, and Ron Spronk, eds. *Essays in Context: Unfolding the Netherlandish Diptych*. Cambridge: Harvard University Art Museums, 2006.

Haraway, Donna. "Situated Knowledges: The Science Question in Feminism and the Privilege of Partial Perspective." *Feminist Studies* 14, no. 3 (1988): 575–99.

———. "The Persistence of Vision." In *The Visual Culture Reader*, edited by Nicholaus Mirzoeff, 191–98. London: Routledge, 2002.

Harootunian, Harry. "Some Thoughts on Comparability and the Space-Time Problem." *boundary 2* 32, no. 2 (2005): 23–52.

———. "Remembering the Historical Present." *Critical Inquiry* 33, no. 3 (2007): 471–94.

Harris, Jonathan, ed. *Globalization and Contemporary Art*. Oxford: Wiley-Blackwell, 2011.

Hartog, Francois. *Régimes d'historicité: Présentisme et expériences du temps*. Paris: Seuil, 2003.

Haskell, Francis. *History and Its Images*. New Haven: Yale University Press, 1993.

Hassan, Salah. "The Modernist Experience in African Art: Visual Expressions of the Self and Cross-Cultural Aesthetics." In *Reading the Contemporary: African Art from Theory to the Marketplace*, edited by Olu Oguibe and Okwui Enwezor, 215–35. Cambridge: MIT Press, 1999.

Hausenberg, Margarethe. *Matthias Grünewald im Wandel der deutschen Kunstanschauung*. Leipzig, Germany: J. J. Weber, 1927.

Hayum, Andrée. *The Isenheim Altarpiece: God's Medicine and the Painter's Vision*. Princeton: Princeton University Press, 1989.

Heffernan, James. "Ekphrasis and Representation." *New Literary History* 22 (1991): 297–316.

———. *Museum of Words: The Poetry of Ekphrasis from Homer to Ashbery*. Chicago: University of Chicago Press, 1993.

———. "Speaking for Pictures: The Rhetoric of Art Criticism." In *Cultivating Picturacy: Visual Art and Verbal Interventions*, 39–68. Waco, Tex.: Baylor University Press, 2006.

Heidegger, Martin. "The Origin of the Work of Art." In *Poetry, Language, Thought*, translated by Albert Hofstadter, 15–86. New York: Harper and Row, 1971.

Heinemann, Katharina. "Entdeckung und Vereinahmung: Zur Grünewald-Rezeption in Deutschland bis 1945." In *Grünewald in der Moderne: Die Rezeption Matthias Grünewald im 20. Jahrhundert*, edited by Brigitte Schad and Thomas Ratzka, 8–17. Cologne: Wienand, 2003.

Henare, Amiria, Martin Holbraad, and Sari Wastell. "Introduction." In *Thinking through Things: Theorizing Artefacts Ethnographically*, 1–31. London: Routledge, 2007.

Hernandez Navarro, Miguel Angel. "Presentacion: Antagonismos temporales." In *Heterocronias: Tiempo, arte y arqueologias del presente*, edited by Miguel Angel Hernandez Navarro, 9–16. Murcia: CEDEAC, 2008.

———. "Contradictions in Time-Space: Spanish Art and Global Discourse." In *The Global Art World: Audiences, Markets, and Museums*, edited by Hans Belting and Andrea Buddensieg, 136–53. Ostfildern: Hatje Cantz, 2009.

———. "Out of Synch: Visualizing Migratory Times through Video Art." In *Art and Visibility in Migratory Culture: Enacting Conflict and Resistance, Aesthetically*, edited

by Mieke Bal and Miguel Angel Hernandez Navarro, 191–208. Amsterdam: Rodopi, 2011.

Hoffmann, Konrad. "Panofskys 'Renaissance.'" In *Erwin Panofsky: Beiträge des Symposions Hamburg 1992*, edited by Bruno Reudenbach, 139–44. Berlin: Akademie Verlag, 1994.

Hollander, Jaap den, Herman Paul, and Rik Peters. "Historical Distance: Reflections on a Metaphor." Special issue, *History and Theory* 50 (December 2011).

Holly, Michael Ann. *Panofsky and the Foundations of Art History*. Ithaca: Cornell University Press, 1984.

———. *Past Looking: Historical Imagination and the Rhetoric of the Image*. Ithaca: Cornell University Press, 1996.

———. "Patterns in the Shadows: Attention in/to the Writings of Michael Baxandall." In *About Michael Baxandall*, edited by Adrian Rifkin, 5–16. Oxford: Blackwell, 1999.

Hutchison, Jane Campbell. *Albrecht Dürer: A Biography*. Princeton: Princeton University Press, 1990.

Hütt, Mathis. *Gothardt-Neithardt gennant "Grünewald": Leben und Werk im Spiegel der Forschung*. Leipzig, Germany: E. A. Seemann, 1968.

Hütt, Wolfgang. *Deutsche Malerei und Graphik der frühbürgerlichen Revolution*. Leipzig, Germany: E. A. Seemann, 1973.

Hutton, Patrick. *History as an Art of Memory*. Hanover, N.H.: University Press of New England, 1993.

Iggers, George. *The German Conception of History: The National Tradition of Historical Thought from Herder to the Present*. Middletown, Conn.: Wesleyan University Press, 1968.

Iversen, Margaret, and Stephen Melville. *Writing Art History: Disciplinary Departures*. Chicago: University of Chicago Press, 2010.

Jameson, Fredric. *Postmodernism, or, the Cultural Logic of Late Capitalism*. Durham: Duke University Press, 1991.

———. "The End of Temporality." *Critical Inquiry* 29, no. 4 (2003): 695–718.

———. *A Singular Modernity: Essay on the Ontology of the Present*. London: Verso, 2002.

Jardine, Lisa, and Jerry Brotton. *Global Interests: Renaissance Art between East and West*. Ithaca: Cornell University Press, 2000.

Jarzombek, Mark. "De-scribing the Language of Looking: Wölfflin and the History of Aesthetic Experientialism." *Assemblage* 23 (1994): 28–69.

Jauss, Hans Robert. "Literary History as a Challenge to Literary Theory." In *Toward an Aesthetic of Reception*, translated by Timothy Bahti, 3–45. Minneapolis: University of Minnesota Press, 1982.

Jay, Martin. *Songs of Experience: Modern American and European Variations on a Universal Theme*. Berkeley: University of California Press, 2005.

Jentsch, Ralph. *George Grosz: The Berlin Years*. Milan: Editori Associati, 1997.

Kahane, Catharina. "Das Kreuz mit der Distanz: Passion und Landschaft in Pieter

Bruegels Wiener Kreuztragung." In *Gesichter der Haut*, edited by Christoph Geissmar-Brandi, Irmela Hijiya-Kirschnereit, and Satô Naoki, 189–211. Frankfurt: Stroemfeld, 2002.

Kapur, Geeta. "When Was Modernism in Indian Art?" In *When Was Modernism: Essays on Contemporary Cultural Practice in India*, 297–324. New Delhi: Tulika Books, 2000.

Karlholm, Dan. "Surveying Contemporary Art: Post-war, Postmodern, and Then What?" *Art History* 32, no. 4 (2009): 712–33.

Kaufmann, Thomas DaCosta. "Periodization and Its Discontents." *Journal of Historiography*, no. 2 (2010): 1–6.

Kemp, Wolfgang, ed. *Der Betrachter ist im Bild: Kunstwissenschaft und Rezeptionsästhetik*. Cologne: DuMont, 1985.

Kerrigan, William, and Gordon Braden. *The Idea of the Renaissance*. Baltimore: Johns Hopkins University Press, 1989.

Killein, Thomas. *Hiroshi Sugimoto: Time Exposed*. London: Thames and Hudson, 1995.

Klein, Kerwin. "On the Emergence of Memory in Historical Discourse." *Representations* 69 (2000): 127–50.

Kober, Rudolph, and Gerd Lindner. "Paradigma Grünewald: Zur Erbe-Rezeption in der bildende Kunst der DDR." In *Grünewald in der Moderne: Die Rezeption Matthias Grünewald im 20. Jahrhundert*, edited by Brigitte Schad and Thomas Ratzka, 32–43. Cologne: Wienand, 2003.

Koerner, Joseph. *The Moment of Self-Portraiture in German Renaissance Art*. Chicago: University of Chicago Press, 1993.

———. "The Icon as Iconoclash." In *Iconoclash: Beyond the Image Wars in Science, Religion, and Art*, edited by Bruno Latour and Peter Weibel, 164–213. Karlsruhe, Germany: Center for Art and Media, 2002.

———. "Impossible Objects: Bosch's Realism." *RES: Anthropology and Aesthetics* 46 (2004): 73–97.

———. *The Reformation of the Image*. Chicago: University of Chicago Press, 2004.

———. "Unmasking the World: Bruegel's Ethnography." *Common Knowledge* 10, no. 2 (2004): 220–51.

———. "Wirklichkeit bei Hieronymus Bosch." In *Realität und Projektion in Antike und Mittelalter*, edited by Peter Schmidt and Martin Büchsel, 227–38. Berlin: Mann, 2005.

Koselleck, Reinhart. *Futures Past: On the Semantics of Historical Time*. Cambridge: MIT Press, 1985; 1st ed. Frankfurt, 1979.

Kracauer, Siegfried. *History: The Last Things before the Last*. New York: Oxford University Press, 1969.

Krauss, Rosalind, ed. *Cindy Sherman, 1975–1993*. New York: Rizzoli, 1993.

Krieger, Murray. *Ekphrasis: The Illusion of the Natural Sign*. Baltimore: Johns Hopkins University Press, 1992.

Kubler, George. *The Shape of Time: Remarks on the History of Things*. New Haven: Yale University Press, 1963.

Küchler, Suzanne, and Walter Melion, eds. *Images of Memory: On Remembering and Representation*. Washington: Smithsonian Institution, 1991.

Lacan, Jacques. *The Four Fundamental Concepts of Psychoanalysis*, edited by Jacques-Alain Miller, translated by Alan Sheridan. New York: Norton, 1981; 1st ed. 1973.

LaCapra, Dominick. *Rethinking Intellectual History: Texts, Contexts, Language*. Ithaca: Cornell University Press, 1983.

———. *History and Criticism*. Ithaca: Cornell University Press, 1985.

———. "History and Psychoanalysis." In *Soundings in Critical Theory*, 30–66. Ithaca: Cornell University Press, 1989.

———. *History and Memory after Auschwitz*. Ithaca: Cornell University Press, 1998.

———. *Writing History, Writing Trauma*. Baltimore: Johns Hopkins University Press, 2001.

Landauer, Carl. "Erwin Panofsky and the Renascence of the Renaissance." *Renaissance Quarterly* 47, no. 2 (1994): 255–81.

Langdale, Allan. "Aspects of the Critical Reception and Intellectual History of Baxandall's Concept of the Period Eye." In *About Michael Baxandall*, edited by Adrian Rifkin, 17–35. Oxford: Blackwell, 1999.

Latour, Bruno. "Opening One Eye while Closing the Other . . . a Note on Some Religious Paintings." In *Picturing Power: Visual Depictions and Social Relations*, edited by Gordon Fyfe and John Law, 15–38. London: Routledge, 1988.

———. *The Pasteurization of France*, translated by Alan Sheridan and John Law. Cambridge: Harvard University Press, 1988.

———. "What Is Iconoclash? Or Is There a World beyond the Image Wars?" In *Iconoclash: Beyond the Image Wars in Science, Religion, and Art*, edited by Bruno Latour and Peter Weibel, 14–38. Exhibition catalogue. Karlsruhe: Center for Art and Media, 2002.

———. "Why Has Critique Run Out of Steam? From Matters of Fact to Matters of Concern." In *Things*, edited by Bill Brown, 151–73. Chicago: University of Chicago Press, 2004.

Lee, Pamela. *Chronophobia: On Time in the Art of the 1960s*. Cambridge: MIT Press, 2004.

Le Goff, Jacques. *The Birth of Purgatory*, translated by Arthur Goldhammer. Chicago: University of Chicago Press, 1984.

———. *History and Memory*, translated by Steven Rendall and Elizabeth Claman. New York: Columbia University Press, 1992.

Legro, Michelle. "Wanted Dead or Alive: How We Experience Sugimoto's Portraits." BA thesis, Barnard College, 2005.

Lenoir, Timothy. "Inscription Practices and Materialities of Communication." In *Inscribing Science: Scientific Texts and the Materiality of Communication*, edited by Timothy Lenoir, 1–19. Stanford: Stanford University Press, 1998.

Levine, Gregory. *Daitokuji: The Visual Cultures of a Zen Monastery*. Seattle: University of Washington Press, 2005.

Lewis, Beth Irwin. *George Grosz: Art and Politics in the Weimar Republic*. Princeton: Princeton University Press, 1991.

Lindop, Barbara. *Sekoto*. London: Pavilion, 1995.

Lindsay, Kenneth, and Bernard Huppé. "Meaning and Method in Bruegel's Painting." *Journal of Aesthetics and Art Criticism* 14, no. 4 (1956): 376–86.

Lippit, Yukio. "Negative Verisimilitude: The Zen Portrait in Medieval Japan." In *Asian Art History in the Twenty-First Century*, edited by Vishaka Desai, 64–95. Williamstown, Mass.: Clark Art Institute, 2007.

Liu, Lydia. *Tokens of Exchange: The Problem of Translation in Global Circulations*. Durham: Duke University Press, 1999.

Lyotard, Jean-Francois. *The Postmodern Condition: A Report on Knowledge*, translated by Geoff Bennington and Brian Massumi. Minneapolis: University of Minnesota Press, 1984.

Mangani, N. Chabani. *A Black Man Called Sekoto*. Johannesburg: Witwatersrand University Press, 1996.

Marcoci, Roxana. *Thomas Demand*. New York: Museum of Modern Art, 2005.

Marin, Louis. "La description de l'image." *Communications* 15 (1970): 186–209.

———. *On Representation*, translated by Catherine Porter. Stanford: Stanford University Press, 2001.

Massey, Doreen. *For Space*. London: Sage, 2005.

McEvilley, Thomas. "Art History or Sacred History?" In *Art and Discontent: Theory at the Millennium*, 133–67. New York: McPherson, 1991.

Meadow, Mark. "Bruegel's Procession to Calvary, Aemulatio and the Space of Vernacular Style." *Nederlands Kunsthistorisch Jaarboek* 47 (1996): 181–205.

———. *Pieter Bruegel the Elder's Netherlandish Proverbs and the Practice of Rhetoric*. Zwolle, Netherlands: Waanders, 2002.

Meinecke, Friedrich. *Historicism: The Rise of a New Historical Outlook*, translated by J. Anderson. New York: Herder and Herder, 1972.

Melville, Stephen. "The Temptation of New Perspectives." *October* 52 (1990): 3–15.

Mercer, Kobena, ed. *Cosmopolitan Modernisms*. Cambridge: MIT Press; London: Institute of International Visual Arts, 2005.

———, ed. *Exiles, Diasporas and Strangers*. Cambridge: MIT Press, 2008.

Merker, Reinhard. *Die bildende Kunste im Nationalsozialismus: Kulturideologie–Kulturpolitik–Kulturproduktion*. Cologne: DuMont, 1983.

Merleau-Ponty, Maurice. "Eye and Mind." In *The Primacy of Perception and Other Essays on Phenomenological Psychology and Philosophy of Art, History and Politics*, edited by James Edie and translated by Carleton Dallery, 159–90. Evanston, Ill.: Northwestern University Press, 1964.

Mignolo, Walter. *The Darker Side of the Renaissance*. Ann Arbor: University of Michigan Press, 1995.

Miller, Daniel. *Material Culture and Mass Consumption*. Oxford: Blackwell, 1987.

Mirzoeff, Nicholas. *An Introduction to Visual Culture*. London: Routledge, 1999.

Mitchell, W. J. T. *Iconology: Image, Text, Ideology*. Chicago: University of Chicago Press, 1986.

———. "'Ut Pictura Theoria': Abstract Painting and the Repression of Language." *Critical Inquiry* 15, no. 2 (1989): 348–71.

———. *Picture Theory: Essays on Verbal and Visual Representation*. Chicago: University of Chicago Press, 1994.

———. "Showing Seeing: A Critique of Visual Culture." In *Art History, Aesthetics, Visual Studies*, edited by Michael Ann Holly and Keith Moxey, 231–50. Williamstown, Mass.: Clark Art Institute, 2002.

———. *What Do Pictures Want? The Lives and Loves of Images*. Chicago: University of Chicago Press, 2005.

———. *Cloning Terror: The War of Images; 9/11 to the Present*. Chicago: University of Chicago Press, 2011.

Mitter, Partha. *Much Maligned Monsters: A History of European Reactions to Indian Art*. Oxford: Clarendon, 1977.

———. "Can We Ever Understand Alien Cultures? Some Epistemological Concerns Relating to the Perception and Understanding of the Other." *Comparative Criticism* 9 (1987): 3–34.

———. *The Triumph of Modernism: India's Artists and the Avant-Garde 1922–1947*. London: Reaktion, 2007.

———. "Decentering Modernism: Art History and Avant-Garde Art from the Periphery." *Art Bulletin* 90 (2008): 531–48.

Molho, Anthony. "The Italian Renaissance, Made in America." In *Imagined Histories: American Historians Interpret the Past*, edited by Anthony Molho and Gordon S. Wood, 263–94. Princeton: Princeton University Press, 1998.

Mosquera, Gerardo. "Some Problems in Transcultural Curating." In *Global Visions: Towards a New Internationalism in the Visual Arts*, edited by Jean Fisher, 133–39. London: Kala Press and the Institute of International Visual Arts, 1994.

Moxey, Keith. "Art History's Hegelian Unconscious: Naturalism as Nationalism in the Study of Early Netherlandish Painting." In *The Practice of Persuasion: Paradox and Power in Art History*, 8–41. Ithaca: Cornell University Press, 2001.

———. "Making Genius." In *The Practice of Theory: Poststructuralism, Cultural Politics, and Art History*, 111–47. Ithaca: Cornell University Press, 1994.

———. "Panofsky's Melancolia." In *The Practice of Theory: Poststructuralism, Cultural Politics, and Art History*, 65–78. Ithaca: Cornell University Press, 1994.

Munch, Paul. "Changing German Perceptions of the Historical Role of Albrecht Dürer." In *Dürer and His Culture*, edited by Dagmar Eichberger and Charles Zika, 181–99. Cambridge: Cambridge University Press, 1998.

Nagel, Alexander, and Christopher Wood. *Anachronic Renaissance*. New York: Zone Books, 2010.

Navarro, Miguel Angel Hernandez. "Presentación: Antagonismos temporales." In

Heterocronías: Tiempo, arte y arqueologías del presente, edited by Miguel Angel Hernandez Navarro, 9–35. Murcia, Spain: CEDEAC, 2008.

———. "Contradictions in Time-Space: Spanish Art and Global Discourse." In *The Global Art World: Audiences, Markets, and Museums*, edited by Hans Belting and Andrea Buddensieg, 136–53. Ostfildern: Hatje Cantz, 2009.

———. "Out of Synch: Visualizing Migratory Times through Video Art." In *Art and Visibility in Migratory Culture: Enacting Conflict and Resistance, Aesthetically*, edited by Mieke Bal and Miguel Angel Hernandez Navarro, 191–208. Amsterdam: Rodopi, 2011.

Newman, Jane. "Periodization, Modernity, Nation: Benjamin between Renaissance and Baroque." *Journal of the Northern Renaissance*, no. 1 (2009): 19–34.

Nicodemus, Everlyn. "Inside. Outside." In *Seven Stories about Modern Art in Africa*, 29–36. London: Whitechapel Art Gallery, 1995.

Nora, Pierre. "Between Memory and History: *Les Lieux de mémoire*," translated by Marc Roudenbush. *Representations*, no. 26 (1989): 7–24.

Oguibe, Olu. "Reverse Appropriation as Nationalism in Modern African Art." In *The Third Text Reader on Art, Culture and Theory*, edited by Rasheed Araeen, Sean Cubitt, and Ziauddin Sardar, 35–47, 351–53. London: Continuum, 2002.

Olkowski, Dorothea. *Gilles Deleuze and the Ruin of Representation*. Berkeley: University of California Press, 1998.

Onians, John. *Art, Culture and Nature: From Art History to World Art Studies*. London: Pindar Press, 2006.

O'Sullivan, Simon. *Art Encounters Deleuze and Guattari: Thought beyond Representation*. London: Palgrave, 2006.

Pächt, Otto. "Design Principles of Fifteenth-Century Northern Painting" (1933), translated by Jacqueline Jung. In *The Vienna School Reader: Politics and Art Historical Method in the 1930s*, edited by Christopher Wood, 243–321. New York: Zone Books, 2003.

Pagden, Anthony. *European Encounters with the New World: From the Renaissance to Romanticism*. New Haven: Yale University Press, 1993.

Panofsky, Erwin. *Perspective as Symbolic Form*, translated by Christopher Wood. New York: Zone Books, 1991; 1st ed. 1927.

———. *Early Netherlandish Painting*. 2 vols. Cambridge: Harvard University Press, 1953.

———. "The History of Art as a Humanistic Discipline." In *Meaning in the Visual Arts*, 1–25. Garden City, N.Y.: Doubleday, 1955.

———. *The Life and Art of Albrecht Dürer*. 2 vols. Princeton: Princeton University Press, 1955.

———. *Renaissance and Renascences in Western Art*. New York: Harper and Row, 1969; 1st ed. 1960.

Paret, Peter. *An Artist against the Third Reich: Ernst Barlach, 1933–1938*. New York: Cambridge University Press, 2003.

Petropoulos, Jonathan. *Art as Politics in the Third Reich*. Chapel Hill: University of North Carolina Press, 1996.

———. *The Faustian Bargain: The Art World in Nazi Germany*. Oxford: Oxford University Press, 2000.

Phillips, John. *The Reformation of Images: Destruction of Art in England, 1535–1660*. Berkeley: University of California Press, 1973.

Phillips, Mark. "Distance and Historical Representation." *History Workshop Journal* 57, no. 1 (2004): 123–41.

———. "Rethinking Historical Distance: From Doctrine to Heuristic." *History and Theory* 50 (December 2011): 11–23.

Piotrowski, Piotr. "On the Spatial Turn, or Horizontal Art History." *Umeni*, no. 5 (2008): 378–83.

Podro, Michael. *The Critical Historians of Art*. New Haven: Yale University Press, 1982.

Pollock, Griselda. *Vision and Difference: Femininity, Feminism, and Histories of Art*. London: Routledge, 1987.

Poulsen, Hanne Kolind, ed. *Cranach*. Exhibition catalogue. Copenhagen: Statens Museum for Kunst, 2002.

Preiss, Bettina. "Eine Wissenschaft wird zur Dienstleistung: Kunstgeschichte im Nationalsozialismus." In *Kunst auf Befehl?*, edited by Bazon Brock and Achim Preiss, 41–58. München: Klinckhardt and Biermann, 1990.

Preziosi, Donald. *Rethinking Art History*. New Haven: Yale University Press, 1989.

Quemin, Alain. "The Illusion of the Elimination of Borders in the Contemporary Art World: The Role of the Different Countries in the 'Era of Globalization and Metissage.'" In *Artwork through the Market: The Past and the Present*, edited by Jan Bakos, 275–300. Bratislava, Slovakia: Center for Contemporary Art, 2004.

Rampley, Matthew. "Art History and Cultural Difference: Alfred Gell's Anthropology of Art." *Art History* 28, no. 4 (2005): 524–51.

Rancière, Jacques. "Le concept d'anachronisme et la vérité de l'historien." In *L'inactuel: Psychanalyse et culture*, 53–68. Paris: Calmann-Levy, 1994.

Réau, Louis. *Mathias Grünewald et le retable de Colmar*. Nancy, France: Berger-Levrault, 1920.

Renda, Gerhard. "Studien zur Gotikrezeption im deutschen Expressionismus." Inaugural dissertation, Friedrich-Alexander-Universität Erlangen-Nürnberg, 1990.

Ricoeur, Paul. *Time and Narrative*, translated by Kathleen Blamey and David Pellauer. 3 vols. Chicago: University of Chicago Press, 1984–88.

Riegl, Alois. *The Group Portraiture of Holland*, translated by Evelyn Kain and David Britt. Los Angeles: Getty Research Center, 1999; 1st ed. 1931.

Riera, Gabriel, ed. *Alain Badiou: Philosophy and Its Conditions*. Albany: State University of New York Press, 2005.

Rogoff, Irit. "Studying Visual Culture." In *The Visual Culture Reader*, edited by Nicholas Mirzoeff, 14–26. London: Routledge, 1998.

Roskill, Mark, and Craig Harbison. "On the Nature of Holbein's Portraits." *Word and Image* 3, no. 1 (1987): 1–26.

Ross, Christine. "The Suspension of History in Contemporary Media Arts." *Intermédialités*, no. 11 (2008): 125–48.

Roth, Michael. *The Ironist's Cage: Memory, Trauma, and the Construction of History.* New York: Columbia University Press, 1995.

Ruehl, Martin. "A Master from Germany: Thomas Mann, Albrecht Dürer, and the Making of a National Icon." *Oxford German Studies* 38, no. 1 (2009): 61–106.

Runia, Eelco. "Presence." *History and Theory*, no. 45 (2006): 1–29.

———. "Spots of Time." *History and Theory*, no. 45 (2006): 305–16.

Rüsen, Jörn, ed. *Western Historical Thinking: An Intercultural Debate.* New York: Berghahn Books, 2002.

Sandrart, Joachim von. *Teutsche Academie der Bau- Bild- und Mahlerey-Kunste*, edited by Christian Klemm. 2 vols. Nordlingen: Dr. Alfons Uhl, 1994.

Sauerländer, Willibald. "*Barbari ad portas*: Panofsky in den funfziger Jahren." In *Erwin Panofsky: Beiträge des Symposions Hamburg 1992*, edited by Bruno Reudenbach, 123–37. Berlin: Akademie Verlag, 1994.

Schacter, Daniel. *Searching for Memory: The Brain, the Mind, and the Past.* New York: Basic Books, 1996.

———. *The Seven Sins of Memory: How the Mind Forgets and Remembers.* New York: Houghton Mifflin, 2001.

Schad, Brigitte, and Thomas Ratzka. *Grünewald in der Moderne: Die Rezeption Matthias Grünewald im 20. Jahrhundert.* Cologne: Wienand, 2003.

Schapiro, Meyer, H. W. Janson, and Ernst Gombrich. "Criteria of Periodization in the History of European Art." *New Literary History* 1, no. 2 (1970): 113–25.

Scheller, Robert. "Concluding Remarks: Some Reflections on Tribal Gossip and Other Metaphors." In *Memory and Oblivion: Proceedings of the 29th International Congress of the History of Art*, edited by Wessel Reinink and Jeroen Stumpel, 19–23. Dordrecht, Netherlands: Kluwer Academic, 1999.

Schmid, Heinrich. *Die Gemälde und Zeichnungen von Matthias Grünewald.* 2 vols. Strasbourg: Heinrich, 1907–11.

Schneider, Norbert. "W.J.T. Mitchell und der 'Iconic Turn.'" *Kunst und Politik* 10 (2008): 29–37.

Schulze, Ingrid. *Die Erschütterung der Moderne: Grünewald in 20. Jahrhundert.* Leipzig, Germany: E. A. Seemann, 1991.

Schwerte, Hans. *Faust und das Faustische: Ein Kapitel deutscher Ideologie.* Stuttgart, Germany: Ernst Klett Verlag, 1962.

Scott, Joan. "The Evidence of Experience." *Critical Inquiry* 17, no. 4 (1991): 773–97.

Sedlmayr, Hans. "Bruegel's *Macchia*" (1934), translated by Frederic Schwartz. In *The Vienna School Reader: Politics and Art Historical Method in the 1930s*, edited by Christopher Wood, 323–76. New York: Zone Books, 2000.

Selz, Peter. *German Expressionist Painting*. Berkeley: University of California Press, 1957.

Shapiro, Gary. "The Absent Image: Ekphrasis and the 'Infinite Relation.'" *Journal of Visual Culture* 6, no. 1 (2007): 13–24.

Smith, Gary, and Hinderk Emrich, eds. *Vom Nutzen des Vergessens*. Berlin: Akademie Verlag, 1996.

Smith, Terry. "Introduction: The Contemporaneity Question." In *Antinomies of Art and Culture*, edited by Terry Smith, Okwui Enwesor, and Nancy Condee, 9. Durham: Duke University Press, 2008.

———. *What Is Contemporary Art?* Chicago: University of Chicago Press, 2009.

Snow, Edward. *Inside Bruegel: The Play of Images in Children's Games*. New York: Farrar, Straus and Giroux, 1997.

Spiegel, Gabrielle. "Memory and History: Liturgical Time and Historical Time." *History and Theory*, no. 41 (2002): 149–62.

Spiro, Lesley, ed. *Gerard Sekoto: Unsevered Ties*. Exhibition catalogue. Johannesburg: Johannesburg Art Gallery, 1989.

Steiner, Wendy. *The Colors of Rhetoric: Problems in the Relation between Modern Literature and Painting*. Chicago: University of Chicago Press, 1982.

Stieglitz, Ann. "The Reproduction of Agony: Toward a Reception-History of Grünewald's Isenheim Altar after the First World War." *Oxford Art Journal* 12, no. 2 (1989): 87–103.

Stierle, Karlheinz. "Renaissance: Die Entstehung eines Epochenbegriffs aus dem Geist des 19. Jahrhunderts." *Poetik und Hermeneutik* 12 (1987): 453–92.

Stokes, Adrian. *The Critical Writings of Adrian Stokes*, vol. 2, edited by Lawrence Gowing. London: Thames and Hudson, 1978; 1st ed. 1937.

Stridbeck, Carl. "'Combat between Carnival and Lent,' by Pieter Bruegel the Elder: An Allegorical Picture of the Sixteenth Century." *Journal of the Warburg and Courtauld Institutes* 19, nos. 1–2 (1956): 96–109.

Strieder, Peter. *The Hidden Dürer*, translated by Vivienne Menkes. Chicago: Rand McNally, 1978.

———. *Albrecht Dürer: Paintings, Prints, Drawings*, translated by Nancy M. Gordon and Walter L. Strauss. New York: Abaris Books, 1982.

Sturken, Marita. "The Remembering of Forgetting: Recovered Memory and the Question of Experience." *Social Text*, no. 57 (1998): 103–25.

Summers, David. *Real Spaces: World Art History and the Rise of Western Modernism*. London: Phaidon, 2003.

Talbot, Charles. "An Interpretation of Two Paintings by Cranach in the Artist's Late Style." In *Report and Studies in the History of Art*, 67–88. Washington: National Gallery of Art, 1967.

Taussig, Michael. *Mimesis and Alterity: A Particular History of the Senses*. New York: Routledge, 1993.

Thomas, Nicholas. *Entangled Objects: Exchange, Material Culture, and Colonialism in the Pacific*. Cambridge: Harvard University Press, 1991.

Tollebeek, Jo. "Renaissance and 'Fossilization': Michelet, Burckhardt, and Huizinga." *Renaissance Studies* 15, no. 3 (2001): 354–66.

Trouillot, Michel-Rolph. *Silencing the Past: Power and the Production of History*. Boston: Beacon, 1995.

Troy, Nancy, Geoffrey Batchen, Amelia Jones, Pamela Lee, Romy Golan, Robert Storr, Jodi Hauptman, and Dario Gamboni. "Interventions Reviews." Review of *Art since 1900: Modernism, Antimodernism, Postmodernism. Art Bulletin* 88, no. 2 (2006): 373–89.

Ullmann, Ernst. "Albrecht Dürer und die frühbürgerliche Revolution in Deutschland." In *Albrecht Dürer: Zeit und Werk*, edited by Ernst Ullmann et al., 55–90. Leipzig: Karl Marx Universität, 1971.

Ullmann, Ernst, Günter Grau, and Rainer Behrends, eds. *Albrecht Dürer: Zeit und Werk*. Leipzig: Karl Marx Universität, 1971.

Unverfehrt, Gerd. *Hieronymus Bosch: Die Rezeption seiner Kunst im frühen 16. Jahrhundert*. Berlin, Mann, 1980.

Vaisse, Pierre. *Reître ou chevalier? Dürer et l'idéologie allemande*. Paris: Maison des sciences de l'homme, 2006.

Velden, Hugo van der. "Medici Votive Images and the Scope and Limits of Likeness." In *The Image of the Individual: Portraits of the Renaissance*, edited by Nicholas Mann and Luke Syson, 126–37. London: Trustees of the British Museum, 1998.

Venuti, Lawrence. "Ekphrasis, Translation, Critique." *Art in Translation* 2 (2010): 131–52.

Warburg, Aby. "The Art of Portraiture and the Florentine Bourgeoisie." In *The Renewal of Pagan Antiquity: Contributions to the Cultural History of the European Renaissance*, translated by David Britt, 185–221. Los Angeles: Getty Research Center, 1999.

White, Hayden. *Metahistory: The Historical Imagination in Nineteenth-Century Europe*. Baltimore: Johns Hopkins University Press, 1974.

———. *Tropics of Discourse: Essays in Cultural Criticism*. Baltimore: Johns Hopkins University Press, 1978.

———. *The Content of the Form: Narrative Discourse and Historical Representation*. Baltimore: Johns Hopkins University Press, 1987.

Wölfflin, Heinrich. *Principles of Art History: The Problem of the Development of Style in Later Art*, translated by M. D. Hottinger. London: Bell, 1932; 1st ed. 1918.

———. *The Art of Albrecht Dürer*, translated by Alastair and Heide Grieve. London: Phaidon, 1971; 1st ed. 1919.

———. *Italien und das deutsche Formgefühl*. Munich: F. Bruckmann, 1931.

Wollheim, Richard. *Art and Its Objects: An Introduction to Aesthetics*. New York: Harper and Row, 1971.

Wood, Christopher. "Art History's Normative Renaissance." In *The Italian Renaissance in the Twentieth Century: Acts of an International Conference, Florence, Villa I Tatti, June 9–11, 1999*, edited by Allen Grieco et al., 65–92. Florence: Olschki, 1999.

The World of Tycho Brahe. Exhibition Catalogue. Copenhagen: National Museum of Denmark, 2006.

Worringer, Wilhelm. *Form in Gothic,* translated by Herbert Read. New York: Schocken Books, 1957.

Wuttke, Dieter. *Nuremberg: Focal Point of German Culture and History; A Lecture.* Bamberg: H. Kaiser, 1987.

Wyss, Beat. "Ein Druckfehler." In *Erwin Panofsky: Beiträge des Symposions Hamburg 1992,* edited by Bruno Reudenbach, 191–99. Berlin: Akademie Verlag, 1994.

Zijlmans, Kitty, and Wilfried van Damme, eds. *World Art Studies: Exploring Concepts and Approaches.* Amsterdam: Valiz, 2008.

Note: Page numbers in italics indicate illustrations. Texts are annotated with the date of publication to distinguish them from works of art.

artifact, aesthetic potential of, 62

art markets, 19–20

Asschaffenburg, Mattheus von. *See* Grüne-
wald, Matthias

asynchrony, contemporaneity and, 41–42

Augé, Marc, 41, 42

Badiou, Alain, 55

Baroque, the, Grünewald and, 144, 149

Barthes, Roland, 39, 58, 100, 110, 122, 134n10

Bätschmann, Oskar, 113, 122

Baudrillard, Jean, 64–65

Baxandall, Michael, 59, 60, 61, 79, 94, 163

Belting, Hans, 64–65, 66, 69, 70, 78, 87, 120,
132; *An Anthropology of Images* (2001), 64

Benjamin, Walter: on mimesis, 114, 117, 122,
124, 133; on translation, 2

Bild, concept of as autonomous, 63–64

Bildanthropologie, 63, 67–68

Bildwissenschaft (image science), 65–66,
67–68, 78

Bismarck, Otto von, 153

Boehm, Gottfried, 63, 66, 78, 94, 95–96; *Was
ist ein Bild?* (1994), 63

Born, Derich, 115, *116*

Bosch, Hieronymus, 84, 102n14; *The Garden
of Earthly Delights*, 84–86, *85*

Bourriaud, Nicolas, 42, 43

Bredekamp, Horst, 64, 66, 70, 78

Bruegel, Pieter, the Elder: historiography
of, 6, 78–79. Works: *Christ Carrying the
Cross*, 87–89, *88*; *The Battle between Car-
nival and Lent*, 80–84, *81*, 86–87, 93; *The
Return of the Hunters*, 96–101, *97*; *The Tri-
umph of Death*, 91–94, *92*

Burckhardt, Jacob, 24, 169n11

Campin, Robert, *Merode Altarpiece*, 27, *27*

capitalism, and cultural criticism, 40

Catholic Church: and German militarism,
147; Grünewald and, 150, 160; and the
Reformation, 80–81, 125, 129; and the
subject matter of the *Isenheim Altarpiece*,
163–64. *See also* iconoclasm, 16th-century

Cézanne, Paul, 101

Chakrabarty, Dipesh, 25

Christensen, Carl, 125–26

chronology, 5, 32, 45–47

Clark, T. J., 59

coat of arms, as emblematic, 117, 120

colonial project, and modernism, 2, 14–15,
18–19

composition, and meaning, 83–84, 90–91

conceptualism, Latin American, 15

contemporaneity, 16–19, 39, 41; as apoca-
lyptic, 41; asynchrony and, 41–42; as
featureless, 44; heterochrony and, 6, 42,
47, 49n16; historicism and, 38–44; multi-
plicity and, 17–18

content, form and, 58–59, 64, 66

context, and memory, 141

Cranach, Lucas, the Elder, 126–27, *128*, 132;
Lamentation under the Cross, 127, *128*;
Martin Luther, 129–31, *130*; and Lucas
Cranach the Younger, *Crucifixion and
Allegory of Redemption*, 127–29, *128*

Cranach, Lucas, the Younger, 126–29

crows, Bruegel's, 99, 100, 101

culture: disparate, and time, 2–3, 6, 13–14,
16–18, 20, 25, 39, 41–46, 173; represen-
tation and, 66; visual, 67; visual studies
and, 54, 66–68

Damisch, Hubert, 60

Danto, Arthur, 16, 40

Darwin, Charles, *On the Origin of Species*, 65

Daston, Lorraine, 56, 69

de Certeau, Michel, 24, 84

Deleuze, Gilles, 55

Demand, Thomas: mimesis and, 7, 108–9,
122, 133. Works: *Glass*, 108, *111*, 125; *Win-
dow*, 108, *110*

Denmark, the Renaissance in, 26

Derrida, Jacques, 39, 59, 60, 69, 142

diachrony, 8, 28–29, 120

Didi-Huberman, Georges, 66, 68, 70; on
anachronism, 25, 28, 29, 31, 156, 158;
on the experience of the work, 60–61;
on synchrony, 28

difference: iconic, 96; idea of, in art history,

4–5, 84, 174; as identity politics, 4, 162; imagery and, 84, 93; metaphysical, between image and language, 94–95; temporal, 3, 4–5, 31, 44–47, 143, 175. *See also* distance, historical

Dinteville, Jean de, 122, *123*

distance, historical: and analysis, 79–80, 140, 174; concept of, 140–41, 143, 154–56, 161, 162, 165; elision of, 7, 140, 161–62; historiography and, 7–8, 45, 59, 156, 158, 161, 164; ideology and, 144–45; between image and text, 99–100; between image and viewer, 59, 79, 139; memory and, 141–43, 165–66; objectivity and, 154–55, 162–64; Panofsky on, 7–8, 154–56, 158, 159, 161; representation and, 140; teleology and, 2

Dürer, Albrecht, 115, 131, 140; four-hundredth anniversary celebration for, 159; historiography of, 7, 27–28, 140, 143, 150–53, 159–61; iconography of, and interpretation, 151–53, 158–59; Koener on, 27–28; literature on, 161–63, 164; Panofsky on, 27, 155–56, 158; as paragon of German art, 144–45, 159; social conscience of, 160. Works: *Knight, Death, and the Devil*, 151–53, *152*, 156; *Melencolia I*, 27, 156, *157*, 158; *Self-Portrait*, 28, *29*, 115, 161, 163

East Germany, Dürer and the political agenda, 159–61

ekphrasis: limitations of, 98, 100, 175; as translation, 94–96

Elkins, James, 62–63, 66, 68, 70, 78; *Visual Practices across the University* (2007), 62–63

emblems, in devotional portraiture, 117

Enwezor, Okwui, 11

Erasmus, Desiderius, 129, *130*, 131, 137n45

exhibitions: *Altermodern: Tate Triennial* (2009), 42; *Degenerate Art* (1937), 151; *Iconoclash: Beyond the Image Wars in Science, Religion, and Art* (2002), 126; *The Short Century* (2001–2), 11, 14, 20; *The World of Tycho Brahe* (2006), 25–26

experientalism, aesthetic, 100

Expressionism, German: Grünewald and, 150–51, 170n25; National Socialism and, 151, 153. *See also* Abstract Expressionism

Fabian, Johannes, 2

facticity, and the invisible, 82–83, 87, 96

facture, as significant, 82–83, 87

Falkenberg, Reindert, 89, 91

Farago, Claire, *Reframing the Renaissance* (1995), 25

Feist, Peter, 160

Ficino, Marsilio, 158

Flanders, late-medieval art in, 26–27, 84

flatness (absence of perspective): in Bruegel, 83, 84, 87, 93, 98–99; in Cranach, 129, 131; in Holbein, 121. *See also* two-dimensionality

form, as intelligent, 91

formalism, 64, 66, 82

Foucault, Michel, 24, 39, 59

Freedberg, David, 60

Freud, Sigmund, 142

Fried, Michael, 60

Galison, Peter, 56

Gauguin, Paul, 12

gaze, and the agency of the image, 64, 87, 93, 122, 124

Gell, Alfred, 57, 114

genealogy, portraiture and, 120

German Democratic Republic. *See* East Germany, Dürer and the political agenda

Germany, art in: 15th-century religious, 121; nationalism and, 7, 140, 143–51, 149–53, 155, 156, 163; naturalism and, 150, 156; the Renaissance and, 140, 143–47, 149–53, 154–61

Ghirlandaio, Domenico, *The Confirmation of the Franciscan Rule*, 120

Gilbert, Felix, 24

Gogh, Vincent van, 12

Gossaert, Jan: *Carondelet Diptych: Jean Carondelet*, 117, *119*; *Carondelet Diptych: Virgin and Child*, 117, *119*

Gossman, Lionel, 24

Gothardt-Neithardt, Matthis. *See* Grünewald, Matthias

Greenberg, Clement, 16

Greenwich Mean Time, 17

Griener, Pascal, 113, 122

Grosz, George, 146; *"Shut Up and Do Your Duty,"* 146–47, *148*; *"Silence!,"* 147, *148*

Grünewald, Matthias (Matthis Gothardt-Neithardt), 140; art of, as expressive, 150–51; historiography of, 7, 140, 143–44, 149–50; literature on, 161, 163–64; as paragon of German art, 144–46, 149, 160; religion espoused by, 163. Works: *Isenheim Altarpiece*, 143, 144, 145–47, *147*, 163–64

Guattari, Felix, 55

Guha, Ranajit, 25

Gumbrecht, Hans-Ulrich, 54

Günther, Hans, *Ritter Tod und Teufel: Der heldische Gedanke* (1937), 153

Haak, Friedrich, *Albrecht Dürer: Deutschlands grösster Künstler* (1928), 150–51

Hagen, Oskar, 150

Harbison, Craig, 113

Hassan, Salah, 19

Hayum, Andrée, on Grünewald, 163–64

Hegel, G. W. F. *See* historicism, Hegelian

Heidegger, Martin, 60

Henry VIII, king of England, *112*, 122, 132

heterochrony, 8; as anachrony, 42–43, 174–75; art history and, 2, 173–75; contemporaneity and, 6, 42, 47, 49n16; cultural difference and, 13–16, 42–43, 47, 174–75; defined, 2–3; historical time and, 1, 2, 20; meaning and, 3–4; periodization and, 23; postcolonialism and, 5, 6, 11–12, 20

historicism, Hegelian, 2, 25; history of art and, 16, 24, 59, 60, 141, 155; rejection of, 31, 38, 44, 173–74

historiography: of Bruegel, 6; of Dürer, 7, 27–28; and the existential presence of objects, 57–58; of Grünewald, 7

history: and the agency of the image, 7; as

analogous to astronomy, 31; end of, 40, 44; language in the interpretation of, 24; narrative of, 1, 2, 16, 38–44; periodization in, 37; philosophy of, 23–25; reception, 162, 164, 174; teleology and, 24–25, 141, 155, 161

history of art: agenda for, 165–66; alternative analyses in, 78–79; and anachrony, 61, 146, 156, 158, 173; and the concept of difference, 4–5, 84, 174; Hegelian historicism and, 16, 24, 59, 60, 141, 155; ideology and, 140, 143–54; periodization and, 5–6, 17–18, 23–25, 39, 43–47, 174; phenomenology and, 45; poststructuralism and, 60; the presence of the object and, 58–61; social, 3–4, 59, 147, 158, 163; time and, as Western, 1–3. *See also* historicism, Hegelian; visual studies

Hitler, Adolf, 153, 159

Holbein, Hans, the Younger, 126, 137n45, 144; mimesis in portraiture by, 108, 110, 111, 115, 120–22, 125, 129, 131–33; and photography, 109–10; presence in portraiture by, 108, 120–25. Works: *The Ambassadors*, 7, 108, 122–24, *123*, 132, *133*; *Erasmus of Rotterdam*, 129, *130*; *Portrait of Derich Born*, 115, *116*

Holbein, Hans, the Younger, circle of, *Portrait of Henry VIII of England*, *112*

Holocaust, the, and the concept of memory, 141

Holy Roman Empire, 159

humanism, 24, 100, 156

Hütt, Wolfgang, 160

Hutton Patrick, 141

iconic turn, the, 54; concept of, 63, 66, 69–71; implications of, for visual studies, 68, 77–78; ontology and, 54. *See also* pictorial turn

iconoclasm, 16th-century, 91, 107, 125–26, 131–32

iconography: of illuminated manuscripts, 96–97; and meaning, 82–83; as theological exposition, 127–29, 131, 132

ideology: cultural, 68; modernism as, 38; political, 20, 68, 144–47, 159

illusionism: Flemish, 26; and meaning, 82–83, 96, 132

illustration, scientific, as form of thought, 65–66

image: agency of (*see* agency of the image); anachrony and, 25, 141; existential status of, 55, 61, 63–67, 69–70, 77, 78, 132; informational, 62–63; nonart, 62; opacity in, 79, 103n17; as presentation (*see* presentation, image as); as representation (*see* representation); role of, 59, 69, 78, 114; significance and, 84; time of the, 1, 3–4, 12, 39, 61, 89–90, 99, 124, 164

imagery: creating by ekphrasis, 95; idolatry and, 125–26; Lutheran, 126–31; medieval devotional, 89, 91, 117–20, 126; transparency in, 127, 129

Image-Worlds of Knowledge (periodical), 66

indifference, ekphrastic, 95

intentionality, 54, 79

interpretation: as contingent, 68–69, 79–80; iconography and, 151–53, 158–59; intentionality and, 54; language and, 24; memory and, 142–43; need for, 165; personal aesthetic response and, 162; pictorial opacity and, 90, 99, 100–101, 103n17; politics of, 4, 68, 70, 143–47; significance and, 4; transparency and, 79

Iser, Wolfgang, 162

Italy, art of, 84; as privileged, 25–27, 154–55, 156

Jameson, Frederic, 39–40

Jarzombek, Mark, 100

Jauss, Hans Robert, 162

Kant, Immanuel, 153. *See also* aesthetics: Kantian

Karlstadt, Andreas, *On the Abolition of Images* (1522), 125, 126

Kemp, Wolfgang, 60

Koerner, Joseph, 94, 127; on Dürer, 27–28, 115, 161–63, 164

Koselleck, Reinhart, 40–41

Kratzer, Nicholas, 122

Krauss, Rosalind, 60

Kreiger, Murray, 95

Kubler, George, 31, 45, 46

Lacan, Jacques, 39, 59, 63, 124; *The Four Fundamental Concepts of Psychoanalysis* (1981), 100–101

language: affect and, 55, 59, 63; as an agent of being, 56, 57, 60–61; experience and, 54; as paralleled in the figure and ground of imagery, 95–96; role of, 69–71, 77–80, 98–99; scientific research and, 56–57; vis-à-vis the visual, 3, 5, 6–7, 45, 63, 69–71, 79–80, 91–96, 100, 175

Latour, Bruno, 56, 69, 126

Leibniz, Gottfried Wilhelm, 153

Leonardo da Vinci, 115

line, the: in German art, 144, 150; as metaphor, 150–51

linguistic turn, the, 54, 166n2

Liu, Lydia, 46

Lollards, 131

Luther, Martin, 125–29, *128*, *130*, 137n45, 153, 163

Lutheranism, imagery and, 12, 126–31

Lyotard, Jean-Francois, 39

macchia (splotch, blot), 82–83, 87

Madam Tussauds, London, 109

manipulation, and photography, 109

Marin, Louis, 103n17

Marxism, historiography and, 159–61

mask, portraiture as, 129–31, *130*

Massys, Quentin, 131

meaning, 63, 100–101; abstraction and, 2, 24; affect and, 56, 174; agency of the image and, 4, 5–6; composition and, 83–84, 90–91; ekphrasis as creating, 95–96; experience and, 55, 58, 162; heterochrony and, 3–4; hidden, 86; iconography and, 82–83; illusionism and, 82–83, 96, 132; metaphor and, 58, 63, 79, 86–87; metonymy and, 58; representation and, 54,

objectivity, and historical distance, 154–55, 162–64

Oguibe, Olu, 12

opacity, 77; the linguistic turn and, 166n2; pictorial, and interpretation, 90, 99, 100–101, 103n17; surface, 87, 124; of the visual, 79, 139

Pächt, Otto, 121

Pagden, Anthony, 25

Panofsky, Erwin: historical distance and, 7–8, 154–56, 158, 159, 161; iconology and, 59, 60, 61; on the ideology of the Renaissance, 24, 26–27. Works: *Early Netherlandish Painting* (1953), 26; *The Life and Art of Albrecht Dürer* (1955), 155–56; *Perspective as Symbolic Form* (1927), 26; *Renaissance and Renascences in Western Art* (1960), 26

Pathosformeln (emotional formulae), 61

pattern, pictorial, 121

pause, interchronic, 46–47, 50n25

"period eye," 59

periodization, 23; anachrony and, 32, 42, 46; contemporary art and, 43–44; heterochrony and, 23; history and, 37; in the history of art, 5–6, 17–18, 23–25, 39, 43–47, 174

perspective: absence of (*see* flatness; two-dimensionality); Albertian (*see* perspective: one-point); atmospheric, 87, 93, 98; contemporary photography and, 109; as metaphor, 7, 154–55, 162; one-point (linear), 7, 26, 27, 84, 131, 145, 154–55, 162; Renaissance (*see* perspective: one-point)

phenomenology, 95; art history and, 45; art objects and, 25, 55–56, 60, 68, 79, 100, 122, 129; ontology and, 68, 100; response to imagery and, 82, 99–100, 134n10, 139, 141, 146, 161–63

photography, 109–10, 134n10

pictorial turn, the, 54, 61–62, 63. *See also* iconic turn, the

Piotrowski, Piotr, 43

planarity (pictorial pattern), 121

Pleydenwurff, Hans: *Georg Graf von Löwenstein*, 117, 118; *Man of Sorrows*, 117, 135n19

Pliny the Elder, *Natural History*, 113, 115

politics: identity, 4, 54, 162; of interpretation, 4, 68, 70, 143–47. *See also* ideology

Pollock, Jackson, 14

portraiture: affect and, 108; allusion and, 113; bourgeois, 120; medieval, 117–20; presence in, 17, 108, 120–25; religious, 28, 115, 117–20; role of, 108, 115–20, 129–31, 132; Zen Buddhist, 115, 117

postcolonialism, 24–25, 39

posthistorical, the, 16, 17, 40, 48n8

postmodernism, 16, 17, 39, 42, 56; reaction against, 142

poststructuralism, 39, 57–60

Poulsen, Hanna Kolind, 131

presence: existential, 57–58; historical, 58; Holbein and, 108, 120–25, 131, 132; iconic, 64–65, 115; images and, 3, 4, 6, 53, 55–65, 78, 79, 82, 83, 99–101, 139; memory and, 142; in portraiture, 17, 108, 120–25; suppression of, in Lutheran imagery, 129, 131

presence effects, 54

presentation, image as, 71n3, 77–78, 90–91, 164; and agency, 55, 63, 67–69; naturalism and, 115

Quemin, Alain, 19

reality, and mimesis, 107–8

reality effect, 58, 122, 127, 133

Réau, Louis, 149

reception: history, 162, 164, 174; viewer's, and mimesis, 83, 108, 122, 124, 132

Reformation, the, 125–26, 131–32, 150, 160

Renaissance, the: as concept, 6, 7, 23–27, 31; Danish, 26; German, historiography of, 140, 143–47, 149–53, 154–61; historical distance and, 154–55, 162; marginalization of, 38, 48n3, 144; role of, 37

representation, 82, 107, 115; in Bruegel, 80, 91–92, 99; culture and, 66; as fabricated, 109–10; historical distance and, 140; ideology and, 55; illusionism and, 26, 121;

representation (*continued*)

imagery and, 55, 63, 66, 68, 69, 90–91, 103n17, 131, 164; linguistic, 56, 79; meaning and, 54, 79, 91; mediation and, 107, 124; mimetic, 59, 91, 109, 131–32, 133, 150; objectivity and, 164; and the projection plane, 121, 154. *See also* presentation, image as

response, affective, 174

Riegl, Alois, 25, 59

Rogoff, Irit, 66–67

Roskill, Mark, 113

Runia, Eelco, 58

Sandrart, Joachim von, 143

Sassetti family, portraits of, 120

scale, in imagery, 87, 89

Schmid, Heinrich, 144, 169n11

science, imagery in, and visualization, 62–63

science studies, 56–57

Sedlmayr, Hans, 82, 87

Sekoto, Gerard, 12–14, 18, 20; *Two Friends*, 12, *13*

Selve, Georges de, 122, *123*

Selz, Peter, 170n25

Sherman, Cindy, History Portraits, 110, 111; *Untitled # 213*, *113*

skull, symbolism of, and mimesis, 117, 124–25, 132, 133

Smith, Terry, *What Is Contemporary Art?* (2009), 43–44

socialism, 57, 153, 160, 161

socialist realism, Dürer as forerunner of, 160

sociology: art history and, 147, 158, 163; and the status of objects, 57; visual studies and, 66, 67, 68

space, hierarchy and, 25–28

Spiegel, Gabrielle, 141–42

Stieglitz, Ann, 145

Stridbeck, Carl, 80, 82, 86, 102n15

Strieder, Peter, 158

style: identifiability of, in contemporary art, 40, 48n8; meaning and, 25–27; pictorial, in Flemish painting, 84

subject/object distinction, 45–47, 54, 56, 58, 95, 162, 164–65

Sugimoto, Hiroshi, 109–11; *Henry VIII*, *112*

supermodernity, 41

supplement, ideological, 55, 142, 156

synchrony, 28, 42

tapestry, as analogy, 93

technique, as representation, 82

teleology, 2; and history, 24–25, 141, 155, 161

text. *See* language

Thomas, Nicholas, 57

thought, scientific illustration as, 65–66

time: acceleration of, 41; aesthetic, 1, 5, 6, 175; as alienating, 139–40; anachronic (*see* anachrony); as asynchronous, 41; categorization of (*see* periodization); concepts of, and works of art, 1; contemporary art, 16–17, 39; cultures and, 2–3, 6, 13–14, 16–18, 20, 25, 39, 41–46, 173; definition of art and, 16–17; as an eternal present, 41, 43, 89; heterochronic (*see* heterochrony); historical, 1, 2, 20, 141, 174–75; of the image, 1, 3–4, 12, 39, 61, 89–90, 99, 124, 164; meaning and, 39–44, 46; mediation across, 124; as multiple (*see* heterochrony); teleology and, 24; of the work (*see* image: time of the)

transference and counter-transference, 31

translation: ekphrasis and, 94–96; limitations of, 79; meaning and, 5–6, 46; as metaphor, 1–2, 5–7, 14, 46, 175

transparency, 77; ekphrasis and, 94; as goal of interpretation, 79; narrative and, 103n17; in religious imagery, 127, 129

turn, philosophical. *See* iconic turn, the; linguistic turn, the; pictorial turn, the

two-dimensionality: in Dürer, 145; in Flemish painting, 84, 87, 98–99; in Holbein, 121–22; in late-medieval Netherlandish art, 121; in Lutheran painting, 12, 129–31

Ullmann, Ernst, 160

Venuti, Lawrence, 95

Vera Icon, the, and portraiture, 28, 115

verisimilitude: as illusionary, 124; and natu-

ralism, 26–27, 98, 115, 120, 126, 127, 129; power of, 7, 113–15, 117

Veronica, Saint, 115

viewer: engagement with the image and, 55, 68, 82–84, 89, 99, 121, 132, 160, 174–75; interpretation of the visual and, 6, 44–45, 66–69, 82–84, 90–91, 127–29, 164; personal response and, 28–31, 60–61; role of, 67

visual culture, 67. *See also* history of art; visual studies

visual studies: and culture, 54, 66–68; development of, 78; and the iconic turn, 68, 77–78; ideology and, 66; nonart images as field for, 62–63; ontology and, 54; theory in, 61–71

Waetzold, Wilhelm, 151–52

war: First World War, and German historiography, 145–46; Franco-Prussian War, 144; German Peasants' War (1525), 159–60; Second World War, 151

Warburg, Aby, 59, 61, 120

Warhol, Andy, *Brillo Boxes*, 16

waxworks, and the mimetic impulse, 109–10

Weimar Republic, political agenda of and history of art, 143

Werner, Gabriel, 66

White, Hayden, 24, 57

Wittgenstein, Ludwig, 63

Wölfflin, Heinrich, 59, 169n11; on Dürer and Grünewald, 144–45, 169n12; on style, 25, 149

work, time of the. *See* image: time of the

Worringer, Wilhelm, 144, 150

Wycliffe, John, 131

Zen Buddhism, role of 13th-century portraiture in, 115, 117

Zwingli, Ulrich, 125